Designer's Guide
to Print Production

Designer's Guide to Print Production

EDITED BY NANCY ALDRICH-RUENZEL
Editorial Director
Step-By-Step Graphics

With contributions by: Gordon Bieberle • Peter Brehm • Robert Dainton •
L. Mills Davis • Daniel Dejan • Jerry Demoney • Linda Duncan •
Helene Eckstein • Melene C. Follert • Murray Grant • Scott Griswold •
Gary Hespenheide • Amy Inouye • Andy Perni • Frank Romano •
Michael Scricco • Jack Siderman

A STEP-BY-STEP PUBLISHING BOOK
WATSON-GUPTILL PUBLICATIONS/NEW YORK

Jacket credits: Art and photography by Jayme Odgers,
Hollywood, California; electronic color retouching and
separations by George Rice & Sons, Los Angeles, California.

Step-By-Step Graphics staff for Designer's Guide to Print Production

Editorial Director: Nancy Aldrich-Ruenzel
Director of Art and Production: Mike Hammer
Special Project Editor: Catharine Fishel
Assistant Editor: Susan Goldberg-Dinges

First published in 1990 in New York by Watson-Guptill Publications,
a division of Billboard Publications, Inc.,
1515 Broadway, New York, N.Y. 10036, in conjunction with
Step-By-Step Publishing, a division of Dynamic Graphics, Inc.

Library of Congress Cataloging-in-Publication Data

Designer's guide to print production / edited by Nancy Aldrich
 -Ruenzel.
 p. cm.
 "A Step-by-step publishing book."
 ISBN 0-8230-1314-6
 1. Printing, Practical. 2. Printing, Practical—Layout.
 I. Aldrich-Ruenzel, Nancy.
 Z244.3.D47 1990
 686.2'24—dc20 89-48706
 CIP

Distributed in the United Kingdom by Phaidon Press Ltd.,
Musterlin House, Jordan Hill Road, Oxford OX2 8DP

Manufactured in the United States of America

First printing, 1990

1 2 3 4 5 6 7 8 9 10/94 93 92 91 90

Acknowledgments

The staff of *Step-By-Step Graphics* and I wish to thank the many individuals who made valuable contributions to this reference guide when it was first published as the "Designer's Guide to Print Production," the 1988 special annual issue of *Step-By-Step Graphics* magazine, and who subsequently gave us permission to reprint that material for publication in this book:

• Gordon Bieberle is the director for printing services at Columbia College in Chicago.

• Peter Brehm is the vice-president of print technologies for the Graphic Communications Association, a volunteer, non-profit organization for the print and publishing industries.

• Robert Dainton is the national training supervisor of Agfa-Gevaert's Graphic Systems Division, which supplies pre-press products for the print, art and advertising industries.

• L. Mills Davis is the president and founder of Davis Inc., the publisher of *Davis Review*. He is a noted consultant and the author of several industry studies, including "Toward the Electronic Studio."

• Daniel Dejan is the senior manager of design and production for Baxter Hospital Sales and Distribution Group.

• Jerry Demoney is the design director for Mobil Oil Corporation and the co-author of *Pasteups & Mechanicals*, a guide to preparing art for reproduction.

• Linda Duncan is a consultant to the communications industry, with a specialty in paper-related products.

• Helene Eckstein is widely known for her lectures on color separation methods. She is vice-president, marketing, at Spectrum, Inc.

• Melene C. Follert, vice-president and technical director at Potomac Graphic Industries, has more than 15 years' experience in digital imaging and has recently published a book, *Data Transmission for the Graphic Arts*.

• Murray Grant is a communications specialist for Strathmore Paper Company. He has more than 30 years of experience in the paper industry.

• Scott Griswold is a professional photographer specializing in black and white, and is a contributing editor to *Pedersen's Photo-Graphic*. A Kodak "mentor," he has exhibited his work with the likes of Ansel Adams and Edward Weston.

• Gary Hespenheide, a Los Angeles–based graphic designer, is currently a principal of his own design firm, which specializes in publication design and environmental graphics.

• Amy Inouye is a graphic designer, typographer and educator working in Los Angeles. She is the owner of Future Studio, a multi-faceted art and language studio.

• Andy Perni, a leading consultant, lecturer and author in the color industry, is the former president of Perni Color Process Corporation. He recently earned a doctoral degree for his dissertation, "The Technology of Electronic Color Scanning and Four-Color Lithographic Printing of Art Reproductions and Their Effect on the Image Transference of an Artist's Original Painting."

• Frank Romano is the editor and publisher of *Type World* and is a consultant in the field of electronic typesetting and publishing. He is the author of eight books, the latest of which deals with desktop typography.

• Michael Scricco is senior art director for Keiler Advertising, a full-service agency in Farmington, Connecticut.

• Jack Siderman is senior vice-president of Pantone, Inc. He is also a consultant for the graphic art and design communities on a variety of marketing, color, production and copywriting projects.

Additional acknowledgments should go to Chris Hershey, Gauge-O-Rama; Mark Beach, Coast-to-Coast Books; Fiorella Ogiba, Old Colony Envelope; Beryl Bridges, Paper Sources International; Margaret K. George, Baum USA; Alan Rowland, James River Corp./Premium Printing Papers Group; Corbett L. Saunders, S. D. Warren Co., Div. of Scott Paper Co.; Jayme Odgers; George Rice & Sons; Ken Sabatini; Wayne Adams, Reid Miles Photography; Scott Fishel; and Duane Zehr.

In addition to the contributors mentioned above, I would like to acknowledge the following people: the entire Dynamic Graphics, Inc., staff, for their unwavering commitment to and support of professional development in the visual communications field; the dedicated *Step-By-Step Graphics* team, especially Director of Art and Production, Mike Hammer, for his print production expertise and meticulous attention to quality; Special Project Editor Catharine Fishel, for her organizational ability and critical eye; our technical consultant, Daniel Dejan, for his infectious enthusiasm for graphic arts education; Assistant Editor Susan Goldberg-Dinges, for her help with research and proofreading; and Editor John Fennell, for keeping regular issues of the magazine on course while the rest of us were preoccupied with this guide. Special thanks also go to my husband and son, for their patience and understanding; and to all the colleagues and clients with whom I have had the pleasure of working—especially Terry Ewing. The collective mentoring of everyone listed above has helped prepare me for this project and a variety of other challenges, not the least of which was directing the successful launch of *Step-By-Step Graphics* magazine, now nearing its sixth year of publication.

Finally, it is to the thousands of readers of *Step-By-Step Graphics* magazine that we dedicate this book—to all the professional graphic communicators working in the trenches, whose loyalty and support continue to reinforce the need for practical information. It was for them and all others in the graphic arts that this reference guide was originally compiled in 1988—and for them that it is now being updated and republished in book form in 1990.

Nancy Aldrich-Ruenzel
Editorial Director
Step-By-Step Publishing

Contents

Preface

When the editorial staff of *Step-By-Step Graphics* magazine first began researching practical subjects for its second annual "Designer's Guide" issue, we did not have to search long to find out that the one subject area that could fill the greatest void in professional graphic arts training and education was print production: planning, producing and buying black-and-white and color printing—on time, within budget, and, of course, with impeccable quality. A research study we had commissioned (conducted by an independent research firm) confirmed that these were indisputably the biggest concerns of those working at all experience levels and in all creative and production environments. So when the "Designer's Guide to Print Production" issue finally hit the streets in 1988, it sold out in less than a few months. Since that time, we have received virtually hundreds of calls and letters from people working within the field as well as in allied fields asking us to reprint the issue. Based on this high demand, we decided to republish the information, which has been updated where necessary, in hardbound book form.

This guide has been developed for anyone who plans, designs, produces or buys 1) type; 2) photography and art; 3) color for reproduction; 4) paper and printing. Divided up into these four sections, with a fifth covering future technologies, this book offers useful demonstration and reference articles with easy-to-use charts, tables, diagrams and illustrations—all devised not only to help you implement and maintain high-quality print production standards but also to better your personal—and corporate—bottom lines. Considering the industry-wide support we received in the creation of this guide—as well as the enthusiastic reports we continue to hear from those who are using the first edition—we are confident that this nuts-and-bolts print production book will answer all your questions, from the most basic art and copy preparation methods to the most sophisticated color-separation and printing techniques.

PREPARING COPY FOR TYPESETTING

The type in an effectively-designed, well-printed piece can look effortless. But as anyone who has specced, copyfitted, marked-up or keystroked type can tell you, it takes practical skills and knowledge. Witness one managing editor: ''The type we had so carefully specced for the 20-page personnel section of our publication, basically rows and rows of names that corresponded with photos, turned out to be only one point short in depth between each name. Since we were under a tight deadline, we decided to cut the names apart and re-space them by hand. Well, not only did this take all night, but after we had mailed the boards to the printer, the wax on our copy froze due to bad weather, and most of those tiny pieces fell off before arriving at the printer. Needless to say, we missed our deadline and had to run all the type out again, this time at the proper leading. It certainly would have been worth it to double-check our specs at the outset.''

The articles and charts that follow are filled with just the reference material you will need to meet these and all of your other typographical challenges on time and on budget.

Copyfitting and Mark-Up Aids

Working with type and art is a snap when you use these established guidelines.

Thanks to designers and typographers who have gone before us, much of the math and standard-setting involved with copyfitting and mark-up has already been established. Use the reference charts in this section to simplify your layout and design work. The text below explains how to use each of the charts to follow.

COLUMN DEPTH

If you are working on a job that has running columns of text, the chart on page 13 will help you determine how many lines of type you need to fill your column depth (in inches). Your basic format must already be established, including type size and linespacing. The important thing to remember when working with column depths is that you need to convert inches to points and vice versa. Type is spaced from baseline to baseline in points, and column depths are usually measured in inches. There are approximately 72 points in one inch.

A simple example using this chart: Your specifications are Baskerville 10/10 point (10 point type on 10 points of leading). Your page allows for a six-inch column depth of text—according to the chart, you will need 43 lines of type to fill this depth. Remember to add any additional spacing increments to the depth. For example, should your specifications in the preceding example change to 11 point spacing, you would add one point for each line, or 43 points total, to the depth (a little more than one-half inch).

Remember that since type sits on the baseline, the capitals and ascenders will occupy the space above the baseline. This chart compensates for this added vertical height.

CHARACTER COUNT

Once you have chosen a type style, type size and line length, you need to determine how many characters will fit in your chosen line length (horizontal measure). To accomplish this, you will need to research your alphabet's length measurement in points in order to use this chart. (That is, a lower case alphabet, "a" through "z" with no spaces between letters, in your chosen type style and size.) This information can be provided by your typographer or determined from a type manufacturer's or type house's stylebook. Consult with your typographer on jobs with extensive text so that any special letter spacing or "house style" values will be taken into account.

The chart on page 14 lists characters-per-pica figures, so you will need to multiply that figure by your pica line length to get the average number of typeset characters per line.

If your copy has not yet been written, you can use this information to determine how much copy will be needed to fit your layout. If you already have copy, you will need to count the number of characters in the manuscript and divide that figure by the character per line figure to see how many typeset lines the copy will yield. Then, you can check that information against your layout and determine if your chosen specifications will work. If the copy is not fitting the layout, adjust the specifications and recalculate them until a proper fit is achieved.

DECIMAL CONVERSION

You can determine exact reduction and enlargement percentages by using a calculator and this very simple formula: Divide the measure you want by the measure you have. This method is more accurate than using a proportion wheel, but your measurements must be consistent—picas to picas, inches to inches, and so on. Also, calculations must be made using the same parameters: width to width and depth to depth.

Use the Decimal Conversion Chart on page 15 to convert fractions of measurement to their numerical equivalents. For example, you have an illustration that now measures 4 inches tall, and you need to reduce it to 2⅜ inches tall. Divide 2.375 by 4 and you get .59357—rounded off as a percentage amount, which means you would shoot the illustration at 59 percent. (As a means of double checking yourself, a reduction will mean the shooting percentage of the art will be less than 100 percent; an enlargement will be more than 100 percent.) It is recommended that when you determine a reduction or enlargement percentage, you should check all the other proportions to make certain all dimensions will fit your allotted space. If you determine a percentage for a width, make sure the height will also fit.

PROOFREADER'S MARKS

It is important to use consistent proofreading marks when working with type so that communication between writers, designers, editors and typographers can be maintained. Optimally, all manuscript copy should be cleanly typewritten and double-spaced. All markings should be made in a contrasting ink color. The proofreader's marks shown on page 16 are the most widely used and accepted in the typesetting trade. These symbols (in addition to other specialized symbols) are also used in marking up copy for typesetting.

If there is a complex situation or query while proofreading, write the question out in the margin. When using abbreviations or other special symbols, make certain these are understood clearly by everyone involved with the project.

In proofreading and revising copy, your goal should be clear and concise communication. If notations are unclear or messy, you run the risk of unnecessary errors, missed deadlines and extra charges. ∎

—Amy Inouye

COLUMN DEPTH CHART™

This chart shows how many lines of a given type size will fit into a specified depth (in inches). The chart assumes linespacing is solid. If the type is to be leaded, be sure to compensate for the extra depth by adding the extra measure to the determined depth.

72 Points = 1 Inch • 1 Point = .0138 Inch

COLUMN INCHES	POINT SIZE OF TYPE													
	6	7	8	9	10	11	12	13	14	15	16	18	20	22
¼	3	2	2	2	1	1	1	1	1	1	1	1		
½	6	5	4	4	3	3	3	2	2	2	2	2	1	1
¾	9	7	6	6	5	4	4	4	3	3	3	3	2	2
1	12	10	9	8	7	6	6	5	5	4	4	4	3	3
2	24	20	18	16	14	13	12	11	10	9	9	8	7	6
3	36	30	27	24	21	19	18	16	15	14	13	12	10	9
4	48	41	36	32	28	26	24	22	20	19	18	16	14	12
5	60	51	45	40	36	32	30	27	25	24	22	20	18	16
6	72	61	54	48	43	39	36	33	30	28	27	24	21	19
7	84	72	63	56	50	45	42	38	36	33	31	28	25	22
8	96	82	72	64	57	52	48	44	41	38	36	32	28	25
9	108	92	81	72	64	58	54	49	46	43	40	36	32	29
10	120	102	90	80	72	65	60	55	51	48	45	40	36	32
11	132	113	99	88	79	71	66	60	56	52	49	44	39	35
12	144	123	108	96	86	78	72	66	61	57	54	48	43	39
13	156	133	117	104	93	84	78	71	66	62	58	52	46	42
14	168	144	126	112	100	91	84	77	72	67	63	56	50	45
15	180	154	135	120	108	97	90	82	77	72	67	60	54	48
16	192	164	144	128	115	104	96	88	82	76	72	64	57	52
17	204	174	153	136	122	110	102	93	87	81	76	68	61	55
18	216	185	162	144	129	116	108	99	92	86	81	72	64	58
19	228	195	171	152	136	123	114	105	97	91	85	76	68	62
20	240	205	180	160	144	130	120	110	102	96	90	80	72	65
21	252	216	189	168	151	136	126	116	108	100	94	84	75	68
22	264	226	198	176	158	142	132	121	113	105	99	88	79	72
23	276	236	207	184	165	149	138	126	118	109	103	96	82	75
24	288	246	216	192	172	156	144	131	123	114	108	99	86	78

CHARACTER COUNT CHART

In order to use this chart, you must know the **Alphabet Length** (in points) of a lowercase alphabet of the type you are specing. This information can be obtained from your typographer (or from his comprehensive type book). Remember to factor in overall kern or letterspace values. This chart will cover most text sizing between 5 and 20 point type. For alphabet lengths not shown here (or for special cases, such as a quantity of copy to be set in all caps), use the formula: **342 ÷ Alphabet Length = Number of Characters per Pica**. Use of a calculator makes this whole process a lot simpler.

ALPHABET LENGTH IN POINTS	NUMBER OF CHARACTERS PER PICA	ALPHABET LENGTH IN POINTS	NUMBER OF CHARACTERS PER PICA	ALPHABET LENGTH IN POINTS	NUMBER OF CHARACTERS PER PICA	ALPHABET LENGTH IN POINTS	NUMBER OF CHARACTERS PER PICA
60	5.70	88	3.89	116	2.95	144	2.38
61	5.61	89	3.84	117	2.92	145	2.36
62	5.52	90	3.80	118	2.90	146	2.34
63	5.43	91	3.76	119	2.87	147	2.33
64	5.34	92	3.72	120	2.85	148	2.31
65	5.26	93	3.68	121	2.83	149	2.30
66	5.18	94	3.64	122	2.80	150	2.28
67	5.10	95	3.60	123	2.78	151	2.26
68	5.03	96	3.56	124	2.76	152	2.25
69	4.96	97	3.53	125	2.74	153	2.24
70	4.89	98	3.49	126	2.71	154	2.22
71	4.82	99	3.45	127	2.69	155	2.21
72	4.75	100	3.42	128	2.67	156	2.19
73	4.68	101	3.39	129	2.65	157	2.18
74	4.62	102	3.35	130	2.63	158	2.16
75	4.56	103	3.32	131	2.61	159	2.15
76	4.50	104	3.29	132	2.59	160	2.14
77	4.44	105	3.26	133	2.57	161	2.12
78	4.38	106	3.23	134	2.55	162	2.11
79	4.33	107	3.20	135	2.53	163	2.10
80	4.28	108	3.17	136	2.51	164	2.09
81	4.22	109	3.14	137	2.50	165	2.07
82	4.17	110	3.11	138	2.48	166	2.06
83	4.12	111	3.08	139	2.46	167	2.05
84	4.07	112	3.05	140	2.44	168	2.04
85	4.02	113	3.03	141	2.43	169	2.02
86	3.98	114	3.00	142	2.41	170	2.01
87	3.93	115	2.97	143	2.39	171	2.00

©1983 Casa de Typography • Los Angeles, California

These charts were reproduced courtesy of Gauge-O-Rama. Gauge-O-Rama is a complete line of gauges and charts for specifying typography. The actual charts are 8½ x 11 and laminated for years of everyday use. The family of Gauge-O-Rama products are available from: Gauge-O-Rama, 3427 Glendale Blvd., Los Angeles, CA 90039. (213) 663-4254.

DECIMAL CONVERSION CHART™

For use in converting fractional measures to decimal measures with a calculator.
(A sizing method more accurate than a proportional scale.)

Measure you <u>want</u> ÷ Measure you <u>have</u> = <u>Percentage</u> reduction or enlargement.

EXAMPLE

The measure you want is 1⅝" · You have 2¾" · <u>1.625</u> ÷ <u>2.75</u> = <u>.59</u> (a <u>59%</u> reduction)

Fraction	Decimal		Fraction	Decimal
$\frac{1}{64}$.015625		$\frac{33}{64}$.515625
$\frac{1}{32}$.03125		$\frac{17}{32}$.53125
$\frac{3}{64}$.046875		$\frac{35}{64}$.546875
$\frac{1}{16}$.0625		$\frac{9}{16}$.5625
$\frac{5}{64}$.078125		$\frac{37}{64}$.578125
$\frac{3}{32}$.09375		$\frac{19}{32}$.59375
$\frac{7}{64}$.109375		$\frac{39}{64}$.609375
$\frac{1}{8}$.125		$\frac{5}{8}$.625
$\frac{9}{64}$.140625		$\frac{41}{64}$.640625
$\frac{5}{32}$.15625		$\frac{21}{32}$.65625
$\frac{11}{64}$.171875		$\frac{43}{64}$.671875
$\frac{3}{16}$.1875		$\frac{11}{16}$.6875
$\frac{13}{64}$.203125		$\frac{45}{64}$.703125
$\frac{7}{32}$.21875		$\frac{23}{32}$.71875
$\frac{15}{64}$.234375		$\frac{47}{64}$.734375
$\frac{1}{4}$.25		$\frac{3}{4}$.75
$\frac{17}{64}$.265625		$\frac{49}{64}$.765625
$\frac{9}{32}$.28125		$\frac{25}{32}$.78125
$\frac{19}{64}$.296875		$\frac{51}{64}$.796875
$\frac{5}{16}$.3125		$\frac{13}{16}$.8125
$\frac{21}{64}$.328125		$\frac{53}{64}$.828125
$\frac{11}{32}$.34375		$\frac{27}{32}$.84375
$\frac{23}{64}$.359375		$\frac{55}{64}$.859375
$\frac{3}{8}$.375		$\frac{7}{8}$.875
$\frac{25}{64}$.390625		$\frac{57}{64}$.890625
$\frac{13}{32}$.40625		$\frac{29}{32}$.90625
$\frac{27}{64}$.421875		$\frac{59}{64}$.921875
$\frac{7}{16}$.4375		$\frac{15}{16}$.9375
$\frac{29}{64}$.453125		$\frac{61}{64}$.953125
$\frac{15}{32}$.46875		$\frac{31}{32}$.96875
$\frac{31}{64}$.484375		$\frac{63}{64}$.984375
$\frac{1}{2}$.5		1	1.0

EQUIVALENT VALUES

1 Pica = 12 Points	1 Inch = 14 Agates
6 Picas = approx. 1 Inch (.9936 Inch)	1 Inch = 2.54 Centimeters
1 Point = .0138 Inch	1 Inch = 25.4 Millimeters

GAUGE-O-RAMA

These charts were reproduced courtesy of Gauge-O-Rama. Gauge-O-Rama is a complete line of gauges and charts for specifying typography. The actual charts are 8½ x 11 and laminated for years of everyday use. The family of Gauge-O-Rama products are available from: Gauge-O-Rama, 3427 Glendale Blvd., Los Angeles, CA 90039, (213) 663-4254

PROOFREADER'S MARKS

These are standard symbols used to mark corrections and revisions on typographic proofs. Changes should be marked on the copy, using the appropriate symbol, with an accompanying symbol or note in the margin (left or right, wherever there is space). For special or unusual changes (such as underscoring), circle copy, and explain the change in the margin. Proofreader's marks should be made in a contrasting color.

SYMBOL	ERROR MARKED	EXPLANATION
⌐		Quad left (ragged right)
⌐		Quad right (ragged left)
⌐⌐		Centered copy
[]		Justified copy
℘	He sat inn the chair.	Delete characters or words marked
#	He sat inthe chair.	Insert space
h	He sat in te chair.	Insert letter
lc	He sat in the Chair.	Set lowercase
ital	He sat in the chair.	Reset in *italics*
rom	He sat in *the* chair.	Reset in roman
bf	He sat in the chair.	Reset in **boldface**
cap	he sat in the chair.	Set UPPERCASE
sc	He sat in the chair.	Reset in SMALL CAPITALS
⊙	He sat in the chair.	Insert period (or appropriate punctuation)
tr	He sat the in chair.	Transpose characters or words marked
stet	He sat in the chair.	Let stand as is (disregard marked above dots)
=/	He turned twenty one.	Insert hyphen
←	← He sat in the chair.	Move as indicated
⌃	Then he sat in the chair.	Insert comma (or appropriate punctuation)
⌄	He sat in Johns chair.	Insert apostrophe (or appropriate punctuation)
⌄ ⌄	He sat in the chair.	Enclose in quotation marks
⌒	He sat in the cha ir.	Draw together (close space)
see copy	He sat chair.	Words left out that are to be set from copy
sp	He sat in the (1st) chair.	Spell out
¶	table. He sat in the chair.	Start new paragraph
no ¶	table. He sat in the chair.	Run in (should not be new paragraph)
(the?)	He sat in chair.	Query to author or editor
⌐m	He sat in the chair ⌄	Insert em dash
	□ He sat in the chair.	Indent 1 em
	▣ He sat in the chair.	Indent 2 ems

Step-By-Step Copyfitting Methods

Building your specifications for optimal design solutions.

Specifying type is one aspect of graphic design that many find intimidating. In reality, it is not all that difficult as long as you build your specifications step by step, and then continue to adjust them for the best design solution. It is not an exact science, and it can be affected by such factors as your type house's style of setting, their output devices, and the particular way in which words in the copy fall, can or cannot be hyphenated, and so on. But by following the basic copyfitting procedures outlined in this article, you will be able to achieve an extremely accurate estimate. (See the "Character Count Chart.")

To demonstrate how copyfitting is accomplished, work through the following sample job, from layout through copyfitting.

THE PROJECT

The job is an information sheet, combining display and text type as well as a photo. The manuscript contains final copy. You have already decided to use 11/12 point Century Oldstyle for the text. With these basics established, you can now produce a comp to make sure all of the elements work together and fit the design.

In copyfitting text, there are three crucial variables to deal with: 1) the number of characters in the manuscript; 2) the area to be filled with type; and 3) the type parameters (style, size, letterspacing and line length). Any two of these variables are needed to establish the third.

STEP ONE

Start by determining how many characters there are in the final copy. In typewritten copy, each character, each space, and each item of punctuation occupy the same amount of space. Mark off a point in the manuscript which represents an average number of characters in a typical line and draw a vertical line down the page from that point. You can now determine how many characters are in each line. In this case, you know that there are 60 characters up to the mark. Count out each line, allowing for lines that run short or long. Count one extra character at the end of each line of the manuscript except for lines ending a paragraph or lines ending with a hyphen—these are word spaces. Total the number of characters, paragraph by paragraph.

A SHORTCUT Many type gauges have scales on them to help count typewritten characters in either pica scale (10 pitch) or elite scale (12 pitch).

A WARNING Beware of copy output by word processing systems. Some use proportional character and/or word spacing—that is, characters/words may occupy varying widths. In cases where it is impossible to formally structure your counting, establish averages by counting five to ten representative lines and estimating your count by using that average.

STEP TWO

Now that you have the total number of characters in your manuscript, you can copyfit the type. At this point you choose a line length of 16, giving you an initial markup of 11/12 x 16 picas.

Check in your type catalog or with your type house to locate an exact character per pica (cpp) count for this face and size. In this case, the count is 2.50 cpp. Since you have chosen 16 picas as your line length, multiply 2.50 by 16 for a total of 40 characters per line. Divide the number of characters in each paragraph by this number to obtain an approximate number of lines of type the manuscript will yield. "Round up" to a whole number unless you get a very small fraction leftover. Justified copy tends to condense the copy more. In close calls, "round down" rather than up.

Thus, in this sample, you will get 227 manuscript characters in the first paragraph. Divide 227 (characters in the first paragraph) by 40 (characters per line) to get 5.675 lines of type, which you can round up to 6 lines. Convert each paragraph in this way. Measure the total depth against your layout. You will find that these specifications work well within the parameters of the design.

GENERAL GUIDELINES In copyfitting, start with your optimum set of specs and try them out. If they do not fit your given space, adjust them within parameters acceptable to the design. Copyfitting is a matter of give and take, try and retry, each time narrowing down the possibilities for a workable solution.

In cases where copyfitting is more complex, such as when you are working with shapes, wraparounds, drop caps, and so on, provide your typesetter with a tight tissue layout and a starting set of specifications. You may ask your typesetter to "set-to-fit" in special cases, and they will experiment with fitting your job to your tissue. This will usually incur extra time and costs, of course.

STEP THREE

Now you need to specify the display head. The best way to do this is to do a tight tissue tracing from a type sample book, indicating the kind of spacing you want. This will give the typesetter an excellent guide from which to work. It will also allow you to better visualize the type and its impact.

Headline type presents a different set of problems than text type does. Although there

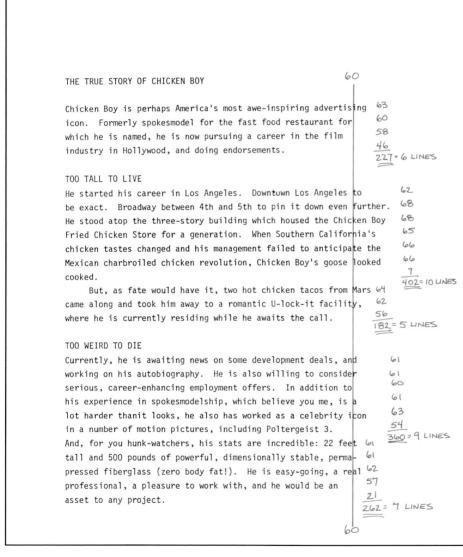

```
THE TRUE STORY OF CHICKEN BOY                              60

Chicken Boy is perhaps America's most awe-inspiring advertising    63
icon.  Formerly spokesmodel for the fast food restaurant for       60
which he is named, he is now pursuing a career in the film         58
industry in Hollywood, and doing endorsements.                     46
                                                                  227 = 6 LINES

TOO TALL TO LIVE

He started his career in Los Angeles.  Downtown Los Angeles to     62
be exact.  Broadway between 4th and 5th to pin it down even further. 68
He stood atop the three-story building which housed the Chicken Boy  68
Fried Chicken Store for a generation.  When Southern California's    65
chicken tastes changed and his management failed to anticipate the   66
Mexican charbroiled chicken revolution, Chicken Boy's goose looked   66
cooked.                                                              7
                                                                   402 = 10 LINES

     But, as fate would have it, two hot chicken tacos from Mars    64
came along and took him away to a romantic U-lock-it facility,      62
where he is currently residing while he awaits the call.            56
                                                                   182 = 5 LINES

TOO WEIRD TO DIE

Currently, he is awaiting news on some development deals, and       61
working on his autobiography.  He is also willing to consider       61
serious, career-enhancing employment offers.  In addition to        60
his experience in spokesmodelship, which believe you me, is a       61
lot harder thanit looks, he also has worked as a celebrity icon     63
in a number of motion pictures, including Poltergeist 3.            54
And, for you hunk-watchers, his stats are incredible: 22 feet      360 = 9 LINES
tall and 500 pounds of powerful, dimensionally stable, perma-       61
pressed fiberglass (zero body fat!).  He is easy-going, a real      61
professional, a pleasure to work with, and he would be an           62
asset to any project.                                               57
                                                                    21
                                                                   262 = 7 LINES

                                                              60
```

Count Out Fit Using an average character per line count of 60, count out each line individually, and then total each paragraph. Multiply your line length (16 picas) and your character per pica count (2.50 for this job) to determine the number of characters per line your typeset copy can accommodate—in this case, 40. Divide the number of characters in each paragraph by 40 cpl to obtain the approximate number of lines this manuscript will yield.

are fewer elements to consider, individual characters and the positive/negative spaces between letters, words and lines take on greater significance. Also, since headline type is larger, its quality (or lack thereof) is amplified.

Whether your headlines are set on a Typositor (or on a similar manual device with only prespecified spacing), output by a computer (wherein special spacing is possible), or "hand set" with pressure sensitive type (wherein anything is possible), you can specifically determine the type size and generally specify whether to "set tight" or "set loose." In this case, we provide a tight tissue and request typositor setting of Futura Extra-Bold Condensed because we want precise spacing.

NOTES ON COPYFITTING
- Take your time. Do not panic—do not rush.
- Double check yourself and your figures along the way, especially if the procedure is new to you.
- Manuscript copy should be typewritten, clean (minimal hand-made changes), double spaced and set flush left.
- Visualizing helps. Measuring out and sketching copy blocks, page sizes and so on will help guide you through the process. It will clearly define what kinds of masses with which you are dealing.
- For good readability, specify line lengths from 40 to 60 typeset characters per line.
- For large jobs and jobs with repeating formats, it is advisable to order sample type to check that specifications work in all cases. Especially when there are repeating formats, specify for "best case" and "worst case" scenarios and get samples to help work out any bugs in the type design.
- Establish a good working relationship with your typographer. Ask them for help if you have any questions or problems. Each type house has its own way of working and its own style of setting. The more familiar you are with the way your type house works, the easier copyfitting will become. ∎

—Amy Inouye

Clear Copy Mark-up for Designers

The key to mark-up is knowing what your type house needs and how to communicate that information clearly.

Once you have determined type parameters through copyfitting, your manuscript must be marked up for the typographer, listing all the pertinent information needed to accurately set the type.

There are parameters for which the designer is responsible. The following is a checklist of basic instructions the designer needs to give the typographer. A listing of some universal mark-up symbols is also included. The mark-up symbols are also shown in use in this example.

TYPE STYLE This should be specified by name (including weight, case, roman or italics and so on.)

TYPE SIZE This should be specified by point size. (Sizing varies from style to style, and from type house to type house. Always consult your type house's style book.)

LINESPACING/LEADING (Also known as vertical measure.) Linespacing or leading should be specified in points (baseline to baseline).

LINE LENGTH (Also known as horizontal measure.) Length should be specified in picas and points.

LINE END FORMAT Should also be indicated, whether justified ([*copy*]), flush left-ragged right ([*copy*), flush right-ragged left (*copy*]), centered (]*copy*[), or asymmetrical (shapes, skews and so on, all of which are best indicated on a tissue layout attached to the copy.)

The five parameters listed above are almost always used together in mark-up ''shorthand,'' as shown in this format taken from the example: 11/12 x 16 pi. Century Oldstyle.

PARAGRAPH INDENTS You should specify with fixed space or em space increments. These symbols are fairly typical.

⌐Drawn around the first letter in a paragraph means paragraph indent per house style, usually an em space.

¶ Start new paragraph.

⊡ One em indent.

☑ One en space (one-half the width of an em).

TEXT 11/12 [× 16 pi CENTURY OLD STYLE, AS TYPED

SUBHEADS 12/12 FUTURA X B COND, CAPS

THE TRUE STORY OF CHICKEN BOY — HEAD, SET TYPOSITOR FUT. XB COND, PER TISSUE

Chicken Boy is perhaps America's most awe-inspiring advertising icon. Formerly spokesmodel for the fast food restaurant for which he is named, he is now pursuing a career in the film industry in Hollywood, and doing endorsements.

½ #

SUBHEAD — TOO TALL TO LIVE

He started his career in Los Angeles. Downtown Los Angeles to be exact. Broadway between 4th and 5th to pin it down even further. He stood atop the three-story building which housed the Chicken Boy Fried Chicken Store for a generation. When Southern California's chicken tastes changed and his management failed to anticipate the Mexican charbroiled chicken revolution, Chicken Boy's goose looked cooked.

☑ But, as fate would have it, two hot chicken tacos from Mars came along and took him away to a romantic U-lock-it facility, where he is currently residing while he awaits the call.

½ #

SUBHEAD — TOO WEIRD TO DIE

Currently, he is awaiting news on some development deals, and working on his autobiography. He is also willing to consider serious, career-enhancing employment offers. In addition to his experience in spokesmodelship, which believe you me, is a lot harder than it looks, he also has worked as a celebrity icon in a number of motion pictures, including Poltergeist 3.

☑ And, for you hunk-watchers, his stats are incredible: 22 feet tall and 500 pounds of powerful, dimensionally stable, permapressed fiberglass (zero body fat!). He is easy-going, a real professional, a pleasure to work with, and he would be an asset to any project.

Step-By-Step Mark-Up In addition to carefully marked typo corrections, your typewritten manuscript should contain neatly written specifications, including boldface (wavy underline) and italic (straight underline) instructions.

SECONDARY LINESPACING This will indicate extra vertical spacing between items, paragraphs, and so on, if needed. It usually indicates one full line space increment of extra vertical spacing. You can also indicate your own shorthand in the margins, such as "# = 3 pts." Then each time you mark "#", 3 pts. of space will be inserted. Similarly, this would indicate a full line space increment of extra vertical spacing.

RULES Call out rules by thickness (in points or fractions of points.)

Additional standard mark-up and proofreader's marks are shown on the "Proofreader's Marks" chart in this guide.

On jobs with repeating formats, a formal type specification sheet should be created so that everyone involved with the project has the same information for reference. You can, on larger jobs, create your own shorthand for certain specs; for example, anything marked "A" could translate to: Subhead, set 12 point Helvetica Bold, all caps, on 12 point linespacing, do not hyphenate, set with 6 points extra vertical line spacing between subhead and next line of text. (See next section, "How to Write Standard Style Sheets.")

All type houses establish their own "house style" of setting type. The house style includes many refinements of typographic spacing as well as specifics such as the number of consecutive hyphens allowed. It will also include such things as how many copies of the repro and checking proofs you receive and how these proofs are output.

Here is a basic checklist of things for which the typographer is responsible:
• Letterspacing (space between letters) minimums and maximums. Usually tighter in justified text.
• Wordspacing (space between words) minimums and maximums. Also generally tighter in justified text.
• Initial proofreading and revisions, if necessary.
• Proper hyphenation, not only for correctness but also for ease of understanding (does it look and sound right?) Also, maximum number of consecutive hyphens allowed. (If you do not want any hyphenation, request it specifically.)

Visualize Your Work Measuring out and sketching copy blocks and line lengths, at the proper leading, will help determine if your copy will physically fit your page (above). The finished board (below) shows the copy was feasible.

• Design of the rag (in ragged text) should be even-looking and flow with nice proportions.
• Widows (one word or partial word line endings) should be kept to a minimum and eliminated if possible. Re-ragging (by the typographer) or re-writing (by the author) can easily remedy this problem.
• Repro density should be even (very black type on very white paper) and should match from day to day and from week to week so that any patch corrections will match previously set type.

As part of copyfitting and marking up manuscript, it is advisable that you carefully read the manuscript for spelling, grammatical errors or any style inconsistencies. It is also recommended that the manuscript be as clean as possible (typewritten and double-spaced), as any extraneous revision markings or deletions will slow down the typesetting process.

When you receive repro or proofs back from your type house, you and your client should again proofread the type. If typesetters keyboard the type, they are responsible for correcting any typos, so long as the words were spelled correctly on the manuscript. (Of course, coding or typographical errors which occur in copy that was keystroked at and telecommunicated from your office will be charged to you as an alteration when corrected. See "Capturing Your Own Keystrokes" later on in this guide for more on this subject.) According to trade customs of typesetting, the client is ultimately responsible for any typos that reach the printing stage. This is an important point of which you and your client should be aware. Sometimes, a type house will correct obvious grammatical and spelling errors as part of its services; other houses will be completely literal as per the manuscript.

Building an excellent working relationship with your type house is an invaluable part of working with type. It will make mark up, as well as copyfitting, easier and more professional for everyone involved. ∎

—Amy Inouye

How to Write Standard Style Sheets

Learn how to provide your typesetter with a style sheet that will prevent unnecessary errors and save time.

When designing and then typesetting longer documents, it is helpful to provide standards for the typesetter to follow, written in the form of a standard style sheet. The style sheet provides specifications for the typesetter explaining how to format the material he is setting. Almost everyone has sent out a marked manuscript for typesetting only to get the repro back with our own specification errors. Often, these mistakes can be avoided. You can reduce the number of alterations and produce a better looking final product by providing the typesetter with a style sheet. A must for any design that appears in a series, style sheets are also worth writing for any brochure or catalog over 12 pages.

Sample Layout In addition to a tight dummy layout, such as the one shown here, you should furnish your typesetter with a complete style sheet that lists specifications for trim and margin size, text, numbered and bulleted lists, cutlines, heads and any other elements specific to your job.

WHAT TO STANDARDIZE
Certain elements of a design lend themselves better to style sheets than others. Common elements such as text, numbered lists, regularly occurring heads, page numbers, or running heads or feet should be listed on a style sheet. Other things to include are drop caps, bulleted lists and margin quotes. Elements that only occur once or twice in a design usually do not need to be standardized. The cover of a book, for instance, would not need to be included in a style sheet unless it was part of a series. Sometimes there are frequently recurring elements in a design that cannot be given exacting specifications. Tables and charts often vary so much it is impossible to write an exact spec. However, the type size and style of the table heads and body, the weight of the rules, and the space above and below elements are all things that can be incorporated into a specifications sheet. By specifying these common visual elements, a more unified look is achieved in the design. As a rule of thumb, any element which occurs more than three or four times in the manuscript should appear in a style sheet.

HOW TO STANDARDIZE
You must establish categories when writing a style sheet. Without these categories, it would be difficult to locate information quickly. A style sheet should be set up like an outline. Information about the trim measurements should appear first, followed by the various kinds of text. After the text specs, list the various levels of heads. Usually, there are only two or three levels of heads, but more complicated designs may need as many as five to ten. Next, you should list features such as part openers, chapter openers, photo captions, figure captions, margin quotes, glossaries, indices and so on. Lastly, you should list tables and charts. These are best broken out from the other features since there are often a limited number of elements that can be specified.

MARGIN AND TRIM
The margin and trim information is more important to the printer than to the typesetter. This information tells the printer how to impose the negatives he shoots of your mechanicals and how to trim down the printed piece. Unlike typesetters, most printers do not use picas and points as measurements. Printers usually use inches and fractions. Unless your typesetter is setting complete pages (full-page makeup) and needs you to supply specifications in picas only, it would be wise to use inches. The following is an example:

- Trim: 8½ x 11-inches
- Margins: Top: $\frac{5}{16}$-inches
 Gutter: $\frac{15}{16}$-inches
 Side: ½-inch
 Bottom: ¾-inch

Printers usually impose film using the top margin and the gutter, or back, margin. While it is helpful to list the side and bottom margins, it is essential that the top and gutter margins are on a style sheet.

TYPES OF TEXT

TEXT There are many things to consider when designing even the simplest text. The type size, leading and paragraph indents are the most common concerns. You can choose to leave the finer details to the discretion of your typographer, or you can control the final output. An example—the size of bullets used with text. Bullets vary in size from one typesetter to another. Most typesetters follow their own house style unless a customer requests otherwise. A typesetter's house style usually includes information about line breaks (i.e., number of consecutive end-of-line hyphens), what reference source is used for hyphenation, whether ligatures are used, and so on.

For textural elements, a style sheet should include the following information in the order shown:

• Point size;
• Leading;
• Typeface;
• Justification (justified, centered, flush left or flush right);
• Measure;
• Paragraph indent;
• Paragraph indent after heads (common typographical practice is to have text flush left to the margin following a head);
• Extra space between paragraphs, if any.

The following is an example of a text specification:
11/13 pt. Century Book justified on 15 picas. The paragraph indent is 18 pts., no indent following heads.

NUMBERED LISTS Numbered lists require all the information of the text specs except for paragraph indent. In addition to the text specifications there are a few more items to specify. You need to specify the horizontal space from the period following the number to the text following, as well as whether the second line of a numbered entry flushes back to the left margin or "hangs" on the first

word of the text above. You need to indicate if you want to "clear for ten." Clear for ten refers to aligning the decimal place as shown below on the left. Text will not align if you do not clear for ten when there are ten or more entries, as shown below on the right.

8. The 8. The
9. The 9. The
10. The 10. The

The last specification needed for numbered lists is for additional space above and below the entire list and any additional space between entries within the list. It is best that you at least use additional space below a list so as not to obscure a paragraph indent should one follow. Otherwise, the paragraph following will look like the continuation of the last numbered item as in the following example.

1. This is an example
2. This is part of the example
 This shows the problem with paragraph indents following a numbered list.

The following is an example of a numbered list specification:
11/13 pt. Century Book flush left, ragged right on 15 picas. Numbers set flush left to the margin, 6 pt. space from the period to text following, clear for ten. Turnlines hang on first word above. Additional 6 pts. b/b above and below lists. No additional space between entries.

BULLETED LISTS The specifications for bulleted lists are very similar to those for numbered lists. Instead of indicating the space from the period following a number to text, you need to specify the distance from the bullet to the text following. It is also necessary to indicate the size of the bullet to be set.

The following is an example of a bulleted list specification:
11/13 pt. Century Book flush left, ragged right on 15 picas. 6 pt. bullets set flush left to the margin, 6 pt. space from bullet to text following. Turnlines flush to left margin. Additional 6 pts. b/b above and below lists. Additional 2 pts. b/b between entries.

GLOSSARY OF TERMS

BASE-TO-BASE Base-to-base (b/b) refers to the distance from the baseline of one line of text to the baseline of another. It is important to specify type in this manner. It is a common practice for people to indicate the distance from the top of the ascenders to the baseline or the descenders of the type above. Typesetting equipment does not measure this distance, but instead measures the distance from baseline to baseline. When you request visual space from the ascenders to the descenders or baseline above, the typesetter must run out samples and visually measure them. As the customer, you will pay for the time the typesetter spends setting and measuring your type. It would save money to establish the measurements yourself and to provide the information to the compositor.

GUTTER A gutter, or backspace, is the space from the fold or spine to the text area.

CLEAR FOR 10 "Clear for 10" refers to aligning numbers in lists flush right, therefore allowing the text following to align.

HANG Hang refers to vertically aligning the second line of a numbered, lettered or bulleted entry on the first word of the text above, as opposed to flushing the text to the left margin.

DASHED LISTS For lists preceded by dashes it is necessary to specify the length of the dash. Usually dashes are specified as either an en dash or an em dash. Since dashes set next to the text following, it is not necessary to indicate the distance between them

LETTERED LISTS

Lettered lists are handled much like numbered lists, with one main difference. Since letters vary in width, it is necessary to decide if you want all the letters to flush left or to

have the periods following align. Unfortunately, you cannot align both. The problem is not very visible in short lists using the letters A to H. Lists that include the letter I or the letters M or W are the most problematic. Current popular style is to flush left the widest letter and then to align the periods for all the other letters. The following is an example of a lettered list specification:

11/13 pt. Century Book flush left, ragged right on 15 picas. The widest letter sets flush left to the margin, align periods. 6 pt. space from period to the text following. Turnlines hang on first word above. Additional 6 pts. b/b above and below lists. No additional space between entries.

EXTRACTS

Extracts are blocks of text that are designed to stand out from the regular text, usually quotes, poetry or scripture. There are a number of methods used to set extracts apart from text. You can add extra space above and below an extract, reduce the type size and leading, indent the extract from one or both margins, set the extract ragged right (if the main text is set justified), or any combination of the above. The following is an example of an extract specification:

10/12 pt. Century Book flush left, ragged right on 15 picas with an 18 pt. indent from both margins. Additional 12 pts. b/b above and below extract.

HEADS

Determine the number of standard heads that will be used in a design. Then assign them either numbers or letters in order of size or importance. The most important head should be the number one head, the next important, number two, and so on. Specifying heads is much the same as specifying text. It is important to list the following information:
• Type size;
• Leading;
• Typeface;
• Capitalization;
• Position (flush left, centered or flush right);
• Hyphenation, if acceptable;
• Space above and below heads.

The following is an example of a head specification:

16/18 pt. Helvetica Bold caps centered on 15 picas. Do not use hyphenation.
**36 pts. b/b above*
**18 pts. b/b below.*

SPECIAL FEATURES

Writing specifications for special features is not much different from writing them for text and heads. But there are a few distinctions. In the case of a chapter or part opener, you should indicate the drop from the trim. Drop refers to the distance from the top trim to the baseline of the first line of type.

Features often include rules or boxes incorporated with type. Many typesetting systems have simplified the process of ruling boxes. The accuracy of a composition system is far greater than manual ruling. For this reason, you should know how to spec horizontal and vertical rules. When setting rules as part of the design of a head, you should include the spec for the rule with the spec for the head. The following is an example of how to specify a rule which sets with a head:

16/18 pt. Helvetica Bold caps centered on 15 picas. Do not use hyphenation. 2 pt. x 15 pica rule sets 6 pts. b/b below the last line of the head.
**30 pts. b/b above*
**18 pts. b/b below the 2 pt. rule.*

This spec tells the typesetter to set a 2 pt. rule that is 15 picas long, 6 pts. base to base below the last line of the head. It is important to specify that the rule should be set only after the last line of the head.

TABLES AND CHARTS

It can be difficult to spec tables and charts. Often, there is little, if anything, in common from one table to the next. To create continuity within a design, you should standardize as much as possible. By establishing type sizes or weights for common elements such as table heads, your design will appear more cohesive. Usually the elements which can be specified are main heads, side heads, rule weight and length, source notes and the spacing around the aforementioned. The following is an example of a general table specification:

Main Heads: 14/16 pt. Trump Italic u/lc, set centered over columns below.
**24 pts. b/b above*
**½ pt. rule sets 6 pts. b/b below*
Side Subheads: 8/10 pt. Trump Bold U/lc, flush left and base align with the first line of table text.
**½ pt. rule sets 12 pts. b/b above*
Table text: 9/11 pt. Century Book Condensed flush left, ragged right. Additional 4 pts. b/b between entries.
**½ pt. rule sets 12 pts. b/b above*
**½ pt. rule sets 6 pts. b/b below the last entry*
**24 pts. b/b below bottom ½ pt. rule to text below.*

(Note: The number of columns and the column width vary according to each individual table.)

Now, rather than marking each individual table, you will only have to specify the column width. The same type of generic information can be applied to charts as well.

MARKING MANUSCRIPT

After writing a style sheet, assign number or letter codes to the various specifications. Use codes you can easily remember. Text is usually designated T, numbered lists NL, table heads TH. Be sure that two different elements do not share the same letter code. These one- or two-letter codes should then be transferred to the manuscript where appropriate.

SAMPLES

It is a good idea to have your typesetter set samples of the various elements that you have written into your style sheet. This way you can check for any problems prior to committing the entire manuscript to typesetting. If possible, use part of the final edited manuscript to set the samples so your samples will better reflect the final product. Should you not make many changes to the samples typeset, there may not be a charge for typesetting them. Most typesetters do not like making alterations any more than you like paying for them. By working out the problems before composition, everyone benefits. ■

—Gary Hespenheide

Capturing Your Own Keystrokes

The interface to typeset-ting eliminates not only re-keyboarding, but also provides substantial cost savings.

Typesetting was easy for text originators at one time. They just whipped their page out of the old Royal or Remmington and gave it to someone else who mysteriously converted it into type.

The editorial originator did very little formatting of a page. All heads were to the left; there was one wide column with a ragged right-hand margin and the only form of emphasis was either underlining or all caps. Since copy was typed on a typewriter or in some cases, handwritten, it had to be specified if the copy was destined for typographic printout by art or typographic specialists.

Then along came word processing, and automatic centering, underlining, enbolding, justification. The typewritten page could be formatted with many of the attributes of typography. To accomplish this, the originator (or someone else) had to insert formatting commands via a single key, a group of keys, a menu selection, a command in a command area (a generic tag or format call), a command in a text area, or by pointing to a menu of alternatives.

Whatever the method, the result was a code or codes embedded in the text stream that indicated a change in typographic or page format. This was an important turning point for authors and editorial originators—it moved the traditional coding function from the specialist to the originator.

All typesetting and publishing consists of two kinds of data: The copy that you see and the codes that determine how they will be seen. Copy is content; codes determine form and format. At the present time, floppies or telecommunicated data are sent to a typographic system with minimal coding, which means that the typesetting service's personnel must go through the copy line by

line and insert the codes necessary to produce the format requested by the art staff. But since typesetting has long been a re-keyboarding process, the interface of word processing or personal computer information eliminates the re-input requirement, providing both cost and schedule benefits.

CODING

Most typesetting services use two forms of coding—literal and stored data recall.

Literal means that if you want 9/10 Times Roman characters on a 30 pica wide column, one must insert codes like this:

***ps09*le10*tfTR*ll30**

(That is, point size 9, leading 10, typeface Times Roman, line length 30.) Sometimes, that set of codes will repeat throughout a job, so the service stores the codes for recall, and keys something like this:

***uf1**

which means "use format 1."

Editorial people need not know these spe-

cial typesetting codes. Instead, they can use generic tags that identify the nature of the copy. Thus, one might key:

.head (for a heading)

.text (for a text block)

and so on. These can be shortened and made to handle more variation:

.h1 (for a first level head)

.bh (for a bold head)

.bi (for an italic head)

When these tags are converted by the typesetting service, they can be translated into any sequence of codes. This is called "table translation," which means the **.h1** = ***ps14*le16*tfHB,** for instance, or **.h1 = *uf23** as an alternative. And it is possible to have the translation set up so that **.h1** means one thing for promotional material and another for packaging material.

The formatter works with the art staff to come up with the basic set of tags, and then sets up the translations for each job. Since the copywriter or originator knows what will be a head and what will be text, some of the repetitive tags can be inserted by them when the text is input.

The front end system would then take the floppy disks and convert them to its required form, translating the tags into typographic codes and required formats.

INTERFACING FOR COMPATIBILITY

When is text interfacing necessary? Interfacing is only required when you must go from electronic data of one manufacturer to electronic data of another manufacturer. If you have video workstations and typesetting machines in-house and they are all made by the same company, there is usually no need for special interfacing, since the supplier has effected its own. Interfacing usually solves a compatibility problem—taking data from one machine and making it useful for another machine.

If interfacing is done properly, information can go from originator to typesetting with minimal intervention. This can provide savings of from 10 to 40 percent in the first passes of typesetting, either in-house or through a typesetting service—input, proofreading, correction and output. The

problem is that the burden shifts to the originator.

This brings up the problem of standardization. If all the originators work on the same device, the media will be compatible. If, however, the originators choose to use any device they want, you will have to convert the data to your internal device or system for editing and typesetting.

Do editorial people have to be typesetters?
They are already. They insert codes in some consistent and standardized fashion so that data can run through word processing. Most of the same techniques are used to get the data through a typesetter or typographic printer untouched by other hands.

If originators do not insert these codes, someone else will have to insert them, and this will affect the possible advantages of economy and schedule.

Does the typesetting device or system matter?
Interfacing only works when it works well, and it only works well in highly intelligent systems with excellent hyphenation and justification and the automatic formatting of pages.

Without such intelligence, the user would have to insert more codes or aid the device manually, thus negating some of the benefits. If the interface only results in eliminating rekeyboarding, but none of the other steps—proofreading, changes, and so forth—there is no reason to interface.

Can I handle all types of material?
The interface works best on straight text. As the complexity of the material increases, the efficacy of the interface decreases. If the originator chooses to learn the proper codes and applies them correctly, then the more complex material might be handled.

Let us repeat: You cannot take raw information and send it to the system (although this might work for extremely simple text.) You must have the codes that tell the system how this material should look—that is, it must be formatted.

What devices are needed for recording?
For our purposes, only those devices used

TO CODE OR NOT TO CODE

Should the originator insert commands in their copy? The answer is yes and no. Certain commands are essential to handling any copy file for text formatting efficiently. These are the commands that are needed when the format of the copy units changes. Major copy units are text, heads, extracts, footnotes and so on. By inserting simple mnemonic "markers," "pointers," "flags" or "tags" to be used by the conversion program to convert the actual commands, we allow relatively uninterrupted processing.

Many editors are against the idea of originators inserting command codes per se. But flags such as **.TE** for text, **.HD** for heads and **.FN** for footnotes certainly are not difficult or time consuming even for the editor not familiar with typesetting. The advent of word processing has conditioned most users to more sophisticated levels of text formatting.

INTERFACE VS. CONVERSION
Interfacing is simply the linking of two units, usually machines. It involves signals, pulse rates and digital electronics. It essentially builds an electronic bridge between two different devices.

Conversion, on the other hand, has to do with characters and codes, and specifically with sequences of characters and codes. This latter area, called string conversion, identifies a sequence such as **jbb** and "translates" it to the code or codes that access the ballot box symbol. (The words conversion and translation can be used interchangeably.)

A translation table consists of the input string on one side and the output string on the other. The input string is converted to the output string.

SEARCH VS. TRANSLATION
Almost every word processing, text editing and publishing system has a search and replace function, which electronically searches for a specified string of characters. The cursor jumps to each occurrence of the string and either stops for the operator to perform some action or it automatically replaces the search string with a replacement string of characters.

Search and replace is essentially a one-at-a-time function, where a transition table within a system is a large number of search and replace steps that can occur more or less at the same time.

for word processing that produce a recorded medium and also have the ability to telecommunicate are important. A recorded medium is some physical unit that allows data recording and reading. Its most common manifestation today is the disk, which has become popular as a result of both low cost and great portability.

Each word processor or word processing device has varying levels of capability for the text handling function. Many of those capabilities are not actually word processing. Adding columns of numbers and printing out the total, or sorting items alphabetically are really data processing, but no one makes the distinction anymore.

As an editorial person, one should be most concerned with editing—and especially the speed at which the system responds to requests. The other bells and whistles may not be useful for editorial purposes, but they can help with general office functions—such as typing out 100 personalized letters automatically.

How do you transfer copy?

The idea of interfacing for typographic printout came about because of the use of new electronic devices by originators. It was reasoned that information already in the electronic form could be "translated" or "filtered" to put into typesetting language. There are specific problems in this translation, most commonly in the area of command coding (which we will discuss later.) But the first problem was getting the information from here—the word processor or personal computer—to there—the publishing system.

There are only two ways to do this at present: Use the floppy disk as input to the publishing system, or send the information over phone lines, which is called telecommunications.

To use the floppy, you must have a disk reader that can handle the physical attributes of the floppy (size, density, number of sides) and can also take the coding of the originat-

INTERFACING PROBLEMS

The person who types on a word processor or personal computer is essentially typing on a typewriter keyboard that has a number of special functions that "automate" typing. Here are how some code conversions on such a system could work.

UNDERLINING Most word processors have an automatic underline function. Instead of typing a word or words and then going back to underscore them, you type a code at the start for "begin underline" and a code at the end for "end underline." These devices then do as instructed when the copy is output to the printer.

For the typesetter, those underline codes are meaningless until we establish a conversion table to tell the typesetter what "begin underline" means. That conversion might look like this:

/ V45 = 253612

It tells the typesetter that the "begin underline" is to be converted to "change to italic font" whenever it is encountered. And "end underline" converts to "change to standard font."

QUOTES The typewriter keyboard usually has just one symbol for quote marks, and it is used for both opening and closing quotes. In typesetting, there are both kinds of quote marks, and our conversion must take this into consideration. Because the system will not know when the typewriter quote symbol is open or close, the conversion table must cover most of the occurrences.

An open quote may be preceded by a blank space (word space), an open parenthesis, the three periods of the ellipsis, or an open bracket. The close quote may be by a question mark, exclamation mark, close parenthesis, comma, period, or close bracket.

If the single quote is used, we must cover the same ground because there is only one symbol on the keyboard for both open and

close. In addition, the single quote is often found in conjunction with double quotes and thus more entries are required to cover the possible situations. (Before you get too nervous about this procedure, remember that it is done only once for a particular word processor and system. It is not necessary to establish the conversion program every time.)

PARAGRAPHS Because most originating devices allow you to key a paragraph of material continuously, without having to have a return at the end of each line, like someone using a typewriter does. At the end of the paragraph, the return is keyed. In this case, we only have to convert the "return" to the required paragraph delimiter, which might be a simple "quad left" or a more sophisticated "*ep."

If you do not hit a return at the end of every line and paragraph, the system needs to know which return is to be converted to a word space (those at the ends of the lines) and which is to be the paragraph delimiter. Since you cannot have it both ways at the same time, you might key two returns at the end of the paragraph.

Or you could think ahead. The end of one paragraph is usually the beginning of another. At the beginning of the next paragraph there is usually a word space or spaces to delineate the indent. A conversion could be established that translates the sequence "return word space" into a paragraph delimiter and the em space. This latter approach may be a problem if there are numerous subheads.

INDENTS The word space in the typing world is a fixed-width space. It never varies. In typesetting, the word space is a variable-width space, expanding or contracting according to the needs of the justification process. To use a single word space as an indent (or even multiples) on the typewriter side will do no harm, but on the typesetter side it will produce indents of variable

widths. The fixed-width spaces, the em and en, have traditionally been used for indents, but these terms and concepts are alien to many office personnel.

We must handle this problem via the conversion process. The "return word space" sequence is one approach, but the most common one is keying three word spaces at the start of the line and then convert those spaces to the required em and en spaces.

WORD SPACES Most of us were trained to key two spaces at the end of a sentence to give it more visual separation from the next sentence. Because you cannot have two word spaces in a row in typesetting (because of their expandability/compressability), a conversion program must convert the two spaces back to one. Since the conversion program looks for string sequences, it can convert on specific numbers of codes. Thus, three spaces can be the indent. Five spaces might be the tabular "trigger" if there is no tab code as such.

One can see at this point that consistency is important. Because material may be generated by different people before they have been informed of the established conversions, it is possible to re-establish the conversions for an individual situation. All interface functions are "programmable" in that new translation tables can be established at any time.

HYPHENS/DASHES Many word processors have two kinds of hyphens. Hard hyphens are the normal hyphens that are inserted in compound words and will appear no matter how the words they are part of might break. Soft hyphens are used to indicate a word break at the end of a line.

However, word processors can reformat text to different line lengths, and in so doing would not want to pick up a hyphen that was placed at the end of a

line to break a long word. If the line length were changed, such a hyphen would probably not be required. Thus, a soft hyphen is one that the unit uses at its discretion.

The conversion program would change a soft hyphen to a null or a typesetting "discretionary hyphen." The hard hyphen would remain a standard hyphen. Two hyphens in a row are considered an em dash. This conversion is easy. However, if you want an en dash, you may have to use some unique coding sequence to specify it.

NUMERALS/SPACES In listings where a number appears at the beginning of each text block and aligns vertically, the blank space that is used is usually a fixed space. Otherwise, the space between the numeral and text would vary down the page. A conversion might be established that uses the sequence of the numeral followed by a word space to translate to the same numeral followed by the fixed space. Because ambiguity might result from occurrences of the numeral space sequence, it may be safer to use multiple word spaces to create more distinct conversion strings.

"l" FOR "1" The lowercase "l" is used by some typists for the numeral one. Some interface devices are intelligent enough to allow conditional conversions. That is, if the symbol is in the midst of numerals, it must be a one, and if it is in the midst of letters, it must be an "l." However, almost every keyboard today has a numeral one key.

SUB/SUPERSCRIPT Call them inferiors, superiors or even exponential notation, but the problem will be the same. If these are unique characters on the word processor, they can be translated into the appropriate typesetting code sequence (usually a change to the pi font and selection of the symbol). If, however, you are moving the

paper up or down to "manufacture" the symbol on the word processor or personal computer printer, the code that is generated is the numeral itself. On units that have a keyboard command for forward or reverse paper movement, the sequence of that function plus the numeral could be converted to the proper symbol.

The above assumes that you have or can "manufacture" superior and inferiors. Most fonts have them as numerals but not as alphabetic characters.

ACCENTS In typesetting, accents are called "floating" accents. They are keyed first and are followed by the letter they accompany. The accent is then positioned in the character "window" with zero width, thus floating it in position above the character.

Some word processors have the character and accent combined as one key. This can be converted to the typesetting sequence as well. But when there is no accent on the originating device and the originator writes or draws it in after typing, there is no way to convert.

At this point, we come to the items that cannot be converted because of their uniqueness. You need an "accent acute" and there is not one on the keyboard—how do you tell the interface function you want one? The answer is that you must create a code sequence that can be converted and then tell the interface/publishing person what you have done.

We must take a key on the keyboard and use it as a precedence code or flag code. It allows the interface device to recognize a unique sequence. We used to use the asterisk, but it is often in the shift position of the numerals and is hard to use on a regular basis. The slash is usually a non-shift key—but then we have to invent a special sequence just to key in an actual slash character.

ing device and convert its idiosyncratic function codes.

In coding, we assign a set of numbers to represent a character. Because the characters are essentially those that appear on a typewriter, the codes may be somewhat standardized; however, because each device provides certain special functions (such as automatic underlining), codes are used to define them. It is this area that creates much of the confusion in interfacing.

When information is sent over the phone line, it must be changed in form to a system that is compatible with the network. Thus many of the codes get changed to a standard code set, even some of the special ones. Telecommunicated data comes closer to the form we need.

But now, in both cases, we must change the coding we receive into the coding we need for the system. This is called "code conversion," and the function is performed by an interface unit, one that takes either floppy disks or telecommunications, or both.

Interface units are either machine specific (in that they are made for one particular system) or they are generalized (they could be changed from machine to machine with some work). All interfaces are programmable, which allows the user to establish the code conversion or the "translate table" (which changes code or codes to other code or codes as required).

What are the advantages of telecommunications and of sending a floppy disk?
The advantage of telecommunications is the avoidance of floppy disk variations, while providing some degree of standardization. Its problem is the possible degradation of the phone line caused by static or switching.

Certain types of telecommunications have error correction that sends data in various ways to verify its reception. But telecommunication does not give you a manuscript and instructions, although in highly stylized areas, such as magazines, it may not be absolutely necessary.

The floppy can be sent with other material—and many express services can deliver overnight. In my opinion, a floppy disk sent by overnight mail is pretty close to telecommunications.

If you use only one or two kinds of floppy units, then you have standardized enough to use floppies alone. If from one day to another you have no idea what kind of floppy will come in from outside freelancers, telecommunications may have to be used, although there are now conversion services in most American cities that will convert floppy to floppy. These services have one each of most of the popular word processors or personal computers and telecommunicate the data from one to the other, usually with an interface unit in-between.

Can you use meaningful words instead of numeric symbols?
A trend today is to use generic coding, a character sequence that describes the material as it will be produced—for example, **.head** for a head, **.text** for text, or **.bldhead** for a bold head.

The conversion translates these into the required typographic commands. One does not have to remember numbers or codes, but would describe the material—a head, text, an extract, a footnote, and so forth.

IDENTIFYING PAGE ELEMENTS
It is vital that you identify page elements consistently. The identified elements depend on the complexity of the document, the program you are using, the translation utilities available and the desired end result. Element identifiers or tags can look something like this:

[head1] = 24 point Helvetica Bold, centered on 40 picas, kerned two units;

[head2] = 12 point Helvetica Bold, flush left on 20 picas, kerned one unit;

[text1] = 11 point Times Roman, justified on 20 picas;

[text 2] = 9 point Times Italic, justified on 20 picas;

[capt1] = 7 point Helvetica Italic, ragged right on 20 picas.

A manuscript prepared for processing would look like this:
[head1] This is a main headline.
[text1] This is the first paragraph of text that specifies what the copy consists of by using element identifiers.
[head2] This is a subhead.
[text1] This is another new paragraph of text that appears below the subhead.
[capt1] This is a photo caption; the type style will change.
[text2] This is a footnote; again the type style and size will change.

Each of the identifying elements has a different meaning in typographic form. Tags or element identifiers are a form of code shorthand in which the simple command **[head1]** may be "exploded" into a large number of codes required in the formatter. The codes themselves may look like this:

[head1] = [CP24] [CL20] [CFHB] [CC40] [HX] [T2] [RC]
[text1] = [CP11] [CL12] [CFTR] [CC20] [HO] [TO] [RX] [IP2]

By using tags or element identifiers, you can considerably reduce the amount of code which must be entered into the manuscript for typesetting or simulated typesetting. Conversion utilities will translate the strings into the large amount of code required to alter typestyles, sizes, line length, typographic aesthetics and positioning. This is why consistency is so important.

The benefits of the link to publishing are most apparent when the data can flow from the originator through the interface device into typesetting—all automatically. If the publishing person has to go into the copy and insert codes or change codes, the benefits become minimal. The interface must be automatic to be effective and that means that the conversions must be established for the code sequences beforehand.

No one ever said that the interface to typesetting was easy; it only works when it works well, and it only works well when the originator includes all required codes and prepares copy consistently. ∎

—Frank Romano

PREPARING ART AND PHOTOS FOR REPRODUCTION

When preparing art and photos for printing, it is often the tiniest glitches that cause the worst problems. A technical supervisor relates this story: "When we needed to crop keyline boards for a project that required a very critical and complicated fold, I assigned two people to cut enough boards for the project and told them to be very careful with their measurements. During a check of their work, I discovered that the three rulers (theirs and mine) all provided different measurements—as much as ⅛-inch off."

A solid production background and a sensitivity to these kinds of problems is crucial to the success of any print project. As one art director for a large printing company comments, "You are not an excellent designer until your designs can be printed as designed with the results you intended at the price you were quoted."

Although experience usually proves to be the best teacher, it is also the most time-consuming and expensive. So use the practical charts, guidelines and techniques in this section to help build your art and photo prep background to your best advantage.

Camera Formats and Film Sizes

Learn how to select the right camera and film for your project.

The selection of the right camera format or film size is often over looked, but it can make the difference between excellent and mediocre reproduction of the photographs.

Format is a general term used to denote the size of camera or film. Photographers can choose from a range of formats, from 35mm and 120mm single lens reflexes to view cameras that accept film sizes of 4 x 5-inches up to 11 x 14-inches. Most professionals have at least two of these and some have all. So why not just rely on the pro to choose the proper format? Because you, as client, know how the pictures are to be used. It has to be a cooperative decision. Newspapers, magazines, posters, point-of-purchase pieces or giant billboards all have different printing characteristics that must be considered carefully when deciding which format to use.

Camera film is made up of little bits of silver called halides, suspended on acetate in a layer of gelatin-like coating. The density or quantity and size of these silver halides per square inch of film determines two things: The fineness or sharpness of image that can be achieved and the sensitivity to light (or speed) of that film. Films are referred to as "fast" or "slow" and are given numerical ratings (ISO and ASA) in order to tell them apart. The faster the film is, the fewer and coarser the grains of silver per square inch. This allows the film to be exposed very quickly because there are fewer particles to be "touched" by light. The slower films contain finer grains in greater densities and require longer exposure to light.

A good rule of thumb is "bigger is better" and "slower is sharper." The bigger the original image, color transparency or black-and-white negative, the less it will have to be enlarged for final use. Slower film speeds allow sharper enlargements because the halides or "grain" is finer to begin with.

When size and the method of reproducing an image are considered, the choice of film becomes even more critical. The exposed image, made up of grains of silver, must be broken up by an engraver's screen into a mass of dots, etched on a piece of metal, inked and transferred to paper that may or may not accept the dots well—a formidable assignment for film of any speed.

Selection of film type is a straightforward process based on known environmental factors of light, location, weather and subject. Choice of film size is much more subjective.

35mm SINGLE LENS REFLEX CAMERA This is everybody's first choice. It can be easily carried and used "hand held." It will accept film in rolls of 12, 20 and 36 exposures or it can be fitted with a special back designed to hold even more exposures. It will accept lenses from 8 to 4000mm. When mounted on a tripod in a studio, loaded with a fine-grained film, and its shutter is synchronized with an electronic flash unit, it can be used effectively for product or fashion shots. There is even a perspective control attachment available for wide angle lenses when photographing buildings or interiors.

Photojournalists, among many others, use 35mm cameras because they are small and lightweight. Sports photographers love them because they can be equipped with a motor drive that will advance the film, cock and trip the shutter and repeat that sequence at the rate of three frames per second. The built-in auto-focus and auto-exposure systems almost eliminate the technical part of picture taking and let the photographer concentrate on capturing that elusive "decisive moment" of action, whether it be journalism, sports or high fashion.

Its biggest drawback is size of image, only $1\frac{3}{8}$ x $\frac{15}{16}$-inches. For reproduction in most publications, this is sufficient because the enlargements are not extreme, and if care is taken to select the proper film, the sharpness will be acceptable. Beyond regular publication sizes, however, larger formats should be considered.

120mm OR 2¼ x 2¼-INCH These cameras provide almost four times the image size of the 35mm, with only slightly more physical bulk. The range of the lenses is less, but still adequate for most assignments. Some can be used with motor drives, but the number of exposures per roll is limited to twelve. Focusing is done on a ground glass screen located on the top of the camera. This means that when using it "hand-held," it will be held about waist high and care has to be taken to shade the focusing screen from light in order to see the image.

These cameras are most often used when mounted on a tripod either on location or in a studio, because more care must be taken to manipulate the controls. They can be fitted with a Polaroid film pack that allows exposure and composition to be checked before the actual picture is taken. The final image produced is large enough to be looked at without being magnified.

The 120mm format can be used very effectively for fashion or people shots when many variations of a pose are needed, or for almost any photo assignment that does not require fast handling of the camera controls. Enlargements are much sharper than the 35mm format.

VIEW CAMERAS These large format cameras allow more exposure and composition control than is possible with the smaller format. These are the large bellows-type cameras that are always mounted on a tripod for stability. They are called view cameras because composing and focusing are done on a ground glass mounted directly behind the lens with the shutter open before the film is inserted. Film is exposed one sheet at a time and all exposure adjustments are made by hand.

View cameras are available in 4 x 5-inch, 5 x 7-inch, 8 x 10-inch and 11 x 14-inch sizes. The numbers refer to the size of a single sheet of film that the camera will accept. Film

PHOTOGRAPHIC FILMS

Black-and-White	Standard Sizes/Formats	Types	Notes
Film (Negative)	35mm, 120mm, (2¼ sq. and 6 x 7 camera formats), 4 x 5, 8 x 10	• Kodak—T-Max 100, T-Max 400, Plus X, Tri X • Type 2415 (high-speed, high-grain 35mm film for mood effects) • Technical Pan (super-fine grain for photomicography) • Ektagraphic HC (title slides) • Agfa—AgfaPan Professional (ASA 100, 400, 25) • Ilford—FP4, HP5, XP1, Pan F • Fuji—NeoPan (ASA 400)	Kodak replaced b/w Panatomic X film with T-Max, a b/w positive that can be processed in reversal chemistry to make a b/w slide. B/w slides are rarely, if ever, used; they are often made from color slide film because that process is less expensive.
Prints	5 x 7, 8 x 10, 11 x 14, 16 x 20, 20 x 24 (rolls to 50-inches wide); b/w mural paper available in rolls up to 52-inches wide	• Kodak—available in various surfaces • Ilford—available in various surfaces • Agfa—available in various surfaces	B/w prints are often used for product, publicity shots, retouching and fine-arts photography, as well as to produce engravings for reproductions.
Instant Film	Camera formats; 3¼ x 3⅜, 3¼ x 4¼, 4 x 3, 4 x 5, 8 x 10, 16 x 20	• Polaroid—Type 665, 667, 52, 54, 55, 57, 107C, 107, 084, 87, 47, 5T	Unlimited uses, including test for lighting, composition, exposure.
Display Material	Film and print sizes available up to 50-inches wide	• Kodak—Translite	These b/w transparencies (backlit) and prints (frontlit) can be used for display application.

The Charts There are many variables involved in the selection of the best film size and type for your job. For this reason, please use the charts on this and the next several pages as a starting point only. Because they list just some of the more popular film sizes and types, they cannot begin to answer your specific questions. However, the information contained within these charts should provide a point of departure for informed dialogue between you and your local lab, your photographer, your clients and your co-workers.

holders are loaded in a darkroom, inserted into the camera back for each exposure, then removed after each exposure.

This is not a format for photojournalism or action photography. It is for product, still-life, interior, architecture, landscapes and portrait shots. It allows the photographer to instill a sense of "presence" in a picture that is almost impossible to achieve with the smaller formats.

Film images can be manipulated by pre-exposing or "flashing" and after exposing by various development methods. Retouching, if needed, can be done directly on the processed film. Enlargements are not a problem.

View cameras are cumbersome and the film is expensive, but they will almost always produce a superior image. Do not rule them out, despite their disadvantages.

Determining which size is easy: How much money is in the budget for film and processing? The differences between the images produced by a 4 x 5-inch camera and an 8 x 10-inch camera are not enough to worry about. Let the photographer decide that one. ∎

—Jerry Demoney

PHOTOGRAPHIC FILMS

Color	Standard Sizes/Formats	Types	Common Applications
Color Transparency	35mm and 120mm (2¼ sq. and 6 × 7 camera formats) and sheet film	• Kodak 35mm—Kodachrome PKM 25, PKR 64, KPA 40 (Tungsten), PKL 200	Basically all modes of reproduction and presentation. However, larger format preferred for in-studio and tabletop. Ektachrome sometimes chosen over Kodachrome because most cities offer same-day processing.
		• Kodak 35mm and 120—Kodachrome Professional 120 (ASA 64), Ektachrome Professional films; EPR 64, EPN 100, EPY 50, EPP100, EPT 160, EPD 200	
		• Kodak 35mm—Ektachrome EES P800/1600 • Fuji—Fujichrome (ASA 1600)	High-speed, high-grain film.
		• Kodak—Ektachrome Duplicating film (35mm and sheet film)	For the making of duplicate transparencies.
		• Fuji—Fujichrome 50 RFP, 100 RDP, 400 RHP, 64RTP (Tungsten) • Agfa—Agfachrome RS (ASA 50, 100, 200, 1000)	Basically all modes of reproduction and presentation.
	4 × 5, 8 × 10, Larger	• Kodak—Ektachrome 64, 100, 64T, 100 Plus, 200 • Fuji—Fujichrome 50 RFP, 100 RDP, 400 RHP (Tungsten)	
Color Negative		Available in a number of sizes and ASA ratings. Not extensively used in commercial work for reproduction. More applicable for wedding, portraiture, or creation of color prints using Ektacolor papers to make prints from negative. Types: Agfa—XRS (ASA 100, 200, 400, 1000); Kodak—Kodacolor, Vericolor, Vericolor Interneg (used for copying flat artwork and to make color neg. from color transparency).	

Film types with the suffix "chrome" are, as the name implies, chromes (transparencies/slides). Film types with "color" as a suffix produce a direct negative from which prints are made. These films are usually used by amateurs.

PHOTOGRAPHIC FILMS

Color	Standard Sizes/Formats	Types	Common Applications
Prints	3½ × 5, 4 × 5, 5 × 7, 8 × 10, 11 × 14, 16 × 20, 20 × 24, 24 × 30, 30 × 40	• Kodak—Ektachrome papers used to make prints from transparencies • Fuji—NFP, NLP • Agfa—Agfacolor Type 8 (three finishes) • Dye transfer print: made from transparency via b/w interneg. and matrix materials (18 × 24, or 20 × 30 are largest for general use) • Kodak Ektacolor prints (Type C Prints): print made from negative or interneg. (30 × 40 is largest for general use) • Ilford—Cibachrome: prints made from transparencies (30 × 40 is largest for general use) • Kodak—Type R Prints: direct reversal process made direct from transparency • Agfa—Agfachrome Reversal Paper	Color prints are made either from negatives or transparencies and are frequently used for commercial retouching (although dye transfers are most often chosen over color prints for high-quality retouching) in beauty, food, product and fashion shoots, and also for fine art exhibit work. Print paper surfaces vary, check with local lab.
Instant Film	8 × 10	• Polaroid—Type 808, 809	Unlimited uses. Professional studio uses are: casting, location search, lighting, exposure, composition, comps, test shots before final transparency exposed.
	4 × 5	• Type 58, 59	
	Professional film sizes fit accessory camera backs	• Type 668, 669 (Polacolor, Time Zero, High Speed, Autofilm), Type 88 (sq.)	
Display Material	Available in sizes 70-inches wide, in sheets and rolls	• Kodak—Duratrans, Ektacolor, Duraflex • Ilford—Cibachrome • Agfa—Print and Film (opal and clear)	Display transparencies can be printed in almost any size. Backlit for display.

How to Buy Photography

The success or failure of any photo assignment depends on proper planning and skillful art direction.

The basic steps to making a photo assignment are the same regardless of the subject. In this respect, a high-fashion sitting is the same as assigning a product shot or a picture essay. The first step is to talk with photographers and look at portfolios in advance, when you are under no pressure from deadlines.

Before deciding on a photographer, establish the requirements of the job. What is to be photographed, and how will the picture be used? Is it to be done in color or in black and white? How important is this photograph? (That is, how much money are you willing to spend?) When talking about the assignment to a photographer, you must know what you want and why you want it, because photographers can approach the subject in many ways.

Suppose you need a picture of a machine that is located several hundred miles away. The photo will be used in a four-color, offset-printed brochure which will be distributed at a specific time to an

Proper Planning When planning a shoot, you must carefully consider your budget, schedule, models, stylists, set, lighting and choice of photographer. Professional photographer Reid Miles is shown at work (at far left) in his carefully crafted studio. (Photo by Wayne Adams.)

industry audience. Knowing these fundamental facts helps you decide the type of photographer to consider for the assignment.

THE BUDGET

Every photo assignment has special budget considerations. There are many factors that influence a preliminary budget, and they all must be considered, which is why even experienced editors and art directors refer to checklists.

First, determine the photographer's fee. A very good source for this information is published by the American Society of Magazine Publishers (ASMP). The book provides photography day rates, from low to high. Locate the category in the book that best matches your needs. Remember, as in most other things, better costs more. To play it safe as a beginner, you might start with a fee in the mid-to-upper-range. The book also lists travel day rates (usually one-half the photo rate). Total the travel days and shooting days.

Add to that the cost of transportation, food, lodging and film and processing. You can establish the cost of transportation to the location by contacting the appropriate carrier (airline, train, bus) or travel agent. Do not forget to estimate any local transportation which might be necessary, such as a taxi or rental car. Assume that food and lodging costs are comparable to those in your area, but if you are in doubt, call ahead for information.

Film and processing prices are fairly standard. To determine how much film you will need, figure two shots per 36 exposure roll of 35mm, one shot per twelve exposure roll of 120, one shot per four exposure 4 x 5-inch film, or one shot per two exposure 8 x 10-inch film. These are only estimates and should be discussed and agreed upon with the particular photographer assigned to the job. A local film supply store can provide the unit cost of film and processing for any of the above.

By adding these costs together, you will arrive at a rough budget figure which will affect your decisions on the assignment and the level of photographic expertise you can afford. The photographer and the project supervisor or client will also need this information.

THE SCHEDULE

Even though we live in an age of jets and satellites, photography is still a very human endeavor. To make the exposure, a photographer must be at the site physically, and the exposed film must be transported, processed and delivered to you by humans. That being the case, a realistic schedule often makes the difference between success and failure. It also affects the choice of photographer. (Your first and even second choice may be unavailable because of conflicts in schedule.) If insufficient time is allocated, you will also find yourself faced with premium expenses for rush service and overtime charges.

Using the brochure as an example, first determine when and where it is to be distributed. Then find out how long the printer will need for completing color separations, plates, printing, binding and shipping. The time needed by the art department for design and mechanical preparation cannot be overlooked, nor can the time required to process and edit the film.

A typical schedule for our example project might be this:
• Three to five days for selecting the photographer;
• Three days for travel and photography;

• Two days to process the film;
• One day to edit the pictures;
• Two days in the art department for design and mechanicals;
• Three weeks for plant production (including color separations);
• One week to print, bind and ship the finished brochure to its destination.

Surprise! The entire process took 41 days. You can understand why it is so important to move quickly at the early stages. The well-planned schedule will help you maintain an early momentum.

PRELIMINARY ARRANGEMENTS

After checking your files, call in two or three portfolios. When you do this, try to talk directly to the photographers, giving them a general idea of the subject and schedule, and inquiring about their customary fees for such an assignment. This first telephone contact—even before seeing the portfolio—can be extremely important. A general discussion of fees will alert you to the possibility that the photographer may be out of your budget range, or it may cause you to reevaluate the nature of the assignment or budget. Your brief description of the job also gives the photographer an opportunity to tailor the portfolio toward your interests.

Sit down with the photographer and ask him or her to ''talk you through'' the portfolio. At best, portfolios are a brief outline of a photographer's experience within the area that concerns you. By listening to how each photograph was done, you will gain insight into how flexible he or she is in approaching a subject.

Photographers enjoy explaining how they solved a problem or how they could have done it better, which may give you some ideas about other ways to approach your own assignment. This first interview will give you a good indication of the photographer's personality, as well—a very important factor if you are going to spend much time together or if the job entails

working under pressure or with difficult personalities.

MAKING THE CHOICE

If you have the luxury of time, look at the portfolios again after a day or two. If your initial choice still seems right, go with it. Your preference may have to be ratified by someone else on your staff—your immediate supervisor or the person responsible for approving budgets. This is common practice, whether you are considering a $75 publicity shot or a $30,000 shoot for an annual report.

After you and your staff have reached an agreement on the selection, call in the photographer as soon as possible. You will need to begin planning immediately for the details that often take much longer than you assume, like gathering props, obtaining clearances and making travel arrangements, for example. Coordinating the many aspects of a job in a calm and professional manner can only be accomplished if you allow sufficient time.

FINALIZING YOUR CHOICE

At your first meeting with the photographer to discuss the specific assignment, review the portfolio once again. This time, you do the talking. Ask the photographer specific questions about the shots in the portfolio that most interest you, thereby laying the groundwork for what you expect and prefer. The photographer can also indicate whether or not your ideas seem workable and if he or she feels qualified for the job.

If for any reason during this meeting you have any sense of unease regarding the photographer's ability to perform the assignment to your expectations, do not make the assignment. Thank the person

for coming in and explain that you still have others to interview. Interview your second choice and compare the two. You may still decide that the original selection was correct. This does happen from time to time, and you should be prepared to handle it in a graceful and professional manner.

DESCRIBING THE ASSIGNMENT

As soon as you know that this is the right photographer for the assignment, you are ready to discuss the specifics. If you need a product photograph for a brochure or advertisement, state precisely what you want. In this case: "We need a picture of our company's machine to be used in a brochure that will be printed seven weeks from today. The product is located in our upstate facility and must be photographed there." Having stated the basic requirements, give the photographer all the pertinent printed material you have, as well as the names, addresses and phone numbers of on-site contacts.

Next, you will want to convey the mood or style of the photography. To do so, you might show some examples of other photos from your files that demonstrate what you desire. It also helps if you have a layout to suggest lighting and point of view. Having a layout in advance is common practice when planning an ad or brochure, less common in planning editorial. There are, of course, certain points which are common to all jobs and must be communicated to the photographer.

1) Is the work to be in color or in black and white?
Seldom will you have the luxury of covering a job both ways, unless you prepare for it well in advance. Remember, you can always convert a good color shot to black-and-white, so if there is doubt about which way to go, shoot in color.

2) How will the work be used and how will it be reproduced?
The intended use of the photo affects the photographer's fee, and it also affects the camera and the film to be used by the photographer. The same photograph printed by a high-speed web offset press on newsprint paper will look very different when printed on a bright white coated paper on a sheetfed press. Having this information, the photographer will determine the appropriate amount of contrast and/or the degree of color saturation.

3) At what size will the photograph be reproduced?
This question is seldom considered early enough in making the assignment. Focus and color saturation will vary according to whether this picture is designed to fill a giant billboard or a quarter-page ad in a "slick" magazine. While it is true that 35mm film, if properly handled, is now capable of great enlargement, the larger format camera will provide superior enlargement for the best large-scale reproduction. If you happen to feel strongly about this consideration, you have the right to insist on the format you prefer. Naturally, there are exceptions, but it is important that you not overlook this important aspect of the assignment. (See "Camera Formats and Film Sizes," earlier in this guide.)

4) How does the photograph relate to the other elements in the printed piece?
A rough or finished layout, if you have one, is ideal for showing what you have in mind. Without a layout, you would be wise to consider whether or not type will be incorporated in the photograph and, if so, whether the type will be positive or negative. The decision to silhouette or

outline the subject of the photograph might also be made at this time.

5) What is the final shape of the photograph in reproduction?
Now is the time to determine if you will need a horizontal, square or vertical shot.

It may happen that no layout has been made and that the piece will not be designed until *after* the picture has been shot. In this case, you want to arrive at an understanding regarding the number of pictures in a variety of shapes you will hope to see. For example, in the case of "the company machine" assignment, your budget may not allow for a scouting trip that would allow you to choose the most desirable elements for the assignment. Common sense and experience with similar situations should make it possible for you and the photographer to construct a "shot list" or "shooting script" based on what you both can expect. This is simply a list of all the photographs that you and the photographer think might be possible during the shooting. Once on the site, the photographer may have to make adjustments to the list, but the main considerations on the shot list must be covered.

6) What lighting do you prefer for the assignment?
If not shot indoors, pictures are generally done in daylight. However, photographs can also be made at night or in the evening to produce very handsome effects and to conceal distracting details. If you prefer a studio shot, the style of lighting becomes extremely important and must be discussed. On location you can avoid a good deal of anguish by simply calling the head of maintenance at the location to determine the name and type of bulbs used on the site. All professional photographers should be equipped to deal with any type of artificial lighting situation.

BUDGET REVIEW
By now, you and the photographer understand what is expected from the assignment. Review the budget to be certain that all items and responsibilities have been covered and assigned. Who will make travel arrangements and hire models, for example? If you feel the photographer has more experience in handling these matters, there is no reason not to let him or her do so. (You can probably learn a great deal by watching and listening.) This is an area that can throw a budget out of control. For this reason, be certain to establish who pays for what. Get a detailed estimate of costs and responsibilities in advance, regardless of how small the job may be.

FINAL DETAILS
After you have agreed on a final budget, re-examine your schedule for the execution of each step in the process, from making travel arrangements to delivery of the finished pictures. Putting this on paper may seem to be a tiresome extra step, but it is very important. If the assignment happens to be lengthy or complex, a written schedule provides all parties with a convenient guide to completion.

DIRECTING THE PHOTOGRAPHER
Many assignments require that a client representative be present during the shooting. There are, of course, certain assignments where the presence of the client is unwarranted or impractical, such as an assignment that may require weeks or months of shooting (wildlife photography, for example) or an essay that expresses the photographer's point of view. The presence of the client or the client's representative is required whenever important design, marketing or editorial decisions must be made on the spot. Because the photographer, you, or the client may be seeing the situation for the first time, there might be an unexpected detail that could jeopardize the job or make it more successful.

Deciding who should accompany the photographer is based on what is required of the job and who is most necessary to its success. If an art director, editor, account executive, and stylist are essential, they all should be present, but such work must not be considered a "perk," vacation or a welcome break from routines. In this case, too many cooks will spoil the broth, and only those who are indispensable should be present.

No matter how many people attend the shoot, the photographer must know who is in charge. Direction by committee generally produces poor results. The photographer's performance will be affected if he or she detects dissent among the members of the group. Differences that may arise should be resolved amiably on the spot and any substantial disagreement must be handled carefully by calling for a break in the shooting and settling the differences privately, away from the group. It is generally the art director's responsibility to communicate any decision, even if a senior staff member is present. In the end, the photographer is accountable to the person who did the original hiring and all questions, suggestions, or instructions should be channeled through that person.

After the shoot, the photographer will process the film and deliver the results to you. Now it is your job to evaluate the results. ■

—Jerry Demoney

Cropping, Sizing and Scaling

Practical tips on laying out your photos for reproduction.

The reason photographs never seem to fit the spaces allotted to them in a layout is that Mr. Eastman et al did not have today's newspaper or magazine in mind when film sizes and proportions were established. They wanted to produce an image of man and his world that would be exhibited in the home or in a gallery. The concerns of the commercial artist, of course, are quite different (the restrictions of copy, media and layout being the most significant among them).

Quite often, photographers are at fault. They want to create an attractive composition based on the full picture plane as they view it. We are trained to do that, too; but if the photographer is composing on a rectangular 35mm film frame and we are composing on a square piece of paper, some kind of a compromise will have to be made. The photo will have to be cropped (recomposed) and scaled (reproportioned). The first takes courage, the second takes some skill. "Courage?" you ask. Definitely.

A good photograph by a good photographer can be very intimidating. Photographers always want to see how their work is treated. If they are not happy with it, they may not want to work with you again. That is where the courage comes in. Some editors and communications directors do not help much, either. They often think the picture is inviolate and are too concerned with the photographer's feelings. If these kinds of photographers and editors had their way with pictures, printed matter would be dull indeed. We might see lots of "middle distance" pictures of full length figures, trees and buildings — all of which would add up to boring at best.

I was once asked to redesign a Sunday

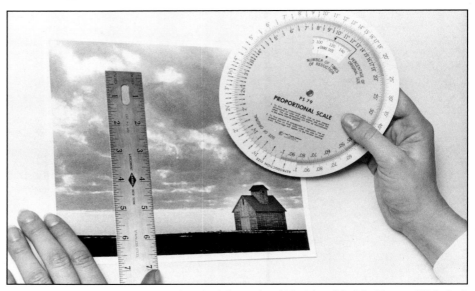

Proportion Wheel When using a proportion wheel, line up the width of the original (in this case, 5⅞-inches) on the inner wheel, with the width available on the layout (7 inches) on the outside edge of the wheel. The window on the wheel displays the percentage of enlargement necessary—119 percent.

magazine, but in the same breath was told not to change the type styles or photographers, who were all on staff and in the Guild. The simplest and most effective thing to do was to crop the shots tighter (closer to the heart of the shot) and to scale them up to dramatic sizes. For instance, instead of showing two full figures exchanging money, I would crop in on hands alone, and then scale the image up to full page size. It was the kind of picture treatment that added drama and interest to the story presentation; unfortunately, it also added tension to the art director/photographer relationship. They soon realized that their work was being handled seriously, however, and they relaxed.

CROPPING GUIDELINES

Cropping actually begins at the picture assignment stage. Describe the kind of pic-

tures you want (close-up, distant and so on) and how they might be used. This helps the photographer to understand your needs.

Once the pictures are in hand, determine which pictures you wish to use and begin the layout process by deciding what size and shape these photos need to become, considering the configuration of available space. In certain cases, your layout determines the size and shape of the photo; in others, the content of the photos themselves determines size and shape in the layout. Once the best composition is selected, frame the portion you wish to use as squarely as possible. If you are working with an unmounted print, tape it to your drawing board so you can draw your suggested crop marks with a nonreproducible pencil in the border area, on an unused portion of the photo itself, or on a tissue flap or overlay. When you start

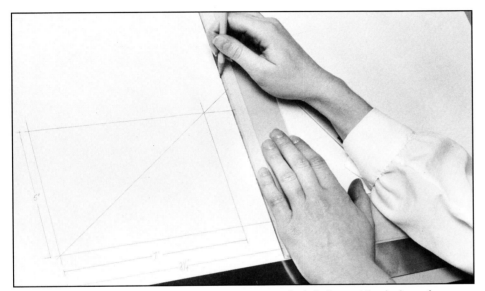

Diagonal Method Simple geometry is the basis for this method. A diagonal line is drawn from corner to corner of a rectangle (your photo). Any size rectangle drawn on the same diagonal (this enlargement will be 8¼-inches wide) will be in proportion to the original (7 inches wide).

scaling the photo, you will soon find out whether your crop will work or not. Each picture should be examined for a crop that achieves the strongest image possible for the story. Because your pictures are helping to tell a story, you must make sure they convey a message independent of the words, but not in opposition to them.

SCALING

Now that you have done the courageous part, and selected and "squared up" the portion of the photograph or illustration you want to reproduce, you need to reduce or enlarge that chosen image area to fit your space. This is called scaling, and you can use a variety of methods to accomplish it, from a mathematical one using your calculator to easier ones like using your stat machine, camera lucida, Lacey-Luci projector or Scaleograph. The Scaleograph, for example,

is a common tool with two L-shaped frames, a diagonal rod and two tightening knobs, which scales and crops in a combined operation. It finds its roots in the tried-and-true diagonal line method of scaling.

THE DIAGONAL METHOD Many graphic artists consider this traditional technique a bit too cumbersome to use on a regular basis, because a T-square and triangle are needed. But the procedure is really quite simple.

First measure the dimensions of the space to be filled in the layout. Let us assume it is 8¼-inches wide by 5⅞-inches deep. Now draw a rectangle at that size on a sheet of tracing paper. Extend the base line and left vertical lines several inches. Using the long side of a triangle, draw a line from the lower left corner through and beyond the opposite corner. Tape the tissue over the photo. Determine the portion of the photo's width to be used. Mark it on the extended base line of the tracing and raise a vertical line from

that point to intersect the previously drawn diagonal. That point shows you the height of the original photo needed for your layout. Complete the rectangle by drawing a horizontal line through the point to the extended vertical rule. Anything within that rectangle will appear in your layout. Move it over the photo until you are satisfied with the new composition and mark those dimensions outside the picture area. Keep in mind that with this method, if you measure from either corner, any new size rectangle that has horizontal and vertical lines which intersect will be in proportion to the original rectangle.

THE PROPORTION WHEEL No doubt the most popular of all methods is the circular proportional scale: a plastic tool with two rotating disks that is found in almost every art department. The "wheel," as it is affectionately called, will give you just as accurate an enlargement or reduction as your calculator will. Once you master the "wheel," you will never work without it.

First measure the width of the space to be filled in the layout. Let us say it is 7 inches. Now look at the photo to be used and measure the width of the area you want to show: 5⅞ inches. Find 5⅞ inches on the "size of original" scale and set it opposite 7 inches on the "reproduction size" scale. Hold that position on the wheel while you measure the height of the space allotted in the layout. We will assume it to be 7¾ inches. Look at the "size of original" scale and you will see 6½ inches. That is the amount of photo needed to fill your layout space. (The percentage of enlargement is 119 percent.) Although the principle is very simple, it is also very important. If you discover the height of the original is not enough, you will have to rethink the cropping.

The more you practice, the more comfortable you will feel juggling sizes and shapes back and forth to reach the best design solution. ■

—Jerry Demoney

Evaluating Black-and-White Prints

Educate your eye to become familiar with the tonal fidelity of your black-and-white prints.

Even though black-and-white photography came before color — all of early 18th- and 19th-century history was recorded in monotones — the word "photography" brings colorful images to mind for most people—rich, blazing reds, too hot to handle, impassioned blues and cool, melancholy purples. For the art director in charge of an important campaign, colors have always played a key role in product packaging, corporate logos and print advertising design. But look over your shoulder. A powerful tool is being applied to establish a dramatic look for progressive, upscale companies: black-and-white photography. Although still a tiny segment of the overall image market, black-and-white images grace the ads for companies like Ralph Lauren, Calvin Klein, Baccarat Crystal, Hanes, Neiman-Marcus, Saks Fifth Avenue and Elizabeth Arden — all found recently while paging through a single issue of *Town & Country* magazine, for example.

Yet for all the renewed interest in black and white, few have a complete understanding of how to use, assign or evaluate commercial black-and-white photography. If you count yourself among those who want the design and tonal fidelity of your black-and-white imagery to be top-shelf quality, there are some important facts to consider.

SELECTING THE PHOTOGRAPHER

For many commercial photographers, color work, specifically transparencies, constitutes the bulk of their repertoire. As you know, a "chrome" is the actual film exposed in the camera during the shoot. This means that virtually all of the creativity and image manipulation must take place in the shooting phase with the aid of lighting, props and camera angle. The E6 process then reproduces what the viewfinder sees.

Negative films, however, allow for an additional creative step. During the making of the print, a talented darkroom person can and will enhance tonal values, increase the contrast range of a scene and may choose to selectively shift colors toward or away from the truth. This extra flexibility is considered by many photographers as an opportunity to "ice the cake." Post-studio decisions to enhance or calm down a particular area are readily accommodated when the enlarger light is switched on.

Most busy commercial studios and custom labs process their black-and-whites in stabilization machines and print on resin-coated photo papers, both of which are designed for speed, not accuracy or tonal fidelity. But only a handful of "die-hards" still continue to hand process films under strict temperature tolerances, using distilled water for mixing all photographic chemicals. These purists would never think of printing on anything but old style, fiber-based papers.

Unlike a color photograph, black-and-white materials are readily adaptable to bold or subtle tonal distortions or enhancements. Using techniques such as burning or dodging, the shooter is able to lighten or darken specific areas as small as a quarter of an inch to accommodate a particular interpretation. Specialty chemicals may be used to manipulate the contrast range of any scene to impart a feeling of sunshine within a scene where none existed. Intensifiers are contrast improvers that are applied often to tiny areas of a negative or a photographic print to highlight a gray plane — or to put snap into soft-toned lines, or just about anything else in need of a tonal boost. The list of enhancements, adaptations and corrections for black and white is limited only by the knowledge, creativity and dexterity of the photographer. There are literally thousands of choices available. It will be in your best interest to locate the photographer with a working knowledge of these practices. Unfortunately, there is a shortage of these fine artisans. To find such a talented practitioner, here are a few things to consider when reviewing photographers and portfolios.

ASK FIRST When the photographer or his/her representative calls to make an appointment to show the portfolio, inquire about that prospect's experience with shooting and processing black-and-white materials. Invariably, each will assure you their "bag of tricks" includes black-and-white expertise.

Once the portfolio is put into your care for review, look with a careful eye at original prints made by the photographer. If the prints are reproduced on resin-coated paper, you can assume they have been cranked out by a commercial photo lab.

EVALUATE PRINTS Carefully observe the tones in the photograph. Are a full range of black, white and gray present? Do the white values in highlights and highly-reflective objects appear crisp? Or do the lighter values become muddied? Are they truly clean?

Study the four extreme corners of the image. Are these areas of the print as sharp as the center portion of the print? Are the tones at these positions as full of contrast as the center?

Next, look at the shadows. Shadow areas of a scene or set up should not be entirely black throughout. Some detail should be evidenced in all sections except those which are completely void of light.

The next evaluation criterion is perhaps the most important element in discovering an accomplished black and white expert: Does the photographer exhibit a strong sense of design? Has the photographer chosen subjects which are suitable for black and white? A masterful black and white photographer will possess a similar ability to see bold lines and blocks of shape, much like

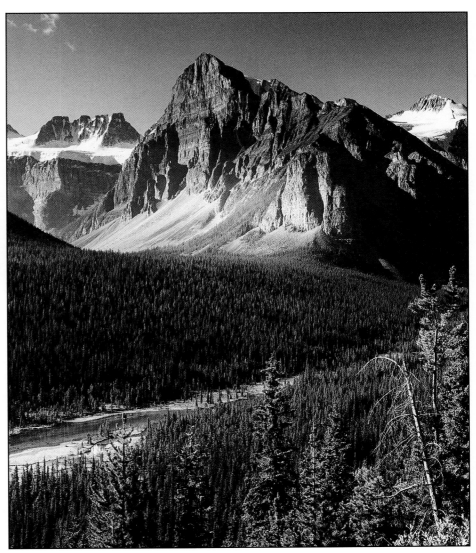

Print Enhancements This particular set of photographs illustrates the amount of enhancement a knowledgeable darkroom person can impose upon a negative in need. The smaller of the two prints was made on No. 2 contrast grade photo paper (considered normal reproduction). The actual scene in the mountains near Banff, Canada was quite hazy the morning this shot was taken. Early morning mists hang near the valley floor and as the sun climbs, the vapor rises and diffuses the light. An overall reduction of contrast is created this way, and in black-and-white photography, clear skies and bright, angular sun are a must if you intend to record a dramatic landscape in print form. I processed the films specifically with the intention of boosting the luminance range of the muted scene. But the treatment was insufficient, as you can see in the smaller print. With the next attempt I used a higher than normal contrast grade No. 3 paper. After the final version of the print has been washed free of any acidic residues left over from the fixing solution, it is soaked for three minutes in a solution of selenium toner/intensifier. This final stage of the finishing process increases the image contrast very slightly, leaving the impression of a cool, clean, purple tint. This, plus selective burning and dodging procedures to various portions of the scene, eliminates the flat, lifeless image I saw on location. Knowing that these kinds of options are available to improve print fidelity will certainly save an important negative and assignment. Mother nature does not often cooperate fully with our schedules.

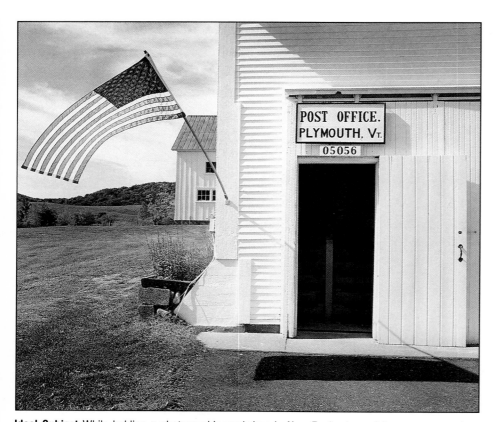

Ideal Subject While holding a photographic workshop in New England one fall, our group met to take pictures at Plymouth, Vermont. The day we arrived at this location, the sun was intense and the sky a deep cobalt blue. The brilliant white clapboard siding of this post office was what I call "radioactive." Such subjects with abundant white planes and deep shadows reproduce in black and white with the greatest illusion of sharpness. The opened stairway entrance provided those wonderful pitch black tones. The flag is the "hook" in this photograph. The winds were very light, just enough to gently lift the stiff fabric in an arc. The white stripes in the design blend with the tones of gray in the flag, making the material appear translucent. The lighting and the subject worked in unison for a perfect exposure. This print required no burning or dodging for tonal enhancement.

intensity as color materials. Instead of reproducing darker, reds and oranges tend to lighten and loose some of their impact. Also, color photos, naturally, can make use of various shades in the spectrum to impart a sense of distance within a scene. One color juxtaposed with another separates one object from the other even if those objects are similarly shaped. Effective black-and-white work, on the other hand, exploits object configuration, surface texture, reflection and background shading to define three-dimensional space. A successful composition might include white against middle gray, next to jet black, near something shiny against something rough, and so on. Of course, overlapping objects of equal reflectance value will merge when photographed in black-and-white, whereas in color they will not. An asset of black-and-white is its ability to intensify rough textures as well as shiny surfaces. Glass, metal, richly-surfaced cloth, stone and jewelry, then, are all ideal subject types.

This particular visual gift of juggling tone with texture and reflectance is keenly developed among top black-and-white shooters. Regardless of the discipline, some photographers will show a preference and prowess for specific subject matter. Still others may prefer the science of photography and will be talented at the exacting procedure in the darkroom. Another may show a talent for studio lighting combinations and insists on shooting only products, and so on. But since high-fidelity black-and-white requires hand work, the ideal shooter will produce a consistent "look" in every print made, a look which may have literally taken years to perfect.

Setting f stops, depth of field, lighting variations and ratios and administering carefully the darkroom controls specifically associated with black and white are not unlike the hand-eye skills acquired by a painter who develops his method over years of practice.

MAKING THE ASSIGNMENTS
Pre-production planning and production

an art director can when refining a sketch or layout.

An excellent way to judge the competence of photographers is to view their work in the identical manner you evaluate black-and-white illustration: Are the major design elements simple and unconfused? Is there

evidence of perspective to convey size and distance? Do the major lines in the image draw the eye within the borders of the composition?

There are certain liabilities as well as assets associated with black-and-white photography. One obvious liability, for instance, is that black-and-white films and papers do not record reds and oranges with the same

costs for black-and-white photography include all of those associated with color, including film, processing, props, models and the like. Print costs are additional. The creation of the print is valued on par with the shooting of the original scene on film. The initial evaluation process will begin with the presentation of contact prints (positive reproductions the same size of the negatives). From these small images, the art director selects the best images with a grease pencil. It is at this level the production and creative staffs evaluate the raw image. Few photo buyers will ask their photographers to provide them with positive transparencies of their black-and-whites, simply because contact sheets are easier to view and mark up. Those who might make positive transparencies from their negatives usually use them in their portfolios to match other transparencies. To make such a transparency from a black-and-white negative, Kodak's Verichrome Pan film can be used with a chemically-triggered reversal kit.

FORMAT Small format is usually 35mm; medium is 2¼-inches; and large format is 4 x 5 -inches and larger. Format choice is dependent on two important factors: the budget available for production as well as the caliber of image fidelity required for the job.

Small format cameras are the fastest and easiest to use of the three categories, and should be considered if the reproduction will be reproduced at a minimum size. Film for the small cameras is also quite inexpensive. Film costs naturally increase with larger formats, as does the time it takes to do the shoot. The larger camera formats also often require cumbersome adjustments but produce the largest original image from which to work. If your budget allows, use medium and large format when possible, as image fidelity (tone, contrast and sharpness) will be at its highest level.

SPEED Another format-related black-and-white area concerns film speed. Film "speed" is a term that defines a film's sensitivity to light. "Fast" films are very sensi-

Prehistoric Summit Rimming a lake high atop the Green Mountains in north central Vermont, hundreds of dead trees watch over the higher, rock-lined banks. Each of these wood "sculptures" has its own character. After walking for several miles in one direction and backtracking I noticed one tree that resembled a mountain. Upon first discovery, the sky was deeply overcast and the aged wood lifeless. Trusting the sun would break through eventually, I set up the photograph in the viewfinder, checked my setting for depth of field and sat down with some coffee to wait. The sun did show its face for a moment, just long enough for me to snap off about five exposures. Until I reviewed the proofs I did not notice the impression of smoke that had been created by the clouds reflecting in the waters surrounding the base of the tree. To intensify the print, substantial amounts of burning and dodging were required to put life into the root system.

tive to light, while "slow" films are less sensitive. Black-and-white films are coated with light-sensitive chips of silver. The larger the chips, the more sensitive to light they are. Average speed films carry an ISO rating of 100 or 200, while the slow, fine-grained films run with an ISO of around 50.

Films are categorized in two ways: 1) According to sensitivity; 2) In relation to how many lines per inch at which the film can resolve (clearly record). Films with a great light sensitivity generally lose resolution. The result is a rougher look photographers refer to as "grainy." A photo

project which depends upon a certain moodiness will be enhanced when shot on a grainy, light-sensitive film. Conversely, finely-detailed subjects require a slower speed film to ensure all the intricacies are maintained.

When making format selections, try to anticipate long-range applications. Though its initial function may be as a small, half-page advertisement, the client may later wish to use the image in a highly enlarged form as

Commercial Beauty This photo was a commercial shot taken for a manufacturer of fishing reels. It was taken in the studio with electronic flash and diffused lighting—glycerin was used to simulate the water droplets. Upon developing the photo, I found I had to burn in the line wrapped around the cylinder an additional 15 percent. I printed the shot using Kodak Elite Fine Art paper and a cold light enlarging source. Cold light, produced by tightly curved fluorescent tubing, is the smoothest light source available. In fact, the rich, smooth tones in Ansel Adams's prints were produced with cool light.

format cameras with TMAX 100 speed film.

EVALUATION OF FINAL PRINTS

Instruct your photographer to provide you with several interpretations of the selected image. This means acquiring a half dozen prints, each representing a range of contrasts starting with soft, low-key tones. The series should progress from that point to a final, high-contrast treatment. Several advantages are gained in having several choices at your disposal: 1) You find an opportunity to study the images that suit the client's creative direction for the client; 2) You may discover an interpretation which had not occurred to anyone prior to the shoot; 3) Knowing at least a half dozen of the photographer's preferences may trigger questions (and answers) about additional enhancements before you go to press; 4) In addition, the printer will have the option of seeing a tonal spread and can then pick the one he feels will reproduce the best.

Always keep in mind that the print reproduction process tends to increase image contrast, so you will want to submit two prints to your printer: one that is representative of exactly what you want, and a second, which may be slightly lower in contrast than the "hero" print. If any onprint retouching is required before printing, it is vital that you see a press proof of an unretouched print first. Once you are satisfied with the reproduction, hand work on that print may begin.

A final word of advice concerning your creative foray into the use of black-and-white photography: Become familiar with high-quality print tones. A great way to start is by checking to see if your library has anything published by the New York Graphic Society during the last 10 years. They typically produce works of master photographers in state of the art lithographic style. An educated eye will be your greatest asset. ∎

—*Scott Griswold*

part of a booth display at trade show time. Fast films do not readily withstand the rigors of extreme enlargement (two by three feet). For example, Kodak Tri-X is considered a very sensitive film, with an ISO rating of 400. Although it is considered low resolution by some, I find it a superb material for making enlargements up to 16 x 20-inches from a Pentax 6 x 7 medium format camera. **NEW TMAX SERIES** Eastman Kodak Company has released a negative film series called TMAX (TMAX 100, TMAX P3200 and TMAX

400). These films are revolutionary in that the scientists at Kodak have figured out a way to flatten the silver crystals in film emulsion. This results in a tablet-shaped grain that receives and responds to more light than conventional chips. Since each "tablet" of silver is flat, overlapping and uniform, graininess is no longer a concern. And a large format look can be achieved using medium

Understanding Halftone Reproduction

Knowing about density values, halftone screens and laser scanning can help you achieve high quality print reproduction.

If the printer's only concern was to reproduce type, his trade would not be nearly as difficult, challenging nor as interesting. The basis of fine printing is in the reproduction of photographs, either in full-color or in black-and-white. Much is written about the four-color process and color separations, but very little is devoted to the black-and-white photographic reproduction known as halftone reproduction.

Halftone reproduction, often taken for granted because of its very abundance, actually requires an understanding of photography, inks, paper, chemistry and the printing presses being used for reproduction.

In its most basic sense, a halftone reproduction is actually only a facsimile, made up of small, regulated dots in a pre-designated grid pattern. Our eyes take in the dots and blend them in the mind's eye into a smooth photograph. If you look through a magnifier (loupe) at any printed photograph, you will notice that it is indeed made up of these small dots. (See Figure 1.)

But why can't a photograph be printed on the paper as we see it and why is the halftone process necessary, novice print buyers or artists might ask? Because printing is an all-or-nothing process—either the press puts down an even coat of ink on the paper or it does not. Printing presses cannot differentiate tonalities or densities of black into the shades of grays we see in photographs. With the halftone process,

Figure 1 A halftone reproduction is actually an illusion. Your eyes take in the small dots which make up the halftone (left), but your mind blends them into a smooth image (right).

however, the dot pattern and the size of the dot itself and its immediate surrounding white space can be controlled. While looking at a halftone (see previous article for examples) through a magnifier, notice that the bright (highlight) areas are small black dots surrounded by a lot of white (paper). In the middle gray range (midtone), the dots are in the same position on the grid but have increased in diameter with less white surrounding. Finally, in the shadow areas the dots are very large (in most cases overlapping) with very small white areas between. By being able to control the size and placement of the dots, a full tonal range from white through

the gray scale to solid black can be achieved, overcoming the ink/no ink limitation of the press.

START WITH THE PHOTOGRAPH
In order to ensure a quality halftone, one must start with a quality photograph (remember GIGO—garbage in/garbage out). Contrast plays the most important role in a quality photograph because it visually defines details, textures, depth and dimension.

Photographs can be separated into

Figure 2 When halftones are shot, a density guide, or gray scale, that displays the entire range of density values is laid beside the photo being shot. A comparison is made between the original and the resulting halftone to ensure there is no loss of tonal values.

three categories: high-key, normal, or low-key. A high-key photograph is one that is made up primarily of highlights, a low-key is made up mostly of shadow areas, and a normal photograph is comprised of equal values of highlights, midtones and shadows. Because the halftone process causes a loss of detail, the original photograph itself must have a full range from white to black to produce an equal result.

To inspect your photographs, take a white sheet of paper and a black sheet of paper and punch holes with a paper punch in each. Place the hole in the white paper over the white in the photograph to see how "white" it actually is. Do the same with the black paper and the blacks in the photograph. If the whites and blacks are not true in the photograph, there is no way the halftone can have proper contrast. Although the halftone process can enhance or compensate for one end of the scale, it will invariably do so at the expense of the other end of the scale. For example, to get whiter whites (highlights), the result will be grayer blacks; to get blacker blacks (shadows), the result will be grayer whites or no whites at all, only light grays. And how can you expect anything to look bright and reflective without pure whites?

Photographs are either sharp or soft; that is, the gradation from a dark to a light area can either be a hard, crisp, or sharp distinction — or it can be a gradual, almost blurred, soft transition. It is easier to produce quality halftones with photographs that are sharp than it is with photographs that are soft. Send originals to be halftoned larger than the final product; the results will be sharper if reduced rather than enlarged.

MEASURING DENSITY VALUES

Ansel Adams once wrote that if we see the world in a ratio of 1:1000, the camera actually records what it sees on a scale of 1:100. Taking that one step further, when a halftone is produced using a graphic arts camera, the scale is further reduced to 1:20. This is known as adjacent tonal modulation: the compression of a smooth continuous tone (the world at 1:1000) into smaller, more defined and graduated steps (the halftone at 1:20). This compression can be measured with a densitometer, an instrument used by printers, color separators and photo labs to measure the optical density, or tonal values of photographs. The density values will range from 0.0 (pure white) to 2.0 (solid black) in .5 increments. (See Figure 2.) There are some commercial density guides with only ten (10) steps with white reading 0.0 to black reading 10, subdivided into 1.0 increments. Most printers use a guide with as many subdivisions as possible for greater accuracy.

When halftones are shot, a density guide, a strip of photographic paper with the entire range, 0.0—2.0, is laid alongside the photograph being shot. A visual comparison is made between the original and the copy made with the halftone to ensure that there was no further loss of tonal values during the halftone process. When tonal fidelity is imperative, a densitometer is used. Readings are first taken from the original and then compared to the readings taken off the halftone reproduction. During the plate-making and printing processes, the printer will again take densitometer readings to ensure that the tonal range has remained true to the original photograph, now several generations removed.

THE HALFTONE SCREEN

Halftones are reproduced with the aid of halftone screens. These screens can be made of glass or mylar, the latter being the most popular in commercial use. Most screens are known as contact screens because they are put in direct contact with the film or negative paper. (See Figure 3.)

The screen consists of a grid of vignetted dots at a predesignated measure of dots to the inch. The term "65 line halftone," for example, simply means 65 dots to the inch measured at a 45 degree angle.

The vignetted dots act like a small lens producing one dot when light passes through. Light is reflected from the photograph onto the copyboard, through the camera's lens, in turn through the screen and finally exposes the film or negative paper. The intense light reflected from the highlight areas of the photograph creates large dots; the middle tone grays reflect medium light; and in the shadow areas very little light is reflected. (Note: Since this is working on negative film or negative paper, it is the opposite of what will be seen.) In order for the negative film or paper to record the information, several exposures must be used—a main exposure, a flash exposure, which adds to the shadow areas, and a bump exposure, done with no screen over the film or paper, which produces clean white highlights. The relationship between these exposures is very important. Without added attention, halftones will produce only near whites and near blacks, actually in the range of five to 95 percent dots. When printed, the dot range may extend from 10 to 90 percent.

Experience is a critical factor that the operator must bring to halftone reproduction, for every halftone requires different exposure times based on the particular photograph and how it is to be printed.

THREE DOT SHAPES There are three halftone dot shapes available: round, square and elliptical. (See Figure 4.) Each is used for different types of presses or for special types of subject matter.

Round dots are best suited for high-speed web offset printing because the uniform round shape extends the midtone range while minimizing highlight and midtone dot gain.

Square dots, the most popular, also known as conventional dot screens, are used with letterpresses, sheet- and web-fed offset. Square dots are unusual in that

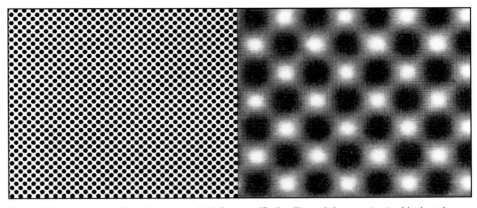

Figure 3 A photo shot with a tint screen (at left, magnified) will result in a contrasty, black-and-white shot. The vignetted dots of a halftone screen (at right, magnified) will yield a shot which contains tonal areas.

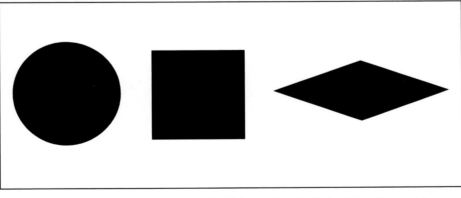

Figure 4 Round halftone dots are best suited for high-speed, web offset printing. Square dots are generally used with sheet- and web-fed offset. Elliptical dots are ideal for halftone printing in which the emphasis is in the midtones.

the dots are square-shaped in the midtones yet are round in shape in the highlight and shadow areas. The symmetrical square shape minimizes the density variations due to the directional effects and "shimmy" of the presses.

The elliptical dot, also called chain dot, offers a very smooth gradation in the midtones and is ideal for portraits or other halftones where the emphasis is in the midtones.

SCREEN VALUES The number of dots to the inch or the line screen used will determine how closely the halftone resembles the original continuous-tone photograph. The untrained human eye no longer recognizes

47

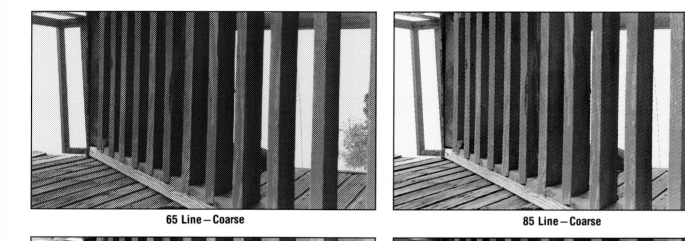

65 Line — Coarse

85 Line — Coarse

100 Line — Medium

120 Line — Medium

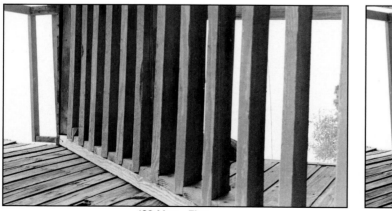

133 Line — Fine

150 Line — Fine

Figure 5 The number of dots to the inch or the line screen used will determine how closely a halftone resembles the original continuous-tone photograph. Notice how progressing from a coarse to a fine screen affects this photo's resolution.

a dot pattern once it exceeds 120-133 lines to the inch. Very fine brochures, annual reports, magazines and art prints use line screens of 150, 200 or even 300 lines (the tightest commercially available screen) to the inch. The idea is to print the smallest dot pattern possible so that the eye cannot perceive the dots at all, and thus will mistake the printed halftone for the original photograph. (See Figure 5.) Currently, there are experiments being done with halftone screens with values as high as 400 and 500 lines to the inch.

The line screen used is determined primarily by two factors: the paper it is to be printed on and the printing press to be used. Uncoated, rough stocks such as newsprint and inexpensive offset papers are very absorbent. This absorbency causes the dot of ink to spread, greatly distorting the actual value of the dot and eating up the white space between the dots. This increase shifts the halftone toward the darker (larger dot) scale. This increase in size is known as dot gain. Finer, smoother grades of paper and coated stocks have better ink holdout so that the dot is not absorbed by the stock and the dot retains its shape with little spread or dot gain. The reflective quality of the paper also affects the visual quality of the halftone. The more reflective the paper, the brighter the whites will appear.

A dull, flat, white paper, on the other hand, will make a halftone appear to have very little contrast. The whites will appear dull and gray while the blacks will seem washed out, with no depth.

The press that the halftone will be printed on will also affect which line screen is used. While most presses can comfortably print 65 to 120 line screens, a more exacting, precise machine must be used when printing very fine screens. More important, the press operator must be experienced, have a highly trained eye and know how to troubleshoot press problems as they occur. High-quality halftone reproduction is impossible if the ink/water balance is off, if there is an improper pH in the fountain, if the blankets are improperly packed or if an inappropriate choice of plates for the job has been made. The better the press and the printer, the better the make-ready in preparation for printing the specific halftone.

LASER SCANNING

Recently, stand-alone black-and-white scanners have been introduced in the marketplace to fill the growing demand for laser-scanned halftones. The results from these scanners are stunning. The scanner "reads" with a high-beam laser. Therefore, there are no lenses to go out of focus, no screens to get dirty or scratched, no negatives, no masks, no receiver papers or the necessity of intermediary steps. These scanners can be used as input units to a pagination typesetting station creating a full imaging (type and halftones) station capable of producing hard copy (paper proof), film negatives or positives, even plates with all copy in place and halftones screened and placed in position.

These systems are in great demand because the quality of the halftones is significantly superior to their counterparts produced with conventional copy cameras. Copy cameras "see" the photograph as a whole, distinguishing the highlights, midtones and shadow areas. They subdivide the whole into 10-20 gray levels. The laser is capable of subdividing a halftone into as many as 256 gray levels, with computer control of any gray tones. For example, the midtone dots can be adjusted either up or down without affecting the ratio or balance of the other areas, highlights and shadows.

Laser halftones scan the photograph raster by raster (line for line), therefore alleviating flaring problems, the "halo" that occurs when a dark area is directly adjacent to a light area. The human eye and the conventional copy camera will see a gray "halo" over the darker area that the laser will not. The scanner is also capable of selecting regular, increased or decreased sharpness. Increased sharpness enhances the edges of dark and light areas, which increases overall detail. Reduced sharpness will soften the halftone; it is also used to soften unwanted photo grain.

One of the more amazing qualities of the scanner is its ability to enlarge or reduce horizontally or vertically, independent of the other axis. If, for example, the original photograph was wide enough but not high enough, the scanner could be programmed to make up the difference. This is not recommended for halftones with humans, animals or other objects that might come out looking like a view from the carnival mirror.

Within the computer memories of these scanners are a wide variety of programs capable of copy sharpening, independent midtone control, sizing and cropping backgrounds, outlining and independent horizontal and vertical sizing. Line screens range from 65 to 144 lines. Halftones as well as a variety of special screen selections (mezzotint, posterization, solarization, wavy line, straight line) can be produced with perfect, hard dot output on paper, film or plates.

Remember, the GIGO principle is even more important for scanners. In general, though, you can expect beautiful halftones at only a slightly higher cost (30 to 50 percent) of conventional halftone costs. ∎

—Daniel Dejan

Color Halftones and Duotones

Black halftone, dense black, 200-line screen

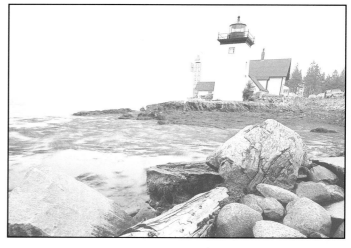

Color halftone, dark blue, 200-line screen

From halftones to duotones and tritones, a wide range of 'color' effects can be achieved.

Creative printers and designers have a variety of techniques at their disposal to extend the reach and impact of the photographic arts. For example, halftones, duotones and other related techniques can be used to achieve effects not possible with a photographer's camera alone.

HALFTONES

INK Halftones can be printed with any black ink or any other ink color that is dense enough to hold the dots in all areas of the photo. Since every area of a halftone consists of a screen value, ink colors are usually best selected by evaluating tonal values of ink samples screened 50 to 70 percent.

With inks, there is black—and then there is black. And every different formulation of black ink can change the feeling of a halftone. The addition of blue ink will give a halftone a cooler feeling; red will make it warmer.

With matte blacks, halftones should usually be shot for shadow detail. Coarser screens help prevent shadow plugging when printing with the thinner inks used for matte black.

HALFTONE SCREENS Screen rulings affect the resolution of the printed image. A general rule is the finer the screen, the better the resolution. The screen ruling used for any photo should be determined by considering operator experience, equipment capability and the nature of the photo itself.

SHAPE OF DOTS The shape of the halftone dots you choose affects the look of printed photographs, particularly in the critical midtone ranges, such as those often found in people's faces. In those ranges, elliptical dots are more likely to produce smoother transitions through the tonal scale. Square dots will generally be acceptable for photographs with a subject predominantly in the shadow and/or highlight ranges.

GHOSTING Sometimes a printer may wish to print a ghost halftone—a halftone with a shortened tonal scale which gives it a phantom appearance.

Ghosted halftones are particularly useful when type is printed over the halftone. The technique lightens the shadow areas of the photo while retaining much of the values of the midtones and highlights.

PRINTING HALFTONES Full-range photographs usually span a range of tonal values too wide to be faithfully reproduced with just one printing impression. Depending on the photo's basic subject matter, printers generally have three basic choices—to shoot for the detail in a photo's highlight areas, to shoot for detail in the shadow areas, or to shoot for some area in between. Most halftones, then, represent some degree of compromise, usually decided by whether the main area of interest in the photo lies in the shadow, midtone or highlight range of the tonal scale.

DUOTONES

Duotones can extend the depth and detail of the subject image further than halftones

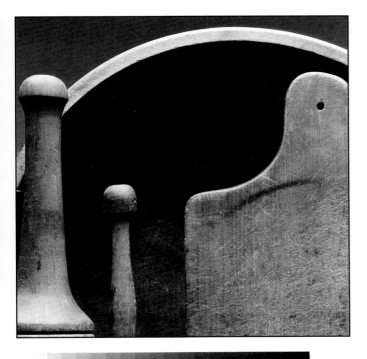

Halftone, dense black, 150-line screen

Halftone, warm black, 150-line screen

Elliptical dot halftone, dense black, 150-line screen

Square dot halftone, dense black, 150-line screen

Ghosted halftone, dense black, 133-line screen

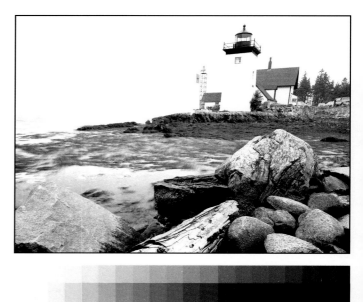

Normal range duotone, dense black and dark gray, 300-line screen

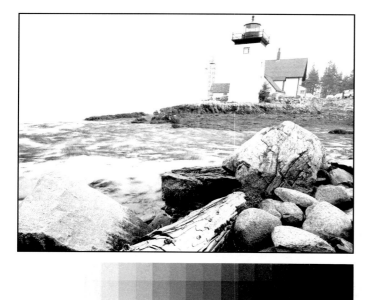

Predominantly black duotone, dense black and dark gray, 300-line screen

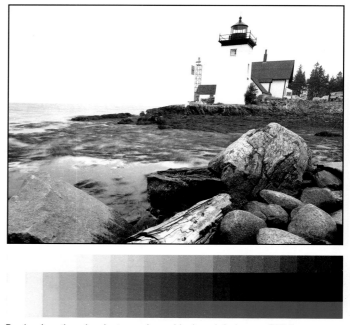

Predominantly color duotone, dense black and dark gray, 300-line screen

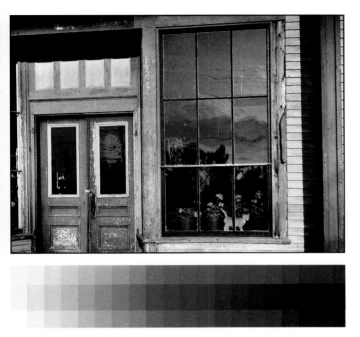

Double-dot duotone, dense black and dense black, 150-line screen

Slip-dot duotone, dense black and dense black, 150-line screen

Electronically-scanned duotone, dense black and warm black, 175-line screen

Conventional camera duotone, dense black and warm black, 150-line screen

Dense black plate

Two-color combination:
dense black and gray

Three-color combination:
dense black, gray and brown

alone. Two plates are necessary—typically one made from film exposed to show the photo's highlight details and the other shot to bring out the shadow details. Then the two plates—with their screens properly angled—are printed in register.

If black ink is used for one impression and another ink color is used on the second impression (especially on the highlight plate), the photo will appear tinted by a third color —a combination of black and the second color. Carefully selected, duotone ink colors can be used to establish moods not present in the original photo.

DOUBLE-DOT AND SLIP-DOT DUOTONES Double-dot duotones are printed with two plates to create impressions in two black inks that provide the depth and detail of a duotone without the appearance of a second color. In the slip-dot process, one exposure is made, then the film is slightly shifted for a second exposure to increase shadow density.

ELECTRONIC SCANNING Electronic scanning techniques need not be limited to four-color work. Some printers use them to attain sharper halftone and duotone images while minimizing distortion. Because of this, scanning techniques are gaining in popularity. One consideration to remember—the original photograph needs to be unmounted so it can be wrapped around the scanner cylinder.

TRITONES Tritones offer even more possibilities than duotones. They bring a third ink color into the image for a tonal shift not possible in a duotone. This third ink color is often selected to match a tone found in the original photograph, such as sepia. Three exposures and subsequent impressions are made. Frequently, the first two will be printed with black and dark gray inks to produce a conventional duotone. Then a third halftone will be printed in another ink color over the combination of the first two to create a new tone in an image already possessing excellent depth and detail.

Information courtesy of the James River Corporation/Premium Printing Papers Group.

In-House Special Effects

How to create a wide range of special effects on your own in-house camera.

The art of reproducing halftones and line copy is fairly simple, but when it comes to special effects work, most designers opt for outside sources. Yet, like halftone and line copy reproduction, special effects can also be generated creatively in-house, without any great difficulty. Whether one uses the diffusion transfer process to get paper positives, or rapid access film to produce film negatives, the methods are the same. The following techniques are those that seem to be most popular among professional graphic artists today.

OUTLINE HALFTONES

Very often a particular design calls for an image to have the background eliminated to cut down on confusing or undesirable details. If a normal halftone is made from a photograph, the background will be reproduced. If the halftone is a negative, then careful, time-consuming opaquing has to be done around the image area, leaving a hard outline. If the halftone is a stat made on paper, it can be cut out—but again, a hard outline around the image area will be formed.

A technique for removing the background is called an "outline halftone" (also known as a dropout halftone or a silhouette halftone). (See Figure 1.) There are several techniques for removing the background, but by far the simplest method is to use a mask. The mask is made from either red or amber film, which are probably more recognizable by their trade names, Rubylith and Amberlith. Though Amberlith is easier to see through, Rubylith is safer to use as some films are sensitive enough to accept light which can penetrate an amber mask. Here is the method of making an outline halftone:

STEP ONE First, the mask has to be cut and registered with the photograph. Cut a piece of masking film to the size of the photo-

Figure 1 In order to eliminate undesirable details from a photo, an outline halftone can be created. A mask is cut to cover all of the elements which must be eliminated.

graph. Register-punch them together. If no register punch is available, tape them together. Place them on a light table, either with register pins or by taping them down securely so that they will not move during the cutting of the mask.

STEP TWO Cut around the area that is to be outlined (try using a swivel blade knife instead of a fixed blade knife).

STEP THREE Peel off the background area, leaving a silhouette of the desired area. The photograph and the mask are now ready for camera work. Any darkroom camera can be used (daylight cameras are fine if their automatic programs can be overridden.)

STEP FOUR Place the original photograph on the copyboard and fix it into position with register pins or tape.

STEP FIVE Place the silhouette overlay mask on top of the original photograph so they line up perfectly and tape one edge (or use register pins).

STEP SIX Position a piece of white paper between the silhouette overlay mask and the original photograph. The white paper should cover the entire photograph.

STEP SEVEN Under darkroom conditions, position a negative in the camera, using tape or register pins. (Note: If you are using a vertical camera with a glass film plane, then tape the negative to the glass along one edge.)

STEP EIGHT Close the camera back and make a normal line exposure.

STEP NINE Remove the silhouette overlay mask and the sheet of white paper from the copyboard to reveal the original photograph.

STEP TEN Position the chosen halftone screen in place, without moving the negative that has already been exposed.
STEP ELEVEN Make a normal halftone exposure.
STEP TWELVE Remove the negative from the camera and process it.

If a film negative was used, the area not protected by the mask would have received a white exposure, darkening the negative to a solid black. The masked portion would not be exposed, leaving a clear area. The second exposure, the halftone exposure, would have added detail to the clear area, but no detail to the black area as it was already exposed. This technique works with diffusion transfer stats as well, except the end result is a paper positive halftone, often incorrectly called a velox.

GHOSTED HALFTONES

Outline and ghosted halftones are closely related. Sometimes the background image is required, but it needs to be fainter or softer than the main image area. Ghosted or phantom halftones are used to produce this effect. (See Figure 2.) As in the outline halftone technique, a mask is needed and is made in the same way. It is in the exposure sequence that the technique changes for ghosted halftones.
STEPS ONE THROUGH THREE Follow steps one through three in the outline halftones section just described. For camera work, any regular darkroom camera can be used. (Daylight cameras are fine as long as their automatic programs can be overridden.)
STEP FOUR Place the original photograph on the copyboard and fix it into position either with register pins or tape.
STEP FIVE Under darkroom conditions, position the negative in the camera using tape or register pins. (Again, if you are using a vertical camera with a glass film plane, tape the negative to the glass along one edge.) Position the chosen halftone screen in place.
STEP SIX Make a normal halftone exposure.
STEP SEVEN Remove the halftone screen. (Note: The screen can be left in place, but the next exposure has to be greatly increased.)
STEP EIGHT Place the silhouette overlay over

Figure 2 If the background of a photo needs to be fainter or softer than the main image area, a ghosted halftone is created. Again, a mask is created to cover up the background.

the original photograph so that they line up perfectly and tape one edge down (or use register pins).
STEP NINE Position a piece of white paper between the silhouette overlay mask and the original photograph. The sheet should cover the entire photo.
STEP TEN Make an exposure, the length of which will determine the amount of ghosting in the end result. The longer the exposure, the fainter the background will become. If the screen was left in place, the exposure time should be longer. If the exposure time without the screen is too short, then the aperture on the camera can be stopped down to a lower f number. Also, a neutral density filter (N.D.) could be used to increase the exposure time.
STEP ELEVEN Remove the negative from the camera and process it.

The technique can be used with film negatives or diffusion transfer materials. If a film negative was used, then the areas that received a second exposure will be darker. When printed, the positive will have light areas around the image as the darker areas of the negative hold back more light.

HINTS

Even though a mask is used, hard edges around the image area may appear. To avoid this, a spacer can be used between the mask and the white paper.
SPACERS This spacer works in the same way as the spacer in spread and choke techniques. The spacer is a piece of clear film. In fact, the clear film receiver sheet used in diffusion transfer could be used. By separating the mask from the white paper slightly, the lights from the camera undercut the mask, lending a softer edge to the image area. This technique is useful when the original is a pencil drawing, soft watercolor or pen-and-ink illustration. The thicker the film, the more undercutting; but there are limits to the thickness that can be used.

Register pins will give a more accurate result as well as saving time, but use low-profile pins under the copyboard glass to avoid cracking the glass. There are less expensive plastic register pins also available for low-profile work.
SPREADS AND CHOKES Photographic techniques for making thicker or thinner line images are called spreads and chokes and they are generally done with the aid of a contact frame. These modified images are normally used to produce overlaps (bleeds) be-

Figure 3 Special effects screens, like this mezzotint screen, come in a complete range of percentages and can be used on any good quality photo in the same way as a halftone screen.

tween two colors for easier registration. This technique is also used to produce larger or smaller halftone dots after the initial halftone negative has been made. Images that are made fatter or thicker are called "spreads." Images that are made narrower or thinner are called "chokes." (Some use the terms "fatties" and "skinnies.") Putting a clear piece of film between the mask and the white paper permits the light to undercut the mask and "choke" the effect of the mask at the edges, thus reducing their sharpness.

SPECIAL EFFECTS SCREENS

Special effects screens can be used with continuous-tone photographs to create new images instead of using conventional halftone screens. These cannot be varied through changes in exposure as with halftone screens. Not only can photographs be used with these screens, but type and logos can be employed. When used with type or logos, these screens are more commonly known as tints. Mezzo, wavy line, straight line, weave and circles are just some of the most common tints or special effects screens that are used. (See Figure 3.) Dot size is ex-

pressed in percentages, such as 75, 70, 65, 60 and 50 percent screens. Special effects screens come in a complete range, though—from 90 to 10 percent.

WITH PHOTOGRAPHS If a continuous-tone photograph is copied on a camera using a high-contrast film, such as any regular line film, then the resulting image will have a very graphic quality (high contrast), but will lack detail. The image will display black areas with white areas—there will be no tone. (See Figure 4.) However, if a special effects screen is used, then the image area will be broken up. Which area, black or white, will be broken up depends on which technique is used. If a line copy is made and is followed by a flash exposure, then the black areas will be broken up into a tint and the white areas will remain white. If a line copy is made with the screen in place without a flash exposure, then the white areas will be broken up into a tint and the black areas will remain solid.

The working procedure for screened or

tinted black areas with clear white areas is the same as for tinted type on a white background. For tinting or screening white areas, the method is the same as that for tinted backgrounds. These two techniques follow.

TINTED TYPE ON A WHITE BACKGROUND Most designers who wish to tint type with a texture or dot pattern generally send the job out or use rubdown tints, when in fact the job could be easily generated in-house on their stat cameras. Instead of using the rubdown tints, if the work is done photographically, the screen tints can be used over and over again, any size type can be produced, and the most intricate type or logo can be quickly tinted.

STEP ONE First, the type or logo to be tinted is typeset or drawn, size being irrelevant as the camera can be set to any size. Then position the type or logo on the camera copyboard and set the camera to the desired size.

STEP TWO Under darkroom conditions, position the negative in the camera. (Any darkroom camera can be used. Daylight cameras can be used if their automatic programs can be overridden.)

STEP THREE Close the camera back and make a normal line exposure.

STEP FOUR Open the camera and place the tint screen so that the emulsion side of the screen is in contact with the emulsion side of the negative. (Note: Halftone screens can be used for dot patterns, but a longer exposure time is required.)

STEP FIVE Cover the copy on the copyboard with a sheet of white paper the same size as the negative.

STEP SIX Close the camera back and make a normal line exposure again on the same piece of film that was used in step three.

STEP SEVEN Remove the negative from the camera and process it. A tint will appear in the type or logo.

Any kind of tint, texture or dot percentage screen can be used, but if fine detail is in the original, a coarse tint screen will break up the image too much and destroy the legibility of the type or logo.

TINTED BACKGROUND Instead of the type or logo being tinted, the background can be tinted. The desired tint, texture or dot percentage screen is selected so that it does not

break up the image or the type. A halftone screen can be used for dots, but the exposure time would have to be increased.

STEP ONE Position the type or logo on the camera copyboard and set the camera to the desired size.

STEP TWO Under darkroom conditions, position the negative and the selected tint screen in the camera and close the camera.

STEP THREE Make a line exposure of double the normal line exposure time. (This time is approximate since it depends on the density of the tint screen.)

STEP FOUR Remove the negative from the camera and process it. A tint will appear in the background and the type will be solid black.

If white type on a tinted background is desired, then follow the same technique as tinted type on a white background except use a reversal negative instead of a normal negative.

LINE CONVERSIONS

An illustration or photograph contains a full range of tones, from white through various shades of gray to black. In graphic reproduction, a normal black-and-white or color photograph is referred to as a continuous tone to distinguish it from a halftone. A halftone is called a halftone because approximately half of the tones from the original are reproduced by using a screen.

Instead of making a halftone from the original continuous-tone image with a screen, a line shot is made. (The same line negative can be used for line work or halftone work.) Since this negative is of a high contrast, the resulting image will have a very graphic quality, but will lack detail. Instead of the subtle grays, the image will display black areas with white areas; there will be no tones. This process is usually known as "Line Conversion." As with tinting and special effect screens, not all photographs are suitable for this treatment. Photographs that have a broad tonal range, but still have some contrast, are best suited for line conversion.

A test exposure has to be made first to determine what effect the line negative will

Figure 4 A line conversion, shot with high-contrast line film, results in a very graphic image that carries no tones, only solid blacks and whites.

have on reproducing the original photograph's tones. A good starting point is the normal, correct line exposure for the negative being used.

STEP ONE Position the original continuous tone photograph on the copyboard.

STEP TWO Under darkroom conditions, position the negative in the camera. (A daylight camera can be used for this technique.)

STEP THREE Close the camera back and make a normal line exposure.

STEP FOUR Remove the negative from the camera and process it. Examine the result as compared to the original. If the result is too dark and lacks detail, either the photograph is not suitable for this technique or the exposure has to be adjusted.

If you are using diffusion transfer materials in order to lighten the exposure, increase the exposure time from one-and-a-half to three times more. If you are using normal line film, then decrease your exposure from one-and-a-half to three times less. The correct exposure depends on the degree of detail you desire. Experiment with different exposures until you find the one that best

suits your needs or style.

HINTS If the effect you want appears on several exposures, then cut out the areas you desire and paste them together in a montage and re-shoot the result. This technique works best if you are using diffusion transfer paper prints. A flash exposure, the same type used to make halftones, can be used to reduce the amount of "blackness." If the line conversion was made on diffusion transfer matte or semi-matte paper, then retouching with pen and ink is easy and border line detail can be enhanced.

POSTERIZATIONS

Posterization is the process of separating tonal areas from an original black-and-white photograph. A high-contrast line negative is used such as that referenced in the line conversion technique. Instead of making just one line shot on the original continuous-tone photograph, four shots are made—underexposed, slightly under-exposed, slightly over-exposed and over-exposed. These four separations are re-photographed onto a piece of continuous-tone material. This style is sometimes called reassembling. The resulting print still shows most of the detail,

Figure 5 A posterized photograph carries most of the detail of the original, but the tones have been separated, making one negative for each flat tone. The negatives are then reassembled.

but now the image is separated out into its tonal areas. (See Figure 5.)

In order to keep the negatives or diffusion transfer prints in register, the use of a registration punch and register pins is highly recommended. Tape can be used to line up the separations, but this tends to lead to misregistration and frustration, not to mention a waste of time and materials. The method described here employs diffusion transfer materials, but film negatives can also be used.

STEP ONE Position the continuous-tone photograph on the copyboard.

STEP TWO Under darkroom conditions, position the negative in the camera. (Daylight cameras can be used for this technique if they have a multi-exposure mode.)

STEP THREE Close the camera back and make a slightly longer than normal line exposure.

STEP FOUR Remove the negative from the camera and process it with a thin-base receiver sheet.

STEP FIVE Repeat step two.

STEP SIX Close the camera and make a longer than normal line exposure (approximately three times longer.)

STEP SEVEN Repeat step four.

STEP EIGHT Repeat step two.

STEP NINE Close the camera back and make a slightly shorter than normal line exposure.

STEP TEN Repeat step four.

STEP ELEVEN Repeat step two.

STEP TWELVE Close the camera back and make a shorter than normal exposure time (approximately half the time.)

STEP THIRTEEN Repeat step four. You now have four line conversion paper stats, each one representing a different tonal area of the original. The prints can be washed and dried at this point, especially if you wish to enhance or retouch any detail with a pen and ink.

Line up the separations on top of each other using a light table. Thin-base receivers were used to make this task easier, but regular base material could be used (negative alignment is, of course, the easiest, but it is more prone to fingerprints and scratching and is harder to retouch). When they are all aligned, register-punch them all together at the same time. The next step is to re-photograph or re-assemble the image onto a piece of continuous-tone material. Four exposures are made onto a single piece of continuous-tone material.

STEP FOURTEEN Position the darkest separation on the copyboard using register pins. (Tape can be used, but it is not accurate.)

STEP FIFTEEN Under darkroom conditions, position the continuous-tone negative in the camera. (Daylight cameras can be used for this technique if they have a multi-exposure mode.)

STEP SIXTEEN Close the camera back and make the first exposure (approximately one-quarter of the normal continuous-tone negative exposure).

STEP SEVENTEEN Repeat step one, but use the next darkest separation.

STEP EIGHTEEN Make the second exposure (approximately one quarter of the normal continuous-tone negative exposure.) Do not remove the negative.

STEP NINETEEN Repeat step one, but use the next darkest separation.

STEP TWENTY Make the third exposure (approximately one quarter of the normal continuous-tone negative exposure.) Do not remove the negative.

STEP TWENTY-ONE Repeat step one, but use the last separation.

STEP TWENTY-TWO Make the fourth exposure (approximately one quarter of the normal continuous-tone negative exposure.)

STEP TWENTY-THREE Remove the negative from the camera and process it with a receiver sheet.

Your finished posterized print should have the tones reproduced in black, dark gray, mid-gray and white areas. If one of the tones is missing or if one tone is too dark or too light, adjust the exposure for that print. Remember, with diffusion transfer, shorten the exposure to darken the image and increase the exposure to lighten the image. (The reverse is true when using film negatives.)

HINTS Once you have found the correct exposure ratios for each separation, write them down for future reference. Use low profile pins on the copyboard so that the glass will not be damaged. If a negative method was used, then re-assembly of the image can be done in a contact frame. ∎

—*Robert Dainton*

Art Prep for Specialty Processes

*Discover how to make
these unique applications
complement your design.*

Most designers quickly learn the ins and outs of printing because they deal with it almost from the time they start doing collateral design. But the specialty processes of engraving, embossing, thermography, leaf stamping, die cutting, silk screening, laser engraving and holography are not used as often and, therefore, the designer may not take the time to totally understand these processes. To understand them is to better take advantage of them in the creative process. Each process has its advantages and its limitations. Each will contribute a new dimension to your design work, each deserves your time.

If you are working with one of these processes for the first time, take the time to visit craftsmen and their plants. Look at samples of their work, question them about each step of the process, particularly those steps dealing with your artwork. Collect samples for your files—these can be used when presenting your proposals to your clients. Understand the time frames required for each step of their process and allow for those time frames in your work schedule. The end result will be outstanding use of the processes in support of your design efforts.

The following chart will help you understand the process, the art preparation and comping techniques, special considerations for use and the paper selection factors for each specialty application. ∎

—Murray Grant and Michael Scricco

THE PROCESS	ART PREPARATION
DIE CUTTING—Sharp, steel rules are positioned in a wooden die and are used like a cookie cutter to cut special designs and shapes out of paper. The die cutting process offers precise edges and can render spectacular visual effects or functional effects. Its reasonable price makes it an attractive design element for clients on a modest budget.	• Black-and-white camera ready art. Avoid placing die cuts too close or on the edge of the paper. • When die cutting portfolios or similar projects, consider using all of the paper. This can turn a simple one-pocket portfolio into an unusual, more dramatic presentation. Consult with your die cutter and printer on how to use the full press sheet.
ENGRAVING—The Rolls Royce of embellishments, engraving is the most elegant process you can use. It adds a sophisticated look and feel to a client's business correspondence. The effect is produced by first etching a design into a copper or steel die. Depending on the design, the die is either machine-tooled, acid-etched or hand-tooled. During make-ready, a heavyweight bristol counter die is prepared on press. The etchings in the plate are filled with ink and the paper is then forced against the die, lifting the ink out of the plate and creating a raised image on the sheet. Best suited for fine, delicate lines and small areas, engraving is often used to provide texture and contrast to a design, or when the image is small but very detailed, like an etching. Since the metallic inks used in engraving are the most realistic, the process is ideal for simulating the look of metal products.	• Black-and-white line art. Use overlays only to show color breaks. Specify ink color and paper selection. • Keep the image in a 4 x 8-inch or 5 x 9-inch area (the size of the engraver's plate.) • Avoid large, solid blocks which could cause ink voids in the engraved image. • Halftones can be reproduced. • The engraver can handle tight registration.
LASER ENGRAVING—This is a process of cutting paper with a laser for special effects or intricate details. A brass plate is immersed in a chemical bath which etches unexposed areas of the image to be reproduced, creating a template which masks paper during a laser scan. This template is dropped and registered into the laser machine. Vacuum feeders then pick up paper and drop it into a 90 degree registered corner below the template. The laser scans the open ends of the template and evaporates the exposed paper.	• Begins with camera-ready high-contrast black-and-white line art. • The image is stenciled and photostatted to produce the art which is then converted into two film positives. Can be done one at a time or two-up, three-up, and so on. • Film positives are exposed on both sides of a brass plate to transfer the stenciled image.

SPECIAL CONSIDERATIONS	HOW TO COMP	PAPER
• Consult die cutter when using delicate, lacy or unusual patterns. • To avoid problems, consult printer or die cutter before presenting comp. • Sharp points can turn out ragged. • Too many die cuts in a single sheet can result in a flimsy-feeling product. • Envelopes are generally converted after die cutting.	• Use your trusty X-Acto knife. • Create as accurate a comp as possible in order to identify fatigue spots. • Consider how printed piece is to be used—and ask questions like: Will die cuts tear, hang up on an envelope, and so on.	• All cotton fiber bond and writing papers will accept the die cutting process. The heavier the weight of the paper, the better the end result. • Text and cover papers are widely used in die cutting with cover weights preferred. • Coated papers are also widely used in die cutting, again with cover weights preferred.
• One plate and one pass will be required for each color. • Engraver's inks do not coincide with the litho printing ink colors, but any color can be matched as long as you provide a sample. • Normally paper color will not affect the color of the engravers inks because the inks are completely opaque. • Because of this opacity, engraving cannot accommodate color processes or traps. • Engrave envelopes after converting to ensure consistent placement of the image. A slightly debossed image will appear on the back of the envelope—in some cases, envelope flaps can be lifted during engraving. • When requesting estimates, remember, dies are a one-time cost. Engravers can easily provide a die strike or proof before going on press. • For fine lettering avoid metallic inks since they will appear grainy.	• You can use clear nail polish or dry transfer sheets, but because of the delicate nature of engravings, simply showing the customer examples of the effect you wish to accomplish would be better. For artwork, Elmer's Glue used with colored dyes will provide a feeling of the effect.	• For letterheads, any cotton fiber bond or writing paper in Wove or Laid can be used with this process. Twenty-four pound is preferred by most engravers. • Medium to deep colors of paper may be used with the engraving process since the inks are opaque and the ink lay is intense. • Although rarely used, coated paper may also be engraved.
• Process can be slow (2,000 to 8,000 sheets per hour)	• Comp as you would for black-and-white line art, the black area being the lasered area.	• Can be done on 20 lb. bond paper up to 110 lb. cover stock. • Papers that cannot be laser cut include 100 percent synthetic stocks, stocks laminated with synthetic materials and fine grades of tissue paper.

THE PROCESS	ART PREPARATION
EMBOSSING—Using a specially crafted metal die, heat, pressure and a counter die, this technique reshapes and remolds the paper.	• Black and white art is required. • Since finished embosses look slightly smaller than original art, compensate by increasing the size of your artwork or type. • Rules should be at least 2 points in thickness or more. • Space type out a little more than normal to provide room for beveling to a greater depth. • Indicate beveled edges or round edges as part of your specification. • Drawing a side view or shading a copy of a line drawing is also helpful to the die maker. • If the emboss is a picture, give the embosser both a line drawing and a photograph of the object. • For multi-level or sculptured dies, use color-coated overlays to indicate various levels. • If the emboss is meant to register to four-color printing, one of the dominant screened four-color negatives should be supplied to the die maker. • Small elements placed too close together will not have sufficient room to form. • Wrinkles and puckers could occur if designs are placed too close to the edge of the paper. • Envelopes can be converted before embossing unless the design cannot appear on the back of the envelope. • Release your artwork for embossing before the rest of the job is released. This provides the die maker with additional time for making the die and gives you time for critiquing the first proof, which allows for changes or added depth to be worked into the die.
SCREEN PRINTING—A hand-cut or photographic mask is made and adhered to a synthetic or metallic fine mesh. Ink is "squeegeed" across the surface and is transferred through the open areas of the screen to the image below.	• Camera-ready black and white artwork. • Avoid very tight register. Avoid extremely fine line rules. • Large ink areas may spread slightly. Take this into consideration when preparing artwork. • Save money by separating your artwork for each color. • Halftones can be used with coarse screens.

SPECIAL CONSIDERATIONS	HOW TO COMP	PAPER
• The embosser can emboss and deboss in the same impression, in most cases. • The embosser can also foil stamp in the same impression, but must cover all of the artwork with foil; otherwise, the foil would be put down first and the embossing in the second impression. Consideration should be given to how the finished embossed piece will be used since it can be crushed in duplicating or word processing equipment.	• Cut the image out of illustration board pasted on top of another board, place your sample paper over the image and rub. • Put color down first, then burnish (for debossing use the negative space). • For large areas, cut the desired images from separate sheets of paper and lay them one on top of another. • For intricate patterns, lay the page over foam core or corrugated cardboard and press on the sheet with a dull instrument.	• Any cotton bond or writing paper will accept the embossing process beautifully. As a rule of thumb, the heavier the weight of the paper, the more fibers the embosser has to work with, therefore a 24 lb. is preferred. • In text and cover papers, the embosser can remove the finish of the paper, thus creating a greater contrast in the embossed area. • When using a medium to dark color of text and cover paper, the embosser can run the embossing dies very hot, thus changing the color of the paper (darkening it), providing even greater contrast between embossed and non-embossed areas. • All intricate embossing requires the use of heat with the die. The exception would be when cast coated paper is specified. • High gloss or dull coated paper is also frequently embossed; however, extremely deep embossing may crack the surface.
• A screen printer uses a variety of mesh sizes depending on the fineness of your work. They do not use lithographic inks or ink systems but can match ink specified using such systems. • Actual color press proofs are easy to make and important for you to work with to test color and ink laydown. • Because of the amount of ink put down, opacity is extremely good. • Inks can be specified from dull to glossy.	• Regular comping methods generally work, although I.N.T.™ custom transfers or Chromatec® sheets can be used.	• Although normally used for letterhead work, cotton fiber bond and writing papers will support screen printing. • Screen printing is an ideal method for small runs using text and cover papers, particularly when trying to achieve an opacified ink color on a deep color of paper. These papers also are often used as the background for screen printed, limited edition art subjects, posters, and so on. • Coated and uncoated papers are used for screen printing. High-gloss spot laminates may be screened on dull coated sheets for contrast.

THE PROCESS	ART PREPARATION
THERMOGRAPHY—In this process, paper is printed with slow-drying rubber- or oil-based inks which are dusted with a resinous powder (dull, gloss or semigloss) while still wet. Excess powder is vacuumed off, and the sheet goes into a heat tunnel where the powder melts, fuses with the ink and swells to create a raised surface. With refinements in powder and equipment, thermography now offers designers the ability to do fine lines, solids, screens, special textures and one-, two- or four-color work.	• Provide good black-and-white artwork. Use an overlay to show those areas that you wish to have thermographed. • Avoid tight elements and small type as they may fill in with powder. • Clear powders can be used to achieve a transparent or glossy look of varnish. • Designs that bleed should be avoided with this process. When designing letterheads, keep thermography out of the ''fold'' areas of the letterhead. • Break up large, solid areas to prevent a blistering effect.
LEAF STAMPING—First, a metal die (usually brass) is made from supplied art. These can be flat stamping dies or combination dies (stamping and embossing in one press run). Then, by heating the die to a specified temperature, the impression transfers a pigment coating from a roll of polyester carrier film to the paper. Foils are available in many styles: metallic, dull and glossy colors, pigment, pastel, clear, shiny, satin, pearl, marble and even wood grain. All create a smooth opaque image in fine lines or solids, allowing the color, texture and finish of the paper to contrast beautifully with the design.	• Black-and-white, camera-ready art should be provided. • Avoid design elements that are close together. Foils tend to ''bridge'' across narrow spaces. • Avoid tight kerning and fine type. • Stamping too close to the edge of the paper without bleeding off the page may cause wrinkles or puckers. • When using combination dies, the entire embossed image must be stamped. Dies are a one-time cost so they may be prorated for repeated runs.

SPECIAL CONSIDERATIONS	HOW TO COMP	PAPER
• The use of heat and powders in the process may alter the color of litho inks. Consult with the thermographer concerning unusual ink color specs. • A variety of differently sized powder granules are used by thermographers depending on whether they are running heavy or light work. • Envelopes can be converted before thermographing so flap and face can be printed at the same time. • Most thermographic presses are one- or two-color and are built to accommodate letter size sheets one- or two-up. • To achieve more than 2 colors, first print the number of colors required, including four-color process, then thermograph using clear varnish to trap the powder.	• Use Elmer's Glue or rubber cement and add color using dyes or inks. • Use clear nail polish over artwork.	• All cotton fiber bond and writing papers will accept thermography. • Both coated text and coverpapers will accept thermography, although deeply textured, "toothy" papers may sometimes trap powder in non-printing areas. • The thermographer should be told if the finished letterhead will be used in laser copiers or printers.
• Foil can be used over lithographic ink and vice versa, but special lithographic inks are required. • Foils are repelled by heavy offset sprays, inks containing wax, silicone or plastic, and varnished papers. • Foils may appear darker or lighter on various paper backgrounds. • Avoid using dropouts in the solid ink background. They require hairline register of foil stamping. • Envelopes are converted after stamping only if an impression of the image is objectionable on the back of the envelope. • The foil stamper has the capability of proof testing to assist you in proper foil selection. • In some cases, more than one color of foil can be stamped in a single impression if your layout provides room between elements. Consult your foil stamper before designing. • Metallics stamp cleaner than pigments. • Pastel leafing works best with sculptured dies.	• Use I.N.T.™ custom transfers or Chromatec® sheets. • Metallic pens or glazed paper can also be used to simulate leaf stamping.	• Cotton fiber bond or writing papers are very compatible with leaf stamping. • As with embossing, a unique contrast between the texture of text and cover paper and the smoothness of leaf stamping may be desirable. • Because of the opacity of this process dramatic results can be achieved with textured, colored papers. • Coated papers also accept this process well.

THE PROCESS	ART PREPARATION	SPECIAL CONSIDERATIONS	HOW TO COMP	PAPER
HOLOGRAMS—Two- and three-dimensional holograms are made from flat art by recording the flat art elements in different planes (foreground and background), producing a two- or three-dimensional image from a laser and high-resolution, light-sensitive plate. Color is first separated into high-contrast masks made for the four colors. A glass plate is then exposed sequentially through each mask by laser beamed in at slightly different angles for each color, diffracting the light. A metal plate is then made from the glass plate and is used to emboss design onto mylar or foil.	• Try starting with line art that contains some stripping and shading. This will provide added dimensionality. • View individual color separations to get a feel for using holographic colors available for final specification. Color use will affect success of hologram, adding energy and flash to line art and giving a kinetic effect when colors shift. • Background can be shot in one color, the line art can be reversed or dropped out to provide a shadow-box effect.	• Busy or detailed designs will not reproduce well. • Line art with open areas for color will reproduce the best.	• Two sets of comps necessary. The first comp should be a head-on view of overall subject. Second comp should be an overhead view of each plane.	• Two- and three-dimensional holograms are embossed into polyester (mylar) 2 ml thick, usually with an adhesive backing, or into conventional foil stamping base. These can then be stamped onto paper.

66

COLOR REPRODUCTION

Your job does not end when you hand camera-ready art to your color separator. Color reproduction technology improves every day, and these advances affect the way in which you work. Electronic scanners ''see'' differently than the human eye, for instance. "I received a Cromalin proof from a separation of an illustration of Pinocchio," says one art director. "Due to the dyes used by the illustrator and how they separated, it looked as if Pinocchio had a bad skin condition." Another designer shares the story of her surprise upon discovering that her printer was laying down color in an order that did not match her film, to the detriment of the final product.

Problems like this will occur despite your most dedicated efforts. This section, with up-to-date guidelines on viewing and evaluating color and separations, using match colors, as well as pre- and on-press color correction, will help you determine why they occur and, most important, how to correct them.

Evaluating Color Transparencies

Judge the suitability of your transparencies for reproduction.

Long before the arrival of the first megabyte, the graphic arts industry knew all too well the computer expression "GIGO" —garbage in, garbage out. It does not take a computer whiz to learn quickly in this business that if you fail to provide top-notch transparencies to your color separator, you will get less than pleasing results back. Because aside from all the controllable variables involved in getting color images on paper, there are just as many uncontrollable ones. Therefore, knowing how to judge the quality of a transparency before it is separated can spare you some expensive disappointments.

Before you can learn the following four-step method of color transparency evaluation, though, it is important to understand why one "uncontrollable" in the lithographic process can affect the outcome of your color images.

TONE REPRODUCTION COMPRESSION

Because the range between highlight and shadow on a transparency well outdistances the range that is reproducible with standard printing inks, the vibrant colors in a transparency cannot be duplicated in print. For example, a transparency's range can be as much as 500 to 1, whereas the range of printing inks is only 100 to 1, or as little as one-fifth of the range of a transparency. To accommodate this limited range, color separators must compress the transparency's tonal range—the area bridging the lightest highlights to the darkest shadows—into a reproduction curve.

Since this process, called tone reproduction compression, is a rather subjective one, the integrity of the original art can suffer if the color separator is not sensitive to the highlight end of the range, which the human eye usually sees first. Add to this a poor original and it is more than likely that the impact of the original will not withstand the rigors—and inherent deficiencies—of the entire printing process.

CHOOSING THE IDEAL

Because client directives as well as personal taste play a large role in a creative's selection process, the "ideal" shot for one may not be as appropriate a choice for another. But most photographers, art directors, designers and editors have little trouble agreeing on

Figure 1 This shot works well for reproduction as it contains data on all points of the tonal range: highlights, ¼ tone, ½ tone, ¾ tone and shadow. Consequently, there is good definition between the dark background and the darker colors of the laces and socks. Put your glass on small detail areas, such as the stitching on the sneakers or the ribbing on the socks, and you will see that the reproduction is crystal clear. The main light source was scrimmed (a card was placed between the main light and the subject) to hold back the light and help balance the exposure. The photographer also used a background light to create a glow on the black Formica background, which adds a feeling of depth and provides subject and background separation.

Figure 2 Can you find what is wrong with this transparency? In this example, we have purposely damaged the good transparency to illustrate some common problems. First look at the top of the sneaker and you will note there is a hole caused by a paper clip. If this transparency had been enlarged to any extent, that tiny hole would have also been enlarged, making it more difficult for the damage to be ''tooled out.'' Tooling refers to the hand work done in a separation plant whereby each printing dot is meticulously repaired to minimize and, often eliminate the damaged area.

the universal characteristics of a transparency which ensure good color reproduction.

1. Sharpness throughout the subject.
2. Good highlight and shadow detail.
3. Moderate tonal contrast (information should exist at all points in the tonal range).
4. Adequate tonal modeling (there should be adequate definition when the eye travels from one point along the tonal range to another). (See Figure 1.)

Before you begin your search for the ''ideal,'' however, you must make sure you have the proper viewing tools.

THE PROPER TOOLS

START WITH A GOOD GLASS First, you need to purchase a good magnifying glass with at least 10-power magnification. Linen testers, although quite inexpensive at $10 to $15, usually only provide 5-power magnification, which is simply not enough to provide you with the detail you need to inspect smaller format photography, like 2¼-inch or 35mm, for example.

Two factors which determine the price of magnifiers are the power magnification and the design of the glass itself. A good 10- to 12-power glass can range anywhere from the relatively inexpensive Dico models, costing $15 to $30, to the more expensive Pre-Cop-Tic and Paragon brands, costing upwards of $50 to $60.

Most designers favor a swivel-arm magnifier, since this type of glass will rotate to any position and is free of distortion. But these models also cost the most. The highest priced magnifiers also offer the ability to fold up the glass, thus keeping it free of dust and scratches. If you will be carrying your glass to various printers, separators and photographers, it would be a wise idea to pay the additional money for a fold-up model.

DEVELOP A VIEWING AREA Once you have a good glass, you should use it to examine materials in a properly illuminated viewing area. The printing industry has adopted the 5,000° Kelvin lighting standard for specific color temperature. This standard was developed by the American National Standards Institute (ANSI). The Institute warns, however, that it is not enough to have a light bulb or tube that meets the standard. You must also make sure that the color temperature also prevails at the actual viewing surface where the transparency is read. There should be at least several inches of illuminated surface surrounding the transparency as you view it.

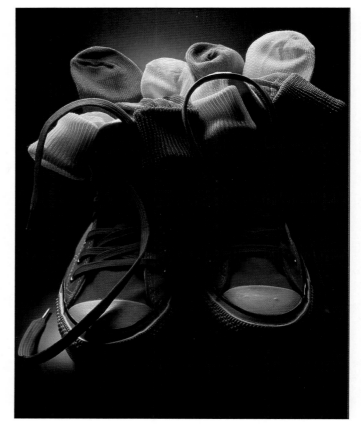

Figure 3 One of the most common transparency deficiencies is an out-of-focus shot, which can be attributed either to focus sharpness or camera movement. In this case, the problem was caused by lack of focus sharpness. Since most transparencies are enlarged and then screened for reproduction, a loss of definition will result from this focus problem. The final reproduction will lack contrast and appear flat overall, as you see here. For example, the sneakers, socks and background lack snap and punch. Overall color saturation is poor. Texture, tonal variety and depth are totally lost.

Figure 4 This high-contrast shot demonstrates lack of detail at all points in the reproduction curve. Because all of the information is compressed into either the highlight or shadow areas, rather than throughout the printing range, the highlights are ''blown out'' or ''burned out.'' The socks now appear a pale yellow and lack detail. At the other end of the range, it is impossible to perceive differences between the sneaker and the background, because the sneaker has now melded into the background. Since the scanner can see deeper into an area than the human eye, it will try to increase the definition between the background and the sneaker. In doing this, however, you will begin to see harsh breaks between bright, vibrant colors such as the red in the sneaker, the blue laces and the black background. In contrast to the lighting used in Figure 1, this transparency was created with a smaller, more directional source which covered a more limited area.

Figure 5 Because the human eye is most sensitive to the highlight area, highlights should never be compressed. Notice how the overall color saturation suffers, especially in the burned out area of the socks. The reds are diminished and the blue has gone pale and the colors lack vitality. Modern scanning equipment is capable of putting weight back into the subject, so the corrected separation could make the color look richer. Yet the scanner cannot put detail in, so there still will not be any folds in the sock or definition in the subject in the corrected transparency. Also if the scanner operator had tried to correct this, the middletone to shadow range (the sneakers and background) would have lacked definition. To create this problem, the photographer moved the light source to the top of the subject and removed the scrim, resulting in an overexposed, high-contrast shot.

Obviously, purchasing a viewing booth is the easiest way to implement the lighting standard. You can purchase 5,000° Kelvin viewing booths from several graphic arts manufacturers, including Acculight and Macbeth. The 31 x 52-inch viewing area, which is most popular, costs approximately $1,200 to $1,500.

A less expensive alternative is to purchase modular units: the lightbox and overhead fixture. Then you can paint your existing walls a neutral gray. This set-up will probably cost you approximately $300 to $500 for the light box, another $300 to $400 for the overhead fixture and around $30 for a gallon of paint. (Make sure you buy the paint from a graphic arts supplier.

If you already have a light box, you can merely outfit it with the GE Chroma 50 bulbs, for example, and you can implement the lighting standard using your light box, a standard overhead fixture, and painting your walls for approximately $100.

When you think of the cost of an average color separation at $150, you can see that the investment in the proper viewing equipment is well worth the cost.

THE EVALUATION PROCESS

Now you are prepared to make the important decisions necessary to ensure good color reproduction.

STEP 1 Start by checking the obvious. Look over your transparency meticulously. Check for cleanliness and make sure there is not even the tiniest spot of dirt embedded in the transparency. Look especially for pinholes, as paper clips can leave tiny holes which, when enlarged, look like giant caverns. (See Figure 2.) Also check for processor marks on the transparency. Unfortunately, even the best photo labs are not perfect; their equipment can leave marks, especially on 2¼-inch and 35mm film. They represent missing information in the yellow dye layer in the transparency's emulsion, yet often are not visible to the naked eye. Because the color scanner can perceive far more than the eye can, this imperfection is difficult, if not impossible, to remedy at the color separation stage.

If any of these problems happen, it is best to re-shoot the job. Of course, if you are operating under deadline, you may not have a choice. In this case, your separator will charge you for time and materials to correct the scratches or defects. It is difficult to say how much this will cost, but you can count on a minimum of $200. Your separator will either be using hand methods or the new elec-

tronic airbrushing technique to make these corrections. No doubt the electronic work will produce a better result, but it may double the price. It is important, therefore, that you decide how critical the correction is before deciding not to re-shoot.

If your transparency is clean, however, you can start to check for the more subtle things that determine good color reproduction.

STEP 2 Using your magnifying glass, check for sharpness. To do this, locate small detail areas—such as tree limbs, eyelashes, type on packages or thread in clothing—and check to make sure they are crystal clear under the glass. (Refer to Figure 1.)

Since sharpness is the most common problem plaguing image and color quality, if you have any doubts at this point, pursue them. Some art directors find that it is well worth the extra cost of having a color print made to reproduction size in order to get a preview. If you are still uncertain about sharpness after careful study, you can rest assured that, by the time this transparency is enlarged and screened, the overall impression will be fuzzy. (See Figure 3.) Just consider the fact that the original color transparency contains 1,800 pieces of information per inch, while its separated and screened counterpart contains only 133 or 150 lines per inch.

Some designers admit that, in the search for overall ''mood,'' they sometimes feel they can sacrifice image sharpness. They must realize that even though the main victim of an out-of-focus shot is sharpness, color also suffers. There is little a separator can do to make an unsharp transparency look good, because the color is so ''washed out.''

STEP 3 The next step is to check your transparency for exposure. It is at this stage that keen eye for detail is most helpful in spotting common problems like overexposure, underexposure and high contrast shots.

First, make sure your photographer brackets the shot. Briefly, bracketing means beginning with a shot at the correct exposure, then shooting the same image again, only this time at ½ f-stop overexposed, then ½ f-stop underexposed, one f-stop overexposed and finally, one f-stop underexposed. You will end up with five shots of the same image at slightly different exposures.

Depending on the numerous variables affecting the amount and nature of the light that is allowed to act on the emulsion of the color film (i.e., exposure), the same image will appear slightly different with minimal changes in the f-stop. Color rendition as well as detail information in the highlights and shadows will be subtly affected. (See Figures 4 through 7.)

Figure 6 Although this is just a simulation of the green color cast you get with daylight film under fluorescent lights, it does show you what will happen when the wrong color temperature light is used. A 30 magenta color correction filter can be used in these situations in order to compensate for the lack of red light. Because this green cast is present throughout the transparency, modern scanning equipment can eliminate it overall. However, detail and definition will also be removed. Thus, it is far better to use the proper lens filtration rather than to rely on the scanner's capability.

Figure 7 Because the film is sensitive to ultraviolet radiation from the sun, some neutral colors in outdoor shots may shift to blue if the photographer does not use a UV lens or other such color corrective filter. The use of tungsten film in daylight might also cause a blue color cast. This problem is a relatively easy scanner correction; but remember, when you take the blue out of the highlight areas, you will also be taking blue out overall. So if you have an outdoor shot with lots of sky, the sky will end up lacking vitality. Clouds will look faded because there is not enough contrast between the clouds and sky. Again, this shot is just a simulation of the blue color cast.

Because art directors and designers evaluate exposure according to personal taste, there is a tendency to choose the exposure with the "punchy" color, quite often the underexposed, darker transparencies. (See Figure 4.) These underexposed shots lack significant detail, especially in the shadow area, yet the rich and deep colors lure the eye making the shot look good under the glass. Such underexposure will reproduce poorly. Therefore, when evaluating these exposures, it is important not only to select the one that contains the color you like best, but also to check for detail in shadow and highlight areas.

In addition, once you have marked your preference, your supplier may appreciate it if you send all five bracketed shots from which to choose. The color technicians may not choose the same transparency you did, but by working with the shot that has the most detail information, they will be able to combine the best qualities of both. (It is best to ask your separators how they want to handle this, as some may desire only one alternate chrome.)
STEP 4 The last check should be for overall color balance. You are checking color last, quite frankly because more problems are created by unsharp and poorly expressed transparencies than by color problems. Also, color is perceived differently by everyone, deeming this stage of the evaluation the most subjective one.

Start by placing the best chromes of the set side by side. The subtleties in color—when viewing flesh tones, hair colors and neutral grays, for example—will become more apparent while comparing. Personal taste plays an important role at this stage, and keep in mind that color corrections can be made using modern scanning equipment.

The two most common color casts which can successfully be eliminated with the scanner are green casts, usually caused by the lack of proper filters when shooting a subject under indoor fluorescent lighting, and blue casts, often found in outdoor shots. (See Figures 6 and 7.)

While many photographers' mistakes can be corrected on the color scanner, it is less expensive to start off with good input materials, by far the most important element in good color reproduction. To help you evaluate the quality of those input materials, Figures 2 through 7 illustrate some of the most common problems you will find. Many of these "intentional" photographic blunders are overstated for purposes of instruction. ■
—Helene Eckstein

Basic Color Separation Methods

Understand the differences between conventional photographic separations and electronic scanning.

Photographic color separation and electronic scanning have one thing in common. They both are exposing systems that record images on four separation halftone negatives. Aside from this similarity, all of the steps in both separation processes are totally dissimilar. In the photographic system, light from every microscopic segment of the color art passes through the lens of a camera onto a sheet of film *at the same moment*. In electronic scanning, each of those segments on the original artwork is seen with a pinpoint light source and recorded before the scanning light moves to the next segment (within a few millionths of a second).

Qualitatively, it is impossible to determine the better separation system. Both the photographic and electronic methods are capable of fine color separation quality. Factors such as economy, expediency, equipment size and availability of the original artwork determine the choice. When the transparency becomes the substitute for the art to be separated, for whatever reason, then electronic scanning is the superior system. If, on the other hand, the actual illustration can be separated in the lithographer's camera, then the photographic system may yield the better result.

Before determining which system is better for your project, review these important considerations.

COST Electronic scanning is less expensive than camera separation. There is, how-ever, wide discrepancy of print and/or separation charges in the lithographic industry. You would be wise to obtain comparative price estimates in advance of production.

QUALITY Generally, the reproduction quality is most assuredly better when the original art is separated rather than a color transparency clone. Frequently, color transparencies are an imperfect match to the original and very often are responsible for many color, contrast and textural problems. Specifically, however, when the color transparency is made photographically accurate and captures the colors in the original, then the scanning process produces a greater degree of replication.

SIZE If the art is 20 x 28-inches or larger, only a few very large, expensive scanners can accept it, and then only sizes up to 38 x 48-inches. Therefore, separations must be made by the camera or by converting the art to a transparency for the scanner.

SURFACES When a painting has a heavy impasto surface, the image may appear distorted by the lights used in the indirect camera method. By converting to a transparency, the photographer can arrange the lighting on the art to retain the quality that properly represents that surface.

When the surface is highly reflective, such as a glossy, varnished illustration or a coated paper stock, the printer's camera may not be able to avoid glare streaks because of the limited control of his camera's illumination. Therefore, the more flexible lighting in color transparency duplication is preferable.

MULTIPLE SUBJECTS Scanning is most practical when more than one subject is to reproduce on a sheet, as in catalog printing. It is more economical to have each piece of art converted to a transparency in the same size as the reproduction and assembled with the others in position on clear acetate for one composite separation.

The following description of separation systems is intended to provide the graphic artist with a working knowledge of the separator's procedures.

THE PHOTOGRAPHIC SYSTEM

Capable of fine color reproduction, the photographic color separation system is most efficient in the hands of an experienced craftsman. The color separator converts the full-color art to four black-and-white films, each consisting of one-third of the color structure (plus the black component). He must then convert these negatives, which are continuous-tone films, to positive films which must be not only exactly opposite in value, but must be formed with hundreds of thousands of dots of all sizes. Further confounding this conversion procedure, the color separator must make preliminary films called ''masks,'' which alter the tonal structure of the continuous-tone negatives. Often as many as 30 films are used to arrive eventually at the four halftone negatives required to make the printing plates. These conversion steps are mentioned in order to emphasize the importance of quality control in each step of exposure and development of the various films. Any variation of a degree in temperature in the processing solutions or even a slight under- or overexposure to the films can affect the resultant color in the reproduction. By pre-press proofing the four separations, it can be determined if corrections need to be made or if the films should be remade.

Whether the direct or indirect method of photographic color separation is used, the somewhat complex step of color corrections masking must be done to minimize color distortion. The electronic system, on

Figure 1

COLOR SEPARATION SYSTEMS

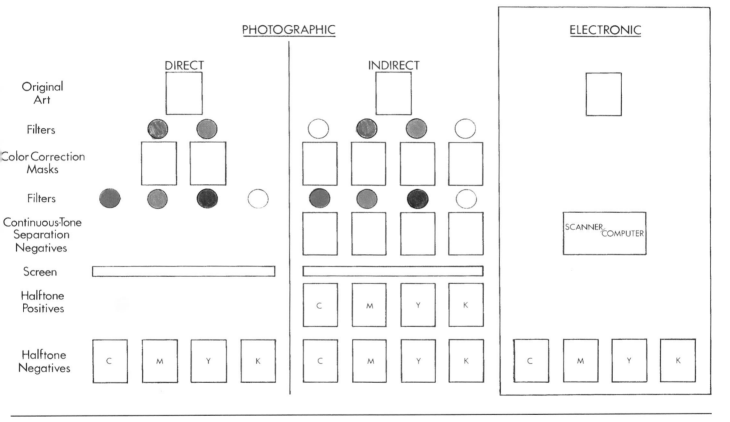

the other hand, eliminates most of the variables of the photographic process.

INDIRECT METHOD "Indirect" refers to the process of producing the halftone positives from continuous-tone negatives, as opposed to the direct method in which the halftones are exposed directly from the artwork. The essential advantage of making continuous-tone negatives is that greater tone and color control can be exercised by various masking techniques.

This minimizes the need for manual color correction by the litho artist.

Starting with the large litho camera, the photographer mounts the art on the copyboard. Critical positioning of the sidelights at approximately a 45 degree angle to the art takes place to illuminate the surface evenly and prevent any unwanted reflections or glare streaks.

Before the four separation negatives are made, the photographer makes four exposures onto special masking film, each

through a different color filter as shown in Figure 1. When developed, these masks will serve as color correction devices designed to compensate for certain deficiencies in the process inks.

Suffice it to say that the cyan and magenta inks are not made as pure as they should be, and if masking were not employed, the color reproduction would render blues, reds, greens, oranges and pur-

ples incorrectly. These masks, which are relatively weak negative images, are positioned back in the focal plane of the camera, one at a time, and the four continuous-tone negatives are then exposed to the artwork, each through a primary color filter with the appropriate mask immediately in front of the film being exposed.

Because each of the masks was exposed through a different color filter, they have densities in certain areas that then influence the densities in their corresponding separation negatives. Proper exposure and development of the four negatives are vital to maintain correct balance of the tonal structure. A "balanced" set of separations reproduces all tones of gray as neutral gray, without any cast of color. This necessitates making the separations "out of balance," with the cyan slightly stronger because equal combinations of cyan, magenta and yellow actually reproduce with a slight brownish cast.

As shown in Figure 1, the mask made with the yellow filter is used to produce the red filter separation negative. After that first exposure, the magenta mask is positioned in the camera and the green filter separation is exposed. The blue separation is then exposed through the green mask, and the white separation of the art, which is really not a separation, but rather a panchromatic rendering—or tonal rendering on black-and-white film—is then made. The four films are then developed to a balanced contrast.

Figure 2 represents a graphic rendering of the three primary color separations, illustrating how each filter transmits its own color and records as a dark or negative value. For example, the red filter transmits the light from the red apple, the magenta flower (magenta consists of *red* and blue), the yellow banana (yellow is *red* and green), and the white moon (white, of course, is made of *red*, green and blue.) These items record as dark densities. Any

item that is not red, such as the blue sky, the green table, the black stem and the cyan airplane, is absorbed by the red filter and never reaches the film, which remains clear or transparent in those areas. The green and blue filters, again, transmit their own colors and absorb their opposites; the fourth film, the so-called "white separation," or black printer, is not included in this illustration as it does not print in any of the colors.

The continuous-tone negatives are then examined for proper balance and correct tonal renderings. If it is detected that a particular color did not record properly, a litho artist may then hand correct the tones of the negatives by applying pencil, stain or a density-reducing solution to lighten or darken the density value. Another method of correction would be to make a photographic mask especially for the local area to be adjusted and register it to that negative, which then influences the next step by lightening or darkening that area.

Lithographic plates used in printing have a light-sensitive surface that is extremely slow compared to photographic coatings on film. To produce an image on a plate, it is necessary to structure that image with a dot pattern whereby light can pass through clear areas and be stopped at dense areas. This is accomplished by photographically converting the continuous-tone negative to a halftone positive. The delicate tonal differences in density will be represented by various sizes of dots in a precise mathematical relationship. The halftone image at normal viewing distance appears as a normal continuous-tone image. Under powerful magnifications, tiny black dots can be seen, usually 150 to the linear inch, creating the illusion of tones by their relative sizes.

To produce this halftone positive, the photographer projects the continuous-tone negative in the camera to the final reproduction size, onto halftone film. Simultaneous with this exposure is the in-

troduction of a halftone screen positioned over the film to be exposed, which will convert the continuous-tone values in the separation negative to dots on the halftone positive. It is less complicated than it sounds, as these dots form automatically by the varying light intensities exposed through the checkerboard dot pattern in the screen. Where a small amount of light, penetrating the dense areas of the negative, passes through the screen, small size dots are formed; where the negative has a relatively light density, more light penetrates the screen, exposing the halftone positive with larger dots.

The photographer controls his exposures and development to produce a five percent highlight dot in a white area in each of the cyan, magenta and yellow positives. Dot sizes are accurately measured by a densitometer, and more commonly by experienced judgment. A perfect checkerboard pattern is formed with 50 percent dots with five percent increments forming in both directions toward a highlight dot (five percent) and a shadow. If the masks are made correctly and all the steps are carefully monitored, the four positives will be formed with the correct dot size representing its corresponding tonal value in all areas of the illustration. These so-called "balanced" positive separations are then exposed onto contact film to produce final negatives.

DIRECT METHOD Figure 1 illustrates how the direct photographic method directly transfers the image of the original halftone film. Before electronic scanning the cost of producing separations by the direct method was approximately one-third that of the cost of the indirect method, and therefore was very popular. However, the elimination of continuous-tone negatives did not allow the degree of color corrections necessary for high-quality reproduction and direct separation was relegated

Figure 2

ART

PRIMARY COLOR SEPARATIONS

R

G

B

CONTINUOUS TONE NEGATIVES

HALFTONE POSITIVES

C

M

Y

INKED IMPRESSIONS

to simple, low-cost, "commercially acceptable" printing. The inclusion of the direct separation method shown in Figure 1 serves as a comparison to the now predominant system of electronic scanning.

ELECTRONIC SCANNING

While the element of subjective judgment by the scanner operator exists in the area of color evaluation as it does in any process, most of the other variables in the separation process are eliminated in electronic scanning. A computer, part of the scanner's equipment, contains programs which calculate how to compensate accurately for any color or contrast problem in the artwork. The computer accurately zeroes in on the proper aimpoints, allowing control standardization and repeatability to replace subjective judgment.

Since 1980, almost every new scanner produced throughout the world is now capable of directly exposing halftone dots to film *without* a screen. This dot-generating innovation is made possible by the complex arrangement of computer-controlled laser beams which expose dot sizes and shapes to extremely fine tolerances on the final film.

Scanners are available today in many sizes with varying capabilities. The smaller, relatively simple models can accept transparencies up to 8 x 10-inches and produce separations up to 19 x 23-inches. Larger models can scan artwork from 25 x 25-inches to 44 x 50-inches.

At the input end of the scanner, there is a transparent plastic drum on which the color original is wrapped. The drum revolves around an exposing light source which moves in a helical pattern between 500 and 2,000 lines per inch. These scan rates are determined by the degree of enlargement of the reproduction; the greater amount of scan lines is used for 1—20x projections. At the front of the scanner is a control panel at which the operator selects or sets the variables, such as color corrections, color enhancement, positive or negative images, screen ruling, dot shape and other reproduction factors.

The final film is mounted on another drum at the output end of the scanner. When the operator starts the drums spinning, the scanning light source penetrates the transparency (or reflects from the reflection copy), sending its beam through an optical system that separates it into three primary color signals. Entering the computer, the signals are manipulated by electronically-programmed data that color corrects, compensates and adjusts for the inherent deficiencies of the printing inks and the color corrections programmed by the operator. The computer converts the output signals to laser beams which are directed to the final film. When all four colors have been scanned and separated, the films are removed and processed by conventional photographic developing.

STEPS IN THE SCANNING PROCESS Separations made by electronic scanning start with artwork preparations in which the transparency or reflection copy is analyzed and evaluated for color and contrast qualities, sizing or scaling, screen ruling (120, 133 or 175 dots per inch), and establishing the aimpoints of dot sizes. It is at this stage that critical judgment is important if the artwork has been converted to a color transparency and the transparency is inaccurate. Careful analysis of the differences between the art and the transparency is most important in order to instruct the scanner to correct the color deficiencies on the control panel.

After determining all the settings, the operator then mounts the original on an interchangeable, transparent, plastic drum and begins the scan. The drum begins rotating and the exposing light penetrates the transparency (or reflects from the reflection copy), sending the light beam through an optical system that breaks up the beam into three rays. These rays each travel through a primary-colored filter (red, green and blue). The color-separated beams enter a computer where the light is manipulated to compensate for printing-ink deficiencies, press conditions, and printing paper characteristics which have been pre-programmed.

The computer outputs electronic signals in the form of laser light beams that are directed to sensitive films which are mounted on the rotating drum in a light-tight housing. (Some scanners expose one separation at a time, some can expose two and the new, larger models can expose all four colors simultaneously.) As the drum rotates in concert with the artwork drum, the laser beams expose the various dot sizes representing their parent tones and color values in the original onto the four separation films. These are then removed to be developed. After processing, the negatives are examined for obvious flaws, such as dirt, streaks or any imperfections in the halftone. The next step is to make a proof.

PERIPHERAL EQUIPMENT AND TECHNIQUES To the commercial graphic designer and the printer, electronic scanning has become more than a separation system. Peripheral equipment attached to the scanner or functioning as separate work stations has introduced sophisticated color and image manipulation. Combining text with illustration for pagination work is rapidly dominating the publishing industry. Now, the scanner can combine by multiple exposures many elements such as type, graphs, charts, drawings, tints and multiple separations on the same film. Previously, this was a separate, time-consuming and costly operation.

Another recent innovation is the ability of electronic scanning to store the color-separated image in digital form. This means that the millions of infinitesimal segments of a painting or photograph can be represented by millions of bytes on a magnetic tape or disk for future recall. ∎

—*Andy Perni*

Realizing Prepress Color Savings

How to cut costs using methods like prepositioning, ganging and duping.

Everyone is always trying to save money. Witness the people at the supermarket who diligently sift through coupons trying to save a few cents on every item. Their total savings may amount to $10.95, but that is still a recognizeable savings and worth the effort. Shouldn't we, who are spending thousands of dollars on goods and products for our firms, be diligent in saving our company's money? Here are some good ideas on how to whittle down your color pre-press printing bill.

TRADING TIME FOR MONEY

Perhaps the easiest way to save money, and one that is often overlooked, is trading time for money. In the color separation business, deadlines have gotten tighter and tighter, and today we are often operating on a standard four-day schedule rather than the week turnaround which we had years ago. If you are a super organized person who works weeks in advance or if you have a project which lends itself to a longer lead time, you can capitalize on other people's shortcomings by negotiating with your supplier for a lower price. This is an easy way to get the product you want for less money and still not sacrifice quality.

Another good way to save money without giving up overall quality is by negotiating some sort of yearly contract with your color separation supplier. Again, the color separation business is fraught with peaks and valleys—a lot of work in the plant one moment, and no work the next. If you can even out these workloads by guaranteeing a certain volume of work on a predictable, regular basis, you can again save money and maintain quality and, in this case, good service.

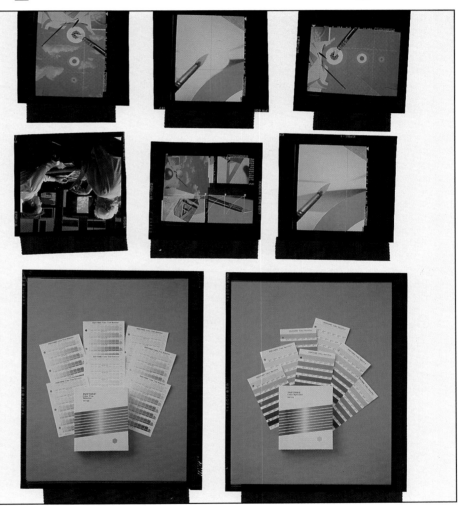

Ganging Your Color The most widely used cost-savings measure in color prepress is ganging—that is, making more than one color separation at the same time. All of the ganged elements must be in the same form (transparencies, color prints or artwork), all must be sized to the same percentage, and the color within each should be compatible.

If, however, you are one of the vast majority of color prepress buyers who do not have the luxury of knowing what your workload will be from one day to the next *and* have tight deadlines, you must, regrettably, sacrifice quality to save money.

GANGING

The most widely used cost-savings measure in color prepress is ganging. Ganging means making more than one color separation at the same time. In order to gang, all the elements must be in the same form. That is, they must all either be transparencies, or prints, or pieces of original artwork. You cannot gang transparencies with prints, or artwork with transparencies.

If this requirement is met, then the next requirement is that every item in the gang must be sized to the same percentage. For example, everything must be enlarged 120 percent or reduced to 80 percent, 90 percent, and so on.

You then come to the most difficult part of ganging—the compatibility of subjects. There are several keys to compatibility. Here are some of these guidelines.

COMPATIBILITY OF SUBJECTS Items are compatible if they are of similar subject matter. In every color separation, the separator is aiming for one key element in the picture. Usually, when pictures of people are represented, good flesh tones are the goal. When there are products pictured, the product becomes paramount and everything else may be sacrificed to get a good product match. In a scenic shot, blue sky, green grass and a crisp look is what most people want. Ganging works best then, when you have all scenics, all people photos or all product shots.

Another aid to compatibility is that all of the shots be done at the same time, under the same lighting conditions. The ideal situation is a series of products for a catalog or flier sheet that are all shot in the same studio, under the same lights, and then processed by the same lab at the same time. Remember, the chemistry in film processors

changes over time, so even if shots were taken under the same lighting conditions, they will appear different if they are processed at different times or in a different film processor.

Before selecting items to be ganged, it is a good idea to evaluate them carefully to see that there are no color casts present in any subject or, if a color cast is present, it is uniform throughout all of the subjects. This is because the color separator cannot neutralize individual color casts as they can in normal scanning. When they make adjustments to any element, they are altering all of the subjects.

You should carefully check the highlight areas of all ganged subjects to see that they are uniform in weight, density and color cast. This is vitally important to ensure even, pleasing reproduction.

These types of evaluations are difficult to make. For this reason, it is a good idea to go ahead and decide to gang your subjects if you wish to save money, but then rely upon your color separator's professional advice before making your final decision. For example, you may wish to gang ten subjects, but the color separator, upon evaluating these shots believes that if they were divided into two gangs, one of four and one of six, it may cost more than one gang of ten, but the quality would be significantly better for the two gangs, and you could still save money over the cost of individual scans.

Many buyers decide that there is really only one subject in the gang that is vitally important. If this is the case, you should tell the separator to program the scanner to reproduce this one vital subject, and then take your chances with the other elements in the gang. This will ensure that the one subject you are concerned with looks good, but it may play havoc with the other elements in the gang.

COST SAVINGS Many times buyers ask me how much money they will actually save by ganging. On average, you can save about one-third by using ganging techniques. You will, however, sacrifice a great deal of quality. Probably the greatest cost savings are

realized when a series of subjects will be reproduced at a rather small size (1 x 1-inch or 2 x 2-inch). Because most color separators have a minimum price, usually 4 x 5-inches or in some cases, 2 x 3-inches, you can capitalize on your numerous small separations going onto a larger ganged image area. Now the savings can be significant—often amounting to 50 percent or more.

PREPOSITIONING

An even greater cost-savings technique is prepositioning your subjects. With this technique, which can only be utilized when you have a significant amount of white space between subjects (usually one inch or greater), you actually preposition your transparencies, artwork or color prints on the individual page or two-page spread. The color separator will then make one separation of the entire area, and you will eliminate the cost of individual four-color stripping on the page. If you are using color prints or artwork, you can preposition them yourself by using a waxer on white paper. If, however, you are using transparencies, it is rather tricky to mount them, and you should pay a color separator to do this for you. They will usually charge about $20 per subject to preposition the images, but you will still get cost savings amounting to one-third or more by utilizing the technique.

DUPING AND PREPOSITIONING

Another good way to save money is by using transparency duping and prepositioning. Duping is a process which involves taking disparate elements and making them compatible so that they can be gang scanned. To do this, either a custom photo lab or color separator will use duplicating cameras or enlargers which can shoot all of your subjects into a standard E6 transparency format so that they will be compatible for gang scanning.

The duping process can accomplish a great deal. First, all of your subjects will

now be shot to the same enlargement or reduction size so that they will be compatible. Also, if there are any individual color casts, they can be neutralized, making them, again, more compatible in a gang scanning situation. Underexposed transparencies can be improved by lightening. Incorrectly processed original transparencies can also be corrected in the duping process. In addition, local color corrections can be made on the individual duplicate transparencies, which usually costs less than dot etching completed after color separations are made.

Despite all of these benefits, duping is not a cure-all and there are still some quality trade-offs which you must be prepared to make. With duping, you are still utilizing gang separation techniques, which means that your subjects will not be individually programmed. Duplicate transparencies have a decreased tonal range and lose detail and shape in the highlights and shadows. In most cases, this will not affect your overall reproduction, but if you are looking for a top-quality job, duping is not the answer.

Duping also represents the least effective cost-saving method of those we have mentioned thus far. This is because the duping lab or separation plant will be charging you for the duplicate transparencies and for prepositioning the images. This can often cost $25 or more per subject, which, at times, can wipe out all of the cost savings that you had originally envisioned. The real savings come to you in lower stripping charges rather than in a lower color separation bill, since prepositioning eliminates the need for expensive individual four-color stripping.

Most savings, therefore, will be realized on those jobs where there are a large number of minimum-sized four-color subjects. Catalogs, travel brochures, small product fliers and wall charts seem to lend themselves best to the duping and prepositioning technique. When you have many minimum-sized images, you can realize some significant price reductions by going to duplicate transparencies and then prepositioning them on the page or two-page spread.

It is wise to remember that the best copy to use for good duplicate transparencies is original transparencies. While duplicates can be made from color prints or original artwork, you will achieve more faithful reproduction when the duplicates are made from original transparencies. This is because the dye characteristics of transparencies are comparable, one to the other, while the dye and tonal characteristics of color prints and original artwork, unfortunately, are not. Thus, when you are making duplicate transparencies from color artwork or previously printed subjects, most duplicate film labs or color separators will charge an additional price for the balancing they need to do in order to make these subjects compatible for scanning.

Keep in mind that while duping works very well for lightening up an underexposed (very dark) subject, it does not work well when darkening an overexposed transparency. This is the opposite of what we normally suggest to clients when utilizing standard scanning techniques.

SCITEX ASSEMBLY

The latest cost-savings technique is utilizing the new Scitex Assembler system in order to duplicate the cost savings accomplished when using duplicate transparencies, while still using individually scanned subjects to get a higher quality job. This breakthrough in electronics enables you to individually scan each subject that you wish to gang, eliminating the need for perfectly compatible subjects, and allowing you to individually size elements. Because of the electronic stripping capabilities of the Scitex Assembler, subjects can easily be placed in position just as you would in prepositioning, and at a similar cost. The advantage, of course, is that you are using first generation originals, giving you individually programmed subjects. While not as cost effective as straight ganging or prepositioning, this new electronic technique presents a new option for cutting costs while still maintaining a high degree of quality.

It may be difficult to find vendors who have the new Scitex Assembler systems. If your local vendor is using a large, full-scale pagination system (Scitex Response, Hell Chromacom, Studio), its price may be too high. In fact, you will find that it costs more to do your job on these systems than it would cost you to have individual separations on a regular scanner. The Scitex Assembler, however, has been formulated especially for high-speed stripping and does not feature the expensive image manipulation capabilities of larger systems. Because this system is less expensive to operate, you can realize some cost savings when you do not need any type of image manipulation (such as cloning, airbrushing and so on), but rather, just need a job preassembled in order to save money. (See "Color Electronic Prepress Systems" in this guide for details on how larger image manipulation systems are being used.)

You must realize, however, that the cost savings of this particular method comes about because the separator is doing all of the separations and the assembly work on line, on the system. This means there will be no intermediate proofing step, and in fact, you will pay dearly for any corrections made from the original proof that you receive. You will find, however, there is usually little need for any corrective work since the color separator can give you a good rendition of your subjects early on by scanning them individually and showing them on a soft video proofer. Overall, the job will be of higher quality than any of the other cost-saving techniques.

You have many choices and many ways to save money in the color reproduction business. Before you select one, though, you must decide what your priorities are in terms of quality, service and price, and then make your decisions based upon the goals you are trying to achieve. Once you understand all of the options available, you can effectively save money while still not compromising your printed piece. Some people even claim it is as easy as clipping coupons for the supermarket. ∎

—Helene Eckstein

Guide to Prepress Proofs

Discover the proofing system which best suits your needs.

Although the chart on the following page is not all-inclusive, the proofing systems listed are common selections in the industry. In pre-press color proofing today, there are basically four types of systems in current use: the electronic proof, the overlay proof, the integral proof and the digital proof. From system to system, the color quality achieved varies greatly.

ELECTRONIC PROOFS The recently introduced Eastman Kodak "Signature" system and Coulter Proofing System are both new technologies in electronic proofing systems. They work with specially-formulated, electrically-charged liquid toners which contain pigments almost identical to printing inks. The separation negatives can be exposed onto any stock—they adhere electrostatically—and the result is a proof that closely resembles eventual printed stock. Because there are no intermediate layers on the proof to affect optical appearance, it comes closer to matching the press print than other proofs, according to color expert Michael Bruno.

DIGITAL PROOFS Still in their infancy, digital proofs are continuous-tone proofs that use color separated data stored in digital form to produce a hard copy proof. This color-separated data is exposed onto color photographic paper using systems like the Chromograph Color Proof Recorder.

OVERLAY PROOFS To make an overlay proof, the four film separations are exposed individually to both a pre-colored and a light sensitive film. These are combined in register, one on top of the other, over a

white stock. Although pigments are accurate, the density of the overlays can result in a yellowish-gray tone. When used in color corrections, a corrected color overlay can be made for evaluation with the uncorrected colors. (Color Key, Cromacheck, Naps & Paps are some of the trade names.)

INTEGRAL PROOFS A good representative image of the eventual printing, integral proofs are made by exposing each of the four separations to a primary-colored, thin-

pigmented emulsion layer, which is laminated in register to a sheet of white paper. The final product is a photographic color print. (Popular products are Cromalin, Matchprint, Gevaproof, Spectraproof and Ektaflex.) Its main advantage is that it can be used to evaluate how the four separation halftones will print. ∎

VIEWING AND EVALUATION CHECKLIST

Why is it that countless printed jobs cannot hold a candle to their flashy (but deceptive) color proof counterparts?

Many complex factors can contribute to dissatisfaction with a finished product. For starters, as basic as it may sound, people perceive colors differently. And although judging color is a subjective process, other variables, such as type and condition of press, type of paper and ink density, all increase the possibility of a disappointing outcome.

In general, however, color proofs can and do help you troubleshoot mishaps before they happen—if you know what to look for and how to look for it.

The following checklist provides guidelines for a thorough proof check. (Photocopy this sheet and add your own items specific to your most common print projects.)

_____ **CHECK SHARPNESS** With a strong magnifying glass, check detail areas to see that they are crisp and clean.

_____ **CHECK ACCURACY OF COLOR** Compare the proof to the original under a color-correct light source (5,000 K).

_____ **CHECK NEUTRAL AREAS** From white to gray to black, make sure they are free of green or blue casts.

_____ **CHECK SIZE** Be certain all sizes are appropriate, in photos and art, headings, type and pages.

_____ **CHECK FOR SPOTS AND SCRATCHES** These could represent imperfections in the printing plates.

_____ **CHECK FOR BROKEN SCREENS** Is the dot pattern disrupted or are any black lines visible?

_____ **CHECK REGISTER** Is the image fuzzy? Is there a change in the process colors or a shadow effect?

_____ **CHECK POSITION** Are photos and art in their proper locations? Should an image be flopped? Should it bleed?

_____ **CHECK FOR BROKEN TYPE** Are there white specks in the type? Is type omitted or covered up?

_____ **CHECK CLEANLINESS OF ART** Any pinholes, crop marks or obvious dust?

_____ **CHECK BORDERS** Are they the correct size and color? Are they in position?

_____ **CHECK FOLDING** Is the pagination correct? Placement of folios correct? Are the scores indicated where necessary?

_____ **CHECK CAPTIONS** Are they correct in length and position?

Proof Name/ Manufacturer	Type of Proof	Development	Appearance	Average Cost	Some Considerations
Blueline, Brown-print (manufactured by various companies)	Paper-type proof used to check text and lay-out. Made from neg./pos.	Machine (ammonia vapor)	Blue, brown or mottled back-ground	Low	Inexpensive to use when checking to make sure everything has been stripped correctly. Type is clean. Cannot check for color but can check registration. On simple two-color jobs, for example, color differences can be shown using varying exposure times.
Dylux (DuPont)	Paper type proof used to check text and lay-out. Made from neg. or pos.	None (exposure to ultra-violet light)	Blue or gray on yellow-cast or white paper	Low	Inexpensive, and uses no chemicals or development. Commonly put into two-sided magazine form, making them easy to check for correct pagination and layout. Type is clean. Cannot check for color, but can check color registration. With basic two-color jobs, for example, color differences can be shown by using different exposure times. Exposure to sunlight or high UV wavelengths will destroy image (on yellow-cast paper).
Color Key (3M)	Polyester layers for each of the four colors. Made from neg./pos.	Single chemical, by machine or hand	Full color	Low	Overlay proofs are inexpensive and used mainly to check color breaks and register. As with all overlay proofing systems, overlay film has a slight color cast when viewing through the layers.
Chromacheck (DuPont)	Mylar layers for each of the four colors. Made from neg.	None (exposure to ultra-violet light, peel-off lamination)	Full color	Low	Uses no chemicals or development. Overlay proofs are inexpensive and enable checking of each color separately or in combinations. As with all overlay proofing systems, overlay acetate has a slight color cast when viewing through the layers.
Spectra (Sage Technology/Polaroid)	Powder/surprint (single layer). Made from neg.	Machine	Full color on any stock	Moderate	All Pantone colors can be used in conjunction with SpectraProof. No polyester material to interfere with color.
Matchprint I and II (3M)	MP I is pressure sensitive lamination system, neg. only. MP II is heat lamination system, pos. or neg.	Machine	Full color on stocks representing most commonly used printing papers. MP I has matte finish.	Moderate	MP II can be proofed on publication- or commercial-based stocks. MP II has high-gloss finish, although it can be deglossed
Cromalin (DuPont)	Powder/lamination. Made from neg. or pos.	Machine and/or hand-toned	Full color on stocks representing most commonly used printing papers. Can have matte finish.	Moderate	Can be proofed on publication- or commercial-based stocks. Available in gloss or matte finish.
Signature (Kodak)	Liquid electrophotography. Made from neg. or pos.	Machine	Full color on any coated, offset stock	Moderate	Generates positive or negative proofs. Toning inks are made with SWOP pigments.
Press Proof, Progressive Proof (Progs.—made by your printer)	Printed	Actual ink on paper	Color final	High	Will show an actual printed job. Often printed on slow, sheet-fed press. If actual job printed on ultra-fast web, color may shift. Color shifts may also occur if proof created from original film, and piece ultimately prints from duplicate. Proofing ink does not always match final printing ink.

Dispelling Color Matching Myths

Learn what is "under your swatchbook's hood" with these answers to common color matching questions.

Although ink may only constitute about three percent of the total cost of a printing job, it is often one of the most critical factors determining your satisfaction. And with more and more printed pieces being produced in color, graphic designers today need practical as well as technical information about color matching more than ever.

The following interview with Pantone, Inc.'s senior vice-president Jack Siderman was developed to help designers specify and achieve a color match as well as to increase their fluency in the technical language of color.

But "Why PANTONE®?" you might ask, when there are other color matching systems available? For the simple reason that most if not all designers already use it to specify color. In addition, the majority of designers, clients and printers working in the United States will consider the PANTONE MATCHING SYSTEM a universal color language.

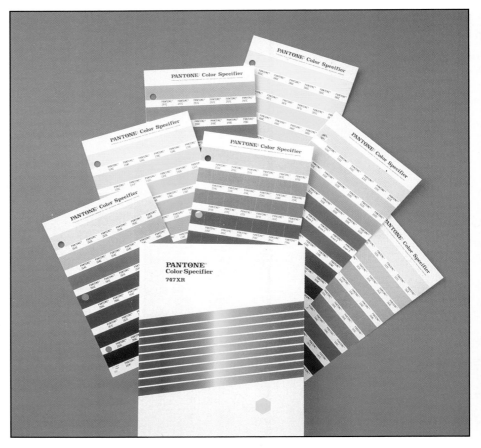

Pantone Color Specifier Tags torn from the Specifier should accompany your print job.

Q: When placing a printed sample or color swatch on a keyline/mechanical that represents the specific color to match, often printers cannot come close enough. Why?

A: It is important that the designer understand that simply putting a swatch on a mechanical or keyline is not enough to ensure color accuracy. It is necessary for the designer to: 1) understand what the printing variables are; 2) know how to resolve the variables; and 3) accept compromise. The key word is compromise. The word "exact" does not exist in the graphic arts because of all the variables possible. The color or ink portion of a printing job, although the most critical area because it is the very thing

seen, represents only about three percent of the job. Paper, one of the variables that affects color, is about 40 percent of the job.

In addition, there are limitations in the printing process in what the printing ink can do, and equally as important, there are limitations in what the eye can see. No two people see color the same; no person sees color the same in the morning as he or she does in the afternoon. People can also be color-weak, seeing a red-orange as more of a cherry-red because they are color-weak in yellow. (Most people are not aware that this phenomenon even exists.) And where you view color and under what

lighting circumstances has a tremendous effect on color.

But the particular swatch you paste down on your artwork will affect the final color that you get. For instance, is the color sample you have put down on the artwork an actual printed swatch? Is it cut out from something that has been varnished—thereby affecting the color and the finish? Is it on the type of paper you are going to print it on (meaning coated or uncoated)? Is it a silk-screen swatch—is it a paint swatch—is it a fabric swatch . . . or is it a swatch from a system that is printed? All

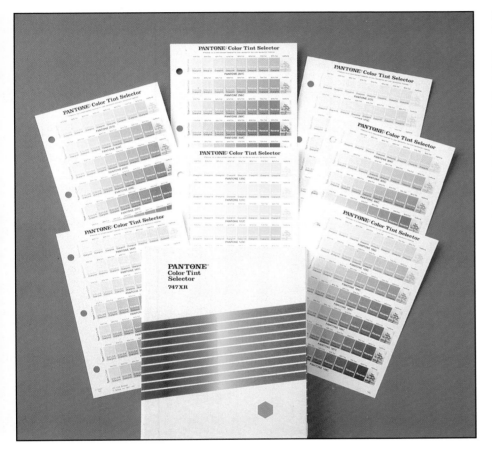

Color Tint Selector Applications for each Pantone color are easy to evaluate in the Selector.

of these will affect the final outcome.

Silk-screen inks—or silk-screen swatches—similar to paint swatches—are usually opaque colors laid down in a very thick film. These opaque colors give you much different effects than a transparent printing ink, and in most cases, printed jobs today are printed with transparent printing inks. An opaque silk-screen swatch carries so much ink that it is physically impossible for today's high speed presses to duplicate that thick film of ink. As a result, they deal with a very thin film of ink. So to get the effect silk screen requires, perhaps two, three or four impressions of overprinting are needed.

The other problems with textile swatches are that they are colors made up from dyes. Therefore, specified color has to then be matched in printing ink pigments. These printing ink pigments are limiting. They are not necessarily the same base colors found in textiles. And even when those colors *are* satisfactorily matched, they will change under different light sources so they no longer match the swatch. This phenomenon is called "metamerism," which means that two areas of matching opaque color that have a reflective surface appear to match

in color under one kind of light and not under another.

In discussing opaque inks in the offset printing processes, it is important to keep in mind that they are not truly opaque. Theoretically, an opaque white printed on a red paper should be completely white. In the offset field, however, if what is called opaque white is printed on red paper, the resulting color would be a pink because the printing ink does not have the hiding power to block out the red. This is due to the fact that the offset press cannot lay down the amount of ink that a silk screener can or that can be put on a wall with a roller or a paintbrush. For that reason, paper will affect the color dramatically. Even when a swatch is a printed sheet of color from an ink book on white paper with a specification number, there are dozens of different colors of white, and each paper mill manufactures a white paper to different color specifications. A transparent color will look different printed on a neutral white sheet of paper than it would printed on a blue-white paper. Therefore, there has to be a compromise because paper *will* affect the transparent ink layer of color.

Another variable occurs in the printing process. Laying down a particular ink at a given film thickness will result in one color; printing that same ink at different pressures on the press will result in another color. The color can lighten up or darken up. It can be stronger or weaker, all from the same can of ink, based on the variables of printing. The variables of printing are not only paper, but the condition of the press, attitude of the pressmen, how the oil and water combination—or in this case, ink and fountain solution combination—is balanced. In many cases, we recommend that a densitometer be used to establish an initial reading of the approved color and then check for density readings of that color throughout the run because if the density changes, the color result will change.

Q: Why are there some colors that just cannot be achieved with the four-color

THE PANTONE MATCHING SYSTEM

The PANTONE MATCHING SYSTEM was developed in the early 1960s to make order out of the color chaos that reigned in the fields of design, printing and ink manufacturing. Before the system evolved, designers were tearing off pieces of fabric, silk-screened swatches or just about anything that featured the color they desired to match in their print project. As a result, colors were being matched in the pressroom and at the ink manufacturer, and these matches were time-consuming and costly. These conditions also raised questions such as: How much will the ink companies charge for a match? Do they charge for the actual time it takes or is there a standard rate? Will the printer pay for it? Will the client accept the match? All too often, the answers to these questions were incongruous. This confusion resulted in Pantone's development of a unique color system that printers *and* designers could use, thus marking the first time that a company unrelated to the manufacture of inks had developed a system to benefit all users. Because Pantone receives no royalties on the sale of ink, nor do they sell ink, printers have the freedom to choose the brands of inks they are comfortable using when matching a Pantone color.

The first book that was developed in the system was a handbook for printers, titled the "Pantone Color Formula Guide." Because the original market for the system was commercial printing, it was decided that the Pantone colors shown in the book had to be readily available and reasonably priced. The colors were initially limited to approximately 500 and were named and translated into formulas using the eight PANTONE Basic Colors, plus black and transparent white. As a result, the formula or recipe allows the printer to mix that color with reasonable accuracy. This color book is still printed and distributed to ink companies.

However, designers needed more than color books in the hands of their printers in order for them to use the system. Designers would not need to know the formulas for mixing a color; they would just need an example of the color itself. The book invented for the designer, then, was titled the "PANTONE Color Specifier," and it allowed graphic artists to tear out a color chip (a printed ink sample of their specified color) and attach it to their artwork. In this way, the designer, client and printer could speak the same color language.

In addition, a line of colored markers, overlays and printed paper were developed so that the designer could do presentations, layouts and comps in the same color specified for print. Such design materials can only *approximate* the colors in a printer's "PANTONE Color Formula Guide," because markers are made of dyes, and overlays are printed on matte acetate.

Even for special printing applications, such as packaging or outdoor signage, designers can still communicate their color selections with the Pantone system. However, their printer will have to ignore the specific formulas in the "PANTONE Color Formula Guide" because in order to meet specific product requirements, these printing projects require specially mixed inks with different pigments. These specialty inks, of course, will be costlier. For example, there could be a special Federal Food and Drug Administration requirement, dictating that colors on a package be more permanent than commercial inks; or the packages may have to be varnished or plastic-coated.

For this reason, it is imperative that the intended end use of the printed piece be communicated to the printer.

Because the Pantone system is used by virtually every ink company in the free world, this universality factors into the success of your printed project. Of course, designers are most likely aware of some of the other color books in existence; there are, in fact, two in Japan, one in England and one in Germany. But unlike the Pantone system, these books are produced by ink companies and feature flat ink colors only. Should you use one of these books for color selection, make sure that your printer can locate the ink. You might also ask your printer if he or she has run that kind of ink before, because if any press time is wasted, it is the designer who must indemnify the printer.

Changing trends in color, evolving technology and the ever-increasing use of color in all aspects of design and production recently prompted Pantone to add 232 colors to the existing palette, thus creating the PANTONE MATCHING SYSTEM 747XR, the first major expansion of the system in 25 years. New clean colors, muted colors, deep tones and a new Basic Color, PANTONE Violet, have been added in the color expansion. Eleven PANTONE Warm Grays and 11 PANTONE Cool Grays have also been added. This extended color system was designed to provide designers with a large enough selection to satisfy most every critical color requirement. And even if you find, one day, that you need a color in between one of those 747 "standards," do not despair: With the help of an expert ink maker, your printer—and, of course, a few more dollars in the printing budget—it *can* be achieved.

—*Jack Siderman*

process? Does this mean a special fifth color pass has to be specified?

A: There are limitations in colors that can be achieved using four-color process, which is a limiting visual reproduction method. The colors themselves are not particularly appetizing. Process magenta is a dirty color; process cyan is a dirty greenish-blue. However, the best warm-orange is 100 percent yellow (which is clean) over 100 percent magenta (which is dirty); therefore, the combination will be dirty. If you print magenta over greenish-cyan, you are going to get a dirty purple. Solid colors are much brighter and cleaner than a combination of two dirty process colors. Even so, colors still have to be combined to make flat colors and as a result, clean colors are unattainable. In many cases, combining the four process colors and their screens can give a myriad of effects that may be acceptable. However, when clean color is imperative, consider producing it as a fifth color pass—a solid color pass—on the five-color machine. Pantone has created a product called the PANTONE Process Color Simulator which shows the closest result to a PANTONE Color in the four-color process. It also shows colors that cannot be replicated. If a company is well-known by a specific color and is running a four-color advertisement, it pays to maintain that identity by running that color as a solid, especially if you know from experience that that color will not reproduce with reasonable fidelity in four-color process. Obviously, it costs more to run five colors—up to 25 percent more. But it may cost less if the printer only has five- or six-color equipment.

Q: Experience has taught most graphic arts professionals that the brilliant colors seen on a color proof are not always the colors that can actually be achieved. How can the color gap between proof and printed piece be bridged?

A: Because the Printing Trade Customs allow for "reasonable" variations between color proofs and printed colors during a press run, it is up to the graphic designer to decide just how much deviation from the proof he or she will accept during that run; and, of course, this depends on whether the job requires what the industry calls either "pleasing" or "critical" color.

But the best way to answer this question is to back up a bit and address the inherent limitations in the color preview process itself. There are basically three ways to preview color for printing: 1) progressive press proofs (or progs); 2) one-off pre-press color proofs (Cromalin, Matchprint, Spectra or Color Key); 3) having the printer do a "drawdown."

Depending on the importance of a job, sometimes the cheapest thing to do is run a press proof on the actual paper. Less expensive than progressive press proofs are the four-color process proofs such as Cromalin, Color Key and Spectraproof (a new proofing system that is licensed to produce PANTONE colors, from Polaroid Graphic Imaging.) These are reasonably accurate in showing what the job will look like on press and are the most popular way graphic artists preview color.

The least expensive (and worst) color proofing method is an ink drawdown, which entails having the printer spread the actual ink on the actual stock to be used in the job. Because drawdowns are nothing more than a palette knife spreading ink on a piece of paper, they are, in my mind, a totally useless method for previewing a color. Obviously, the color achieved with a knife and its inherent lack of control is going to be much different from what will be produced on a printing press running a very thin film of ink.

Q: How will the emerging electronic technologies affect the way in which we preview and achieve colors for printing?

A: Indeed, the use of color is exploding and the future for color is exciting. The major changes that I see coming are in computer-generated film. The equipment, which is becoming lower in price each week, creates original color artwork on a video screen and then translates that video artwork into full-image pages of color. These pages are then translated into actual offset film that can be used for making plates. The problem with this, though, is that the color on a video screen is far more limiting in brilliance and reproductive quality than what appears on a printing press. The ideal machine would be a high-speed computer print machine able to print in accurate colors—similar to what occurs in printing. Although I have no doubt this machine will be developed, it is far from a reality. When it *is* developed, it would become in itself a short-run printing machine able to produce color proofs perhaps in quantities up to 500—which becomes the actual job in some cases. But this, in turn, would have to have some sort of prepress proofing system.

A generation of offset film from computers is here now, although in limited use. The process takes separations made by a scanner and feeds them, with the rest of the copy, into a computer that produces the film. If the printer or prep house wants a proof of this, he or she could make proofs using the Cromalin, Matchprint or Spectra systems. Eventually, all of these computers will become mechanical or automatic, and even the proofing systems will be hooked in so that the end result includes films and proofs. Or better still, proofs could precede the film so corrections could be made before final film.

Remarkably, computer-generated film processors can actually make one percent steps in their process film, which means, for example, that for a color of yellow, a screen of one percent and in one percent increments can be made. This one percent is much finer and tighter than what the average printing press can hold, which means that colors that never existed before can be achieved, but may not be reproducible on a printing press. This, too, will require some type of a reference book and Pantone is looking into this for the future. ■

Color Electronic Prepress Systems

How graphic artists can use color electronic prepress systems (CEPS).

Digital imaging for the graphic arts, which was in its infancy only five years ago, is reaching young adulthood. Although it will be several more years before it can be called a mature technology, the graphic arts business has begun to reap both productive and creative benefits.

The reasons for this growth are based on technological advances and a new acceptance by the creative community. This community includes art directors and production staffs at agencies, designers and conventional retouchers. According to Charles Rosner, senior vice president and group creative director at Lord, Geller, Federico, Einstein, "Computerized retouching is the tool of the year for us."

The final printed products produced may look the same, but the tools, work environments and skills of the people contributing to their creation and production are rapidly evolving. Among the tools which have enabled such changes to take place are four-color electronic retouching and pagination systems.

In the beginning, most of these systems were in production-type environments, such as color separators, printers and publishers. Today, more than 500 such operations of varying sizes exist in the United States alone. But an interesting shift is now taking place. Use of such systems is moving into more creative applications and environments, such as retouching studios.

There are several reasons for this migration of technology closer to the end user. As already mentioned, there are a larger number of installations in comparison to the "early days," making electronic services more accessible. Clients of the color separators, usually agencies, are more sophisti-

Image Assembly Three original transparencies—the car (top left), the columns (below left), and the marble foreground (above right)—were digitized, electronically stripped and retouched. Final output was a second generation transparency (below right) which was used for final separations. Joe Pedone, Saatchi & Saatchi DFS Compton print services director on this project, says, "Time constraints are a

R4030 *SAATCHI 1 *FRGHD * 1987-09-08*16-16

R4030 *SAATCHI 1 *FP 2 * 1987-09-03*1

focal point on why we use this technology.'' All initial digital work on this ad for Toyota Canada, Inc. was completed within two days. (Agency: Saatchi & Saatchi DFS Compton; Art Director: Tom Gardner; Copywriter: Rod Lokody; Photographer: Shin Sugino; Art Buyer: Jo DiSalvo; Electronic Imaging: ZER.)

cated and are now demanding electronic services and products. Their clients, in turn, usually large corporations, have embraced electronics in their day-to-day operations and are demanding similar services from the agencies.

Previously, the color separator's main agency contact was the production department. As separators move into the retouching realm through electronics, contact is shifting to the agency creatives. It is not unusual for the electronic retoucher to receive a call from an agency in the ''think-tank'' stages of a concept, to consult on art creation for more efficient digital processing later on.

The encroachment upon what is commonly considered to be the conventional retoucher's turf has resulted in another shift. When electronics first began to threaten their livelihood, retouchers said the ''electronic operator'' was not an artist, but a technician who lacked the sensibility to handle delicate photo retouching. Within a very few years, however, such claims were challenged by the electronic shops, and the conventionals had to rethink their futures.

The end result may be marriages of retouchers to production shops that are already experienced in electronics. One unique company is ZER, Zazula Electronic Retouching. ZER is an alliance between Hy Zazula Retouching Studios, an established conventional retoucher in New York City and Potomac Graphic Industries, an electronic trade shop. According to Jack Lane, president of Potomac, ''By combining the aesthetic talents of creative retouchers with the knowledge of good separation techniques, we have a reservoir of unbeatable talent for the new world of total electronic print preparation.'' Zazula, on the other side, believes, ''It's better to have the capabilities of giving the art director a choice of computer or conventional retouching or a combination of both.''

Other conventionals are taking the ''go-

it-alone'' approach and have purchased digital equipment on their own, such as Spano-Roccanova Retouching, Inc. and Frenchy's Color Lab, both in New York City. This type of electronic studio will not only have to learn a system's operation, but will now have to become color separators, knowledgeable of printing specifications as well. As more retouchers accept electronics, resistance from the creative community will break down.

HIGH-RESOLUTION SYSTEMS

Often referred to by many names, a term that best describes digital equipment for graphic arts production is the color electronic prepress system, or ''CEPS.'' Such systems handle all prepress operations from initial scanning of continuous-tone color art and keyline, through the production of high-quality, final plate-ready films for engraving (for example, separations). Currently, there are four major vendors producing these high-resolution production systems. They are: Crosfield, Dai Nippon (D.S. America), Hell (HGS) and Scitex. On the average, an initial investment in such equipment will require a capital outlay in excess of $1.5 million, which does not include installation and annual service charges. Cost is another factor which slowed earlier widespread adoption of the technology.

A key term to keep in mind is ''high resolution,'' which defines whether final films will meet print quality reproduction standards. Resolution refers to the number of pixels (data detail) which the electronic scanner assigns to the original artwork.

In video or paintbox systems, resolution is limited to the monitor's resolution, generally 512 pixels square. The total number of pixels possible is 262,144, regardless of final output size. This means that an 8½ x 11-inch image will have no more original pixels than the same image at 35mm size. Although there are methods to increase

the number of pixels once an image has been digitized, such methods cannot improve upon detail that is not there.

True electronic prepress systems have control over resolution, which can be varied by the type of artwork and final printing requirements. Print resolutions will average between 10 and 12 pixels per millimeter (between 254 and 305 pixels per inch). This translates into 64,516 or 93,025 pixels per square inch on the original input scan.

SYSTEM STAGES

Jobs are processed in three distinct steps, regardless of the vendor.

INPUT Continuous-tone flexible art, in the form of color transparencies, reflective art or black-and-white prints, is digitized on an electronic scanner. Sizes ranging from 35mm up to approximately 16 x 24-inches can be scanned. Artwork is converted into numerical information points (pixels) and is usually stored on 300 megabyte disk drives as picture files.

MANIPULATION All picture files are electronically retouched, color corrected and stripped (paginated) on the color console. As system design evolves, a ''modular'' trend toward separate workstations for correction of color art and pagination has developed.

OUTPUT The corrected images or final composed pages, which are stored digitally on the disk drives, are sent to either a film plotter or output scanner unit. Either screened or continuous-tone film separations are produced. Images and pages can be resized and rescreened for various publications by typing in a new set of exposure parameters for additional film. As an alternate to film, second generation ''originals,'' either prints or transparencies, may be produced, reflecting all digital manipulations. This output method requires a specially designed, high-resolution, color digital proof recorder.

STORAGE During job scanning and workstation manipulation, all files are stored ''on-line'' on 300 megabyte disk drives. Once completed, files are written to mag-

netic tape for long-term storage (typically 90 days to one year.)

MANIPULATION FUNCTIONS

Once artwork has been digitized, an endless array of electronic functions is available to the system operator. Picture files are called from the disk and viewed on a high-resolution color monitor. Electronic tools include the mouse (or stylus) and electronic tablet, with functional enhancements through the use of digital keypads and multiple menus.

Manipulation capabilities at the color console fall into three distinct electronic categories.

COLOR CORRECTION This allows for global (overall) or local (defined through a mask) color shifts and the matching of specified tints and samples. A color recipe must first be determined for the process color values (cyan, magenta, yellow, black) ''off-line'' by conventional means, and then converted to the corresponding percentage values on the console. This does not happen by magic, but requires knowledge of the four-color printing process.

RETOUCHING Often called electronic airbrushing, this procedure allows for erasure, exchange and enhancement of the original pixels. This might include adding leaves to a tree, removing facial flaws or shaving off 25 unwanted pounds of flesh. One such technique is often referred to as ''cloning.''

PAGINATION Electronic stripping, as it is also called, allows for complex composition or page editing. Numerous picture files may be combined with computer-generated backgrounds, tints, geometric windows and electronically ''cut'' silhouettes. Text from a front-end system may also be added during this stage. This will usually be done in a publishing environment, but not at a color separator.

ELECTRONIC VS. CONVENTIONAL

One of the best ways to compare conventional job preparation, especially retouch-

ELECTRONIC IMAGING TERMS

The following is a glossary of terms that are used frequently in connection with electronic color imaging systems.

CCD Charged-coupled device—a light-sensitive diode.

CEPS Color electronic processing system (also known as color electronic pagination system).

Clone To reproduce electronically through the duplication of individual pixels or groups of pixels.

Color correction The addition or reduction of one or more of the four process colors to match submitted swatches, products or personal taste of the client.

DDES Digital Data Exchange Standard. A software format being developed by the IT.8 ANSI Committee which will interface the major CEPS's via magnetic tape.

Digital imaging The conversion of hardcopy art into digital images and further processing thereof on computerized systems.

Digitize To convert into numerical points of information called pixels; often used in place of the term "scan."

Digital retouching Alteration of images through pixel modification or replacement.

Electronic airbrushing Airbrushing performed on digital systems using an electronic stylus or mouse. A form of digital retouching.

Front-end A system, put "in front" of the main system to supply additional information or data.

Hardcopy Tangible material or art.

Interface Electronically connected or wired together to enable the transfer of data.

Pixel A picture element; the smallest unit of information of a digitized image.

Resolution (RES) The number of pixels per linear measure (for example, per inch or per mm). Print resolution is generally 10 to 12 pixels per mm. Video resolution is generally limited to 512 pixels in width, regardless of the image size.

Raster Image Processor (RIP) Hardware and software used to convert vector data to (raster) pixel data.

Scan To convert hardcopy into either film or digital separations.

Second generation art Digitally-produced transparencies or prints in continuous-tone color; usually made after extensive digital color correction and retouching.

Soft proofing Job approval on color or video monitors instead of on hardcopy proofs; usually limited to layout and retouching approval—not adequate for finite color.

User Refers to a company or individual who uses and/or owns computerized equipment.

Vendor A company which sells and usually services computerized systems and software.

ing, with electronic methods, is to look at the benefits and drawbacks of the newer methods.

BENEFITS Even if the technical magic were ignored, the rapid turnaround time which electronics can offer was previously impossible. Conventional dye methods require several days and often more than a week for corrections. Retouched art must still be separated, requiring an additional six to eight days to reach ink-on-paper. With electronics, a normal turnaround time of six to eight days includes all retouching, stripping, press proofing and film separations. This can also reduce expensive overtime. Furthermore, when time is of the essence and money is no object, electronics can produce a job overnight, including extensive corrections.

With an eye on quality, electronics can start with the original art, such as transparencies. Conventional methods generally require dupes or enlargements, resulting in loss of color and detail fidelity. Furthermore, the instant zoom or enlargement capability of the CEPS monitor allows for finite retouching at the pixel level and intricate silhouetting. Electronic stripping, whether process-to-process or process-to-tint, produces perfect butt fit.

Although dyes and chemicals used by conventional retouchers have been improved over the years, there still is the possibility of today's separation methods (scanners) detecting subtle differences in color densities caused by hand retouching. This often results in "shoot-through," a staining effect which can be seen on the separations and printed product. This does not happen with electronic methods since retouching is actual pixel modification.

Since color values are measured through sophisticated densitometry and changed with finite color controls, adjustments of one percent through gross moves are exactly achieved. In contrast, conventional correction methods on art or film rely on personal judgment, which varies with the craftsperson.

Once a job is stored in digital form, there are almost no limits for re-utilization. Resizing and rescreening can be done for var-

ious publications, perfectly duplicating previous corrections and color reproduction. Both time and dollars are saved while continuity for all publications is assured. Conventional methods require a new scan each time another film order is placed, running the risk of vast differences in each publication.

With regard to creativity, both conventional and electronic methods depend upon personal skills, experience and "the hand." In the early days of electronics, one of the best defenses of the "conventionals" was their hold on creative sensitivity. Now that retouchers themselves have gone electronic, and many electronic operators are well-seasoned through experience, such claims no longer hold true. In both worlds, jobs are still assigned to craftspeople based upon their skill level.

COST A major question is always, "What does it cost?" A few years ago, the cost was seen as a disadvantage. This is no longer true. Hourly rates, formerly between $700 and $800 per hour, have dropped. Depending on the geographic area, rates now range from $250 to $600. (A word of caution: Choosing suppliers on the basis of lower hourly rates may not result in a lower final price. They may take twice as long as the more experienced, higher-priced supplier.)

Jobs handled by conventional dye retouching can add up on the basis of dye cost, labor and overtime, if extensive corrections and reworks are required. At this point, agencies have had enough experience with electronic costs to realize that they are comparable with conventional methods. Furthermore, some find speedy delivery times can offset the price paid. On a recent job for Toyota Canada, Saatchi & Saatchi DFS Compton used ZER to process a rush job. (See opening spread.) According to Joe Pedone, senior vice president print production, "We had several pieces of artwork and were able to compose that art in a faster turnaround, and I believe the cost will be substantially lower than conventional methods."

DRAWBACKS: WHAT ARE THEY? It may appear that electronics can do anything and everything. However, CEPS is not the magic answer for every problem. As a rule, rendering new images or areas "from scratch," airbrushing broad areas, and certain types of soft vignette techniques are still best suited to traditional methods. These limits are due to the high density of pixels required to define images and the need to work section-by-section on the monitor. However, such limits are being overcome with hardware and software improvements.

Both conventional and electronic methods have their own unique drawbacks. However, the new "marriages" which take advantage of both techniques will probably win out, technically and creatively. This may mean some conventional retouching of art before digitizing or most retouching and composing done electronically with some minor touch-up done on the second generation digital "original."

Another area of digital concern is system management. According to Pedone, "There is a need for a controlled environment and definitive procedures when using electronic techniques." Experienced suppliers can provide the answer.

AN AID TO PHOTOGRAPHY

As digital processing becomes more widespread, even photographers are beginning to feel the effect. Since electronic systems can work with the original transparency, the integrity of the art is maintained. The photographer who understands the speed and flexibility of electronic capabilities can begin to incorporate this into their way of working. What cannot be accomplished with the camera alone may be possible through a series of shots and the computer's help later on. In defense of photographers, the most important element of the job is a good quality photograph. The old cliché still holds true: "Garbage in, garbage out." Even electronics cannot create detail or focus that does not exist in the original.

SPECIFYING THE 'ELECTRONIC' JOB

ART MARKUP AND MECHANICALS Jobs handled by color separators usually require a tight conventional mechanical. There is no difference in the preparation of the mechanical, whether the job is to be done by conventional prepress methods or by a CEPS. If good rapport has already been established with an "electronic" trade shop, however, it may be possible to short-cut some mechanical specifications. Abbreviated mechanicals may be applicable for certain types of jobs, but not for high-quality ad work.

Generally, color separators do not handle type as a digital element. It will be photographed conventionally and superimposed into the final four-color films by means of a fifth film "burner." This method can prove cheaper and faster for both initial type handling and last minute revisions.

Color and retouching corrections on color art should be clearly specified, similar to markups previously done for conventional retouchers. Inexpensive color prints or black-and-white stats, with written instructions, should be used for positioning. When larger transparencies are submitted, markups should not be done on the protective plastic casing. Grease pencil rubs off too easily.

COMMUNICATION Whether a full-service electronic prepress trade shop or electronic retouching studio is being used, good communication is essential. As corrections become more esoteric, it becomes even more important.

This communication must work at two levels: At the agency, through the supplier's salesperson; then, back at the shop or studio where instructions must be re-communicated. A more experienced "electronic" salesperson should be able to offer a wider range of solutions, without promising the impossible.

FUTURE FORECAST

Digitization of the graphic arts will continue at an accelerated rate. In short, we are approaching the filmless society. More and more, film and hardcopy will be replaced by digital formats. This will include all phases of a job, including comps, photography, separation, retouching, proofing

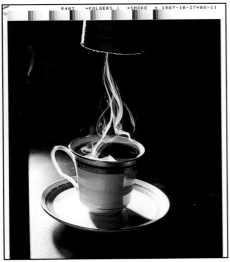

Secondary Enhancement The main shot for this Folger's Coffee ad (above left) did not have the steam necessary to complete the photo. The steam was provided by a secondary transparency (below left). Electronic manipulation accomplishes corrections and final film separations in one continuous production flow. (Conventional manipulation would have required manual stripping and dye retouching.) Furthermore, options for reuse of an electronically retouched image remain flexible. (Agency: Wells, Rich, Green, Inc.; Client: Proctor & Gamble; Senior Art Director: Bob Wilvers; Copywriter; Mike Chappell; Production Director: Harold Singer; Production Supervisor: Vickie Gillis; Electronic Imaging: Potomac/ZER.)

and finally, transmission of digital pages to the printer. This is not to say that all conventional ways of working will disappear, but due to the requirements of speed and flexibility, digital methods will prove more effective for many applications.

DESIGN Many art directors and designers have already begun to incorporate electronics into their comping work through the use of systems from low-end Macintoshes to higher end systems, such as Lightspeed and Contex (for packaging). In most cases, designers are seeing creative enhancement and flexibility. Unfortunately, there is still no definite link for transferring the digital comp to the high end production system. A conventional mechanical must still be prepared and submitted to the separator who in turn ends up redoing his own digital mechanical.

RETOUCHING Will electronic methods replace conventional retouchers? From a retoucher's point of view, Zazula feels that, ''There will always be a place for the skill of a retoucher, but he will probably lose about fifty percent or more of his work to technical advances of digital retouching.'' Similarly, on the agency side, Pedone says, ''If equipment could be programmed with all of the human elements and nuances, yes. However, until that time, conventional retouching will still have a role.''

STANDARDS A major effort is currently in progress to establish digital standards which will enable the transference of data among all forms of graphic arts digital imaging systems. Starting out as the DDES Committee (Digital Data Exchange Standards), the group now known as IT.8 is now accredited by ANSI, having official standards power.

Initially, trade shops, printers and publishers with unlike CEPS equipment saw advantages of being able to exchange digital information. Unfortunately, all of the ''Big Four'' CEPS vendors write their software in different formats. Through the joint efforts of systems users and a vendor group, DDES has grown to include several levels of digital applications. A common

tape format is in development as the first exchange medium.

This standard or others will not change the graphic arts world overnight. Extensive testing will be required for each interface application. However, thoughts of color networks no longer seem to be so farfetched. Although data may currently be exchanged between like-vendor systems, a common format will enable free exchange of data among varied equipment.

PROOFING Up until recently, one of the major shortcomings of digital imaging production systems was the lack of second generation "originals." Agencies, in particular, were used to having their own retouched prints and transparencies for reuse, as well as a permanent record of all corrections. This is now possible in the digital world also. One such unit, Hell's CPR403, can produce a high-quality continuous-tone color print or transparency after a job has been digitally processed on the production system. Uncorrected art can be scanned, passed onto the color console for electronic retouching and turned out as a final print or transparency. The overall time for such turnaround will vary, depending upon the amount of correction work required. This new "original" can be treated as any original photograph or piece of artwork.

Furthering the concept of immediate gratification are remote viewing terminals. Two such units are currently being marketed by Lightspeed and Kodak, and others will follow. A host or primary unit is interfaced to the supplier's CEPS. Receiving or satellite units are installed at client sites, such as an ad agency or a corporation's design department. Images are transmitted over phone lines to the client site for approval.

Although this might sound like the magic answer to rapid turnaround time, all work cannot be judged on a monitor, color in particular. A video monitor is not the equivalent of ink on paper. "Soft proofing," as the process is often referred to, may prove applicable for the approval of layouts, stripping and some retouching. Only further use will prove whether or not such units are a valid tool or merely another electronic gadget.

YET TO COME Digital cameras, although not yet for everyday use, will eliminate the need for a darkroom. This technology will have a profound effect on photographers of the future. Sony's ProMavica electronic disc camera is one such product. A still video floppy disk captures the image, which is then processed in a portable transceiver. The color images can then be transmitted over phone lines and dumped into production systems for digital correction and pagination. Photojournalism could be revolutionized with these new capabilities, which would make it easier to handle last minute stories and still make production deadlines. The only drawback might be the absence of a permanent hardcopy record which we now have with conventional film.

Optical disks will become the mass storage medium of the future for these digital photographs and for CEPS work. Some large photo stock houses, such as The Image Bank, are already using this technology. It is not unlikely to expect photographers' portfolios of the future via this medium. Most digital images today are stored on magnetic tape which can be cumbersome and requires extensive footage per image.

NEW ISSUES: LEGAL AND ETHICAL

The phenomenon of digital imaging raises many business, legal, philosophical and aesthetic issues. For example, the digital input and manipulation of photography, raises problems of authorship and copyright. Of course, retouching and photoassembly are not new. The major differences with electronics are that modification and manipulation are easier; and the tools to do this are now placed in new hands. Should it be assumed that more people will now become unethical because the means to "alter reality" are more readily available? One safeguard against any misuse of digital power is choosing only reputable suppliers. Self-education on the powers of graphic electronics will be another means of self-protection.

From the creative point of view, the issue of "original" art could become *the* issue of the future. What is original art? Is it only the first generation photograph, painting or illustration? Can "original" also include computer-assisted modifications and enhancements? Does it also depend on *who* performed the enhancements?

Most of the digital imaging referred to here is of the "modification" type, similar to the functions formerly performed by conventional retouchers and chrome assemblers. In the future, there will be more total synthesis of entire images. This is currently being done in the video/animation field, mainly for "out-of-time" and "out-of-space" surrealistic visions. However, future print systems are aiming at creating reality, on their own or through interfaces with video technology.

As the use of technology increases in the graphic arts marketplace, such questions will multiply. Legislation and trade customs are being established, but will surely change with the rapid introduction of new products and applications never thought of before.

THE END OR THE BEGINNING?

An attitude and ability to adopt new technology can open both new creative options and business opportunities for those with foresight. Every step in the production of a printed product will be affected by electronics: photography, design, prepress, archiving and final production. Traditional crafts and skills will not become obsolete, but can be enhanced with knowledge and understanding of this digital technology. Although there is much discussion about the future of artificial intelligence (AI) in other fields, graphics systems are still relatively unaffected, except for repetitive tasks and calculations. This means that creative ideas still have to come from the original source—people. The human element will still play the leading role in the graphic arts for years to come. ∎

—*Melene Follert*

"Scitex-ing" Your Color Art

How graphic designer Jayme Odgers produced the artwork for the cover of this guide with equal parts design savvy and electronic wizardry.

"It's kind of like rubbing your tummy and patting your head," jokes cover artist Jayme Odgers, when asked if he enjoys sitting down at the Scitex console and designing with the mouse. But this is not the voice of convention, or of inexperience. He has simply worked with sophisticated color electronic systems long enough to know that it is sheer folly for artists and designers to think that because they have mastered the mouse on their Mac, they can sit down at such a console and attempt to finesse their designs as well as trained computer artists can.

In a more serious tone, Odgers reasons why systems like the Scitex are ideal tools for certain projects: "When the Scitex first came out, it was going to be the big new revolution, changing life as we've known it. And I must say, at a certain level, these kinds of systems do that. You can take four or five transparencies, and bingo, they are together and you can move them around at will. For some kinds of jobs, this capability just can't be matched by any other tool or technique. Especially since you are working with the original; you don't lose any generations, unlike composite chromes, composite prints or prints made from composite chromes that are then air-brushed or painted on, and only later are they wrapped around the scanner. So in this regard, systems like the Scitex allow for a level of crispness and perfection that simply cannot be beat."

Of course, Odgers quickly adds that there are techniques for which the Scitex is not well suited. "Like that little bit of airbrushing that you can do in two minutes, but that takes half an hour on the computer." If you are not an experienced artist to begin with, Odgers stresses, you

1. Odgers began by searching his files for past projects that featured graphic arts-related objects. Items from two different projects were ultimately selected. One 8 x 10, originally created with several collaged and retouched prints for an interior design trade workbook (the Artists & Tradesmen Divider Page in *The Trade*), was selected for use as the background. The other piece, created by "Scitexing" separate chromes together, was first produced as a cover and poster for a Mead Paper Co. "Top 60" promotion.

will be just as limited when using electronic tools. Also, if the person operating the Scitex does not share your vision, he warns, you are working with a handicap.

"The real bottom line is the guy behind the airbrush or guy behind the computer console. That person can do a lot more than a machine. I've got many years of experience in art, drawing and visualizing. I can see what a shadow looks like in my mind; if the operator behind the console can not visualize it, how are they going to create it? So the better artist you are, the

better you will be when working with sophisticated tools like the Scitex."

What better way to demonstrate how sophisticated this tool is than to have Odgers himself — an award-winning special effects photographer and graphic designer—create the cover of the "Designer's Guide to Print Production" issue of *Step-By-Step Graphics* magazine using the Scitex system? In turn, the artwork he produced would be used for the jacket of this book. Odgers was the unanimous choice, not only because of his high level of Scitex-

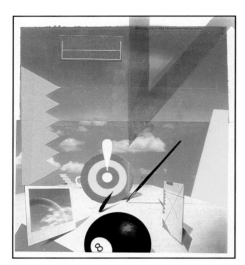

2 The acetate overlay on this layout indicates the items to be added to the original 8 x 10 chrome. The airbrushed blue sky is roughed in.

3 These new comps feature several changes, such as the replacement of the eight ball with the metal type slug of "A," deleting the exclamation mark in the bull's-eye, deleting the pink zig zag, among a few others.

literacy, but also because he takes an extraordinarily fresh and graphic approach to these kinds of collages. In this way, the cover project can provide graphic designers with a real-life experience that demonstrates how a leading artist pushes the limits of the medium.

What follows is a re-enactment of this cover project, concept to finish.

STEP ONE
The idea for the collage actually began with the concept of showing, in a colorful and surreal landscape, various props associated with the graphic arts and print production in general. After discussing the basic concept, Odgers sent for approval tearsheets and printed samples of pieces he had already shot and collaged for many past commercial and self-promotional projects. They featured lots of different subjects, from X-Acto knives to painter's palettes. The subjects most appropriate for the cover were selected with Odgers's help, and he began roughing out various conceptual approaches to their assembly. (See Figure 1.)

STEP TWO
There was little need for pencil sketches on tracing paper, since Odgers could simply photocopy the images and experiment with positioning in that way. His first rough layout, for example, featured an acetate overlay indicating the items he would add to the original 8 x 10 transparency that featured the sky and white platform background. He roughed in more airbrushed blue sky and suggested that the bull's-eye and the eight ball would be "Scitex-ed in." Or the bull's-eye could be stripped in as "Benday callouts," he thought. In his note attached to the layout, he mentioned that the small vertical rectangle to the right of the bull's-eye could be the whole cover minus type, stripped into that spot.

"A cover-within-a-cover idea," he suggested. "If that won't work, then it can be the graphic structure, as indicated." (See Figure 2.)

Reactions to the rough included comments like "fun," "colorful," "lots of movement," and, ultimately, "It's a go — with just a few minor additions and deletions."

STEP THREE
The changes that were discussed and agreed upon by all included: replacing the eight ball with the metal type slug of the letter "A" (a chrome Odgers also had in his files), getting rid of the exclamation mark in the bull's-eye — Odgers decided to add two more that would fade into the background — and also deleting the pink zig-zag, which the designer had originally planned to strip in just as the descending pink triangle would be stripped in — although the pink triangle was much more transparent. (See Figure 3.)

STEP FOUR
It was at this point that George Rice & Sons was contacted, the large Los Angeles–based printing company that operates a full-service and highly sophisticated color prepress operation, complete with three scanners and a 5-Track Scitex Response 350 System. This educational project interested their color department, whose Scitex is used primarily for retouching and color correction. Since Odgers's studio was also based in Los Angeles, they could meet

throughout the project to review progress.

PLANNING In his first meeting with electronic prepress manager Greg Goldman, Odgers explained that in addition to scanning in all of the original transparencies and positioning them according to the layout, he thought some retouching as well as new art would have to be created on the Scitex. "I knew there would be no need for keyline art on the bull's-eye, for example, because all they would have to do is create one and copy that one for the other two. I could just give them the coordinates for the first circle within the bull's-eye and they could create from there."

LESSON IN PERSPECTIVE It was in this first meeting that Odgers approached Goldman with his "cover-within-a-cover" idea. "We talked about it and they said they couldn't do it, that we only would have been able to fit half of the cover in the panel since the top angle and bottom angle of the panel must have the same degree of perspective." The cover-within-a-cover idea would have worked, continues Odgers, if the horizon line had run directly through the center of the panel. "This lesson in how the Scitex makes perspective taught me that when an object is well below or above the horizon line, the computer just cannot put it in the desired perspective."

SCANNING/COLOR CORRECTION Each chrome was individually scanned into the system according to a rough layout Odgers provided — including the 8 x 10 landscape, the 2¼ x 2¼ knife, the 2¼ x 2¼ "A" and the 2¼ x 2¼ triangle. The triangle was the only transparency that Odgers had to shoot in-studio with his Hasselblad medium format camera. They were then checked for size, angle, crop and color balance. At that point they were digitally stored on a disk and the image was then transferred to magnetic tape. Next, the stored information was output to separation film so color proofs could be made and viewed before retouching or page make up.

"Although we knew what retouching needed to be done," says Goldman, "we always feel it is beneficial to show clients our first Cromalin proof. Then we re-scan the transparencies, if necessary, rather than doctor up color on screen. In this case,

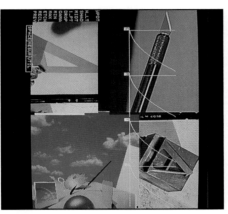

4 After Odgers reviewed random proofs, he marked images up for color correction and retouching, and cut them up for his comps. Detailed masks were cut for each subject. Here you see the elements on screen, ready to be positioned.

Jayme viewed random proofs of all images first, which he marked up for color correction and retouching and then cut up as mechanicals, like putting pieces of a puzzle together."

Odgers offers this critical bit of advice at the scanning stage: Designers should be sure their layouts or comps accurately depict the desired angle of the images being assembled. "Once chromes are scanned in and on screen, you know you can move things up and down, left or right, make them bigger or smaller, zoom in or out, even make things transparent. But there is one thing you can't do: You can't change the axis that was scanned in on a particular transparency. If, for example, I had decided to tilt the triangle one degree this way or that, after masks had been cut and the image had been assembled, the Scitex operator would have had to re-scan that transparency at a different axis and then re-cut all the masks."

CUTTING MASKS After receiving the cut-and-pasted mechanical Odgers made from the random color proofs, Goldman began by directing operator Juan Corona to first cut detailed masks around the subjects.

5 Here the spray brush was used to create the shadow behind the large bull's-eye. Notice how this function can simulate, fairly accurately, the subtle look of an airbrush, since the operator can dial in specific dot percentages on individual — or all four — colors.

Those masks were used for placement onto the page, as well as for color correction. After he cut all the masks and did minor color corrections, he used the editing function to bring all the elements together on screen at once and move them into position. (See Figure 4.)

"Then the entire page was gone through in the 'Execute' mode to create two final files: one for the final continuous-tone element featuring the scanned images, and one for all of the line work — the geomet-

6 Here the copy brush option (also called cloning) was used to add a new cloud underneath the triangle, to enhance the triangle's transparency. As the name implies, the copy brush simply copies one picture area to another.

7 Cromalin (DuPont) proofs went back and forth between Odgers and the magazine's color department until the final cover image began to emerge. Once the last Cromalin was approved, final separation films were generated with a screen ruling of 150.

ric shapes and windows,'' says Goldman. The continuous-tone file is exposed through the line work and output on the Scitex output device, called the Eray. For example, two of the three bull's-eyes were continuous-tone images (CTs) and were ghosted through the sky. The center bull's-eye, however, was created on the system with clean and crisp line work.

STEP FIVE
According to Goldman, although the differences in cost between traditional re-

touching and Scitex retouching are minimal, the big difference is image quality. ''With conventional retouching, you are stepping one generation away from the original when a dye transfer is made. Scans of such retouched prints can never be as sharp as the originals in the system from which the end composite is made.''

The retouching functions on the Scitex provide designers and operators with a variety of airbrushing options: the spray brush, the copy brush, or the etch brush. The spray brush simulates the look of a true airbrush, in that the operator can dial in dot percentages on individual colors, or on all four colors at once. For example, the spray brush was used to create the shadows behind the large bull's-eye and the purplish-gray area near the paintbrush. (See Figure 5.)

KNIFE POINT Originally, Odgers had directed the Scitex operator to make the knife point appear as if it were cutting through the bull's-eye. A subtle shadow was also needed where the blade sticks in the bull's-eye, because it did not have adequate dimensionality. Because this shadow un-

der the X-Acto was a tricky one for the Scitex operators to visualize and, thus, would have taken much longer to do electronically than by hand, Odgers airbrushed it in his studio, and the color department scanned the new art in and cut a mask for it.

SKY AND CLOUDS Because the original 8 x 10 only provided eight inches of sky and the magazine cover called for nine inches, operators first had to stretch the sky before adding a cloud behind the triangle to enhance the triangle's translucency. They chose to use the scaling function to anamorphically distort a piece of the sky rather than clone a piece using the copy brush feature. It was simply too big an area to clone. As its name implies, the copy brush copies a picture area from one place to another. This feature was used, ultimately, to add the cloud behind the triangle. (See Figure 6.) Keep in mind that any percentage of transparency can be designated. For example, the background bull's-eyes were made to be increasingly transparent so that the clouds could show through. In addition, the wall divider with the red triangle line behind it was made to look transparent. Then a transparent bull's-eye was added to the panel to make it look like a mirror.

STEP SIX
Several meetings and marked-up Cromalins of the final composite later, the final cover image began to emerge. (See Figure 7.) Final separation films were generated with a screen ruling of 150. Because of the long-term storage capabilities of the Scitex, however, even after final output to separation films, operators can change the final page size, and screen rulings for later use or changes.

The final Cromalin Odgers sent was used for the cover of the magazine and was then adapted for use on the jacket of this book. This final version was printed in the four-color process plus film lamination — using the four separations generated by the Scitex. ∎

Dot Etching: A Viable Option

When electronic corrections are too costly, this mechanical process offers numerous possibilities.

With today's technology, much of the color correction can be done electronically, using sophisticated computerized color workstations. But sometimes the changes are too minor to use valuable and costly computer time, especially if your correction entails only five minutes of hand work on film. A $65 per hour charge for hand work is much cheaper than several hundred dollars for calling all the digital information back up on the screen and generating new film.

Before the advent of scanners, when process cameras were used to make all separations, corrections were always made manually by highly skilled craftsmen. These craftsmen, known as dot etchers, are still an important part of most quality color separation shops. Dot etchers, who are actually negative/positive film retouchers, are experienced in chemistry, photomechanical masking techniques, as well as fluent with airbrush, sable brush, pen and ink and needle/stylus.

Overall color corrections as well as localized corrections can be done manually. Overall corrections, known as flat etching, are the easiest to accomplish. Localized corrections, also called fine etching, take more time and materials.

To increase color, or increase the size of the dot, the dot etcher will work on film positives, which will eventually be contacted back to negative form to burn the plate(s). To decrease the color, or decrease the size of the dots, the dot etcher will work on film negatives. Ultimately, duplicates from the original negs or pos will be made and saved, as the dot etcher always works on the duplicates.

Using an acid solution, called Farmer's (reducer) solution, which the etcher must mix to the correct strength or pH, the craftsman will apply the solution either in a tray or by painting it onto the film to dissolve the silver off the top and sides of the dot, therefore decreasing its size.

OVERALL CORRECTION If an overall correction is required, the dot etcher will mix the Farmer's solution in a tray and bathe the entire piece of film in the tray, only after masking, or protecting certain elements such as crop marks, fold marks and any color bars or gray bars. In all cases, the dot etcher will first immerse the pos or neg in a water bath along with a few drops of wetting solution which will soften the emulsion protecting the silver and allow for uniform penetration of the acid.

If a five percent reduction of color is required, the dot etcher will mask all but the five percent area of the gray bar, found outside the live or printed area. As the Farmer's solution is dissolving the silver, the dot etcher can constantly monitor the progress, either with a magnifier or a densitometer, until he is satisfied that the proper reduction has been achieved. The dot etcher will leave the Farmer's solution on for only 15 to 20 seconds at a time, and will quickly neutralize it with water. If more etching is needed, he will repeat the process until the correction is made. Up to a 40 percent reduction in dot size can be achieved in manual dot etching.

LOCALIZED CORRECTION Should localized or fine etching be required, the dot etcher must manually mask the areas that he does not want dissolved by the acid. This process is known as staging. He will first place the neg or pos in a wetting solution, dry it thoroughly, and then, with the proper size brush, apply an asphaltum varnish or staging lacquer, carefully opaquing the areas to be protected. The areas to be reduced remain exposed. Again, all the crop marks, folds, color bars and gray bars—except for the percentage he is trying to achieve—must be masked. To break the sharp edge created by staging, graduated areas can be achieved by applying grease pencil or litho crayon to the negative. The staged neg or pos at this time can either be bathed in a tray of Farmer's solution or the solution can be applied with a brush to the localized areas. Once the reduction is achieved, water will be applied to stop the acid's action. This process will be repeated for every percentage required in every area needing correction. The dot etcher must work quickly because every batch of Farmer's solution will only last 15 to 20 minutes before it "self-exhausts."

ADDED APPLICATIONS

BLENDING If the final size of the printed piece is too large for the process camera or even the plotting unit of a scanner for separating in one pass, it will have to be separated in portions and eventually those portions will be recombined to burn the plate. In order to get a smooth, even connection, the two or more pieces will be dot etched at the edges to produce an unnoticeable joint.

INTENSIFYING HALFTONE DOTS Dot etching can also be used to intensify halftone dots. Most halftone dots have soft coronas surrounding them, but should a very crisp, hard-edged quality be desired (to achieve higher contrast reproduction), dot etching can dissolve the soft corona, leaving a "hard" dot.

ADDING LINE DETAIL Dot etching can also be used to add line detail. Thinned down opaque paints are usually used to recreate details in machinery or products, type or anywhere fine details have been lost during the photomechanical separation process. The opaque paint can be applied using a brush or crow quill, or scribed into the negative.

THE LAST STEP

No matter how skilled and careful the dot etcher may be, new color proofs are always a requisite to ensure that the work has been done properly and to the client's specifications. Therefore, either during some of the more difficult staging processes or after the dot etching is completed, new color proofs should be pulled. If the dot etcher has been working on positives, negatives must be made first, then contacted to proofing materials. ∎

—Daniel Dejan

Gray Component Replacement (GCR)

Art directors, graphic designers and production managers interested in improved color reproduction should understand Gray Component Replacement.

A color separation process that has been found to improve color consistency, stabilize neutral tones and provide for quicker color OKs has not yet been widely used—or understood—by separation buyers or printers. This process is called Gray Component Replacement, or GCR, and many color separation experts believe its time has come.

Gray Component Replacement refers to a color separation technique that uses the black printer for the neutral gray, or achromatic portion of any color, instead of a mixture of chromatic colors (yellow, magenta and cyan). In conventional separations, color is produced by some combination of cyan, magenta and yellow primary inks. The two predominant color inks used in the image determine the hue, or color, of the overprint, while the least dominant third ink primarily darkens the color to give the image "shape." This overprint of varying dot areas of cyan, magenta and yellow produces a specific gray component that can be replaced with black ink. Thus, a 60 percent GCR separation removes 60 percent of this gray component and compensates equally by printing black ink.

Other names do exist for this color separation technique. In one DuPont publication on GCR, the following terms are listed as synonyms: Achromatic; Gray Stabilization; PIR; CCR; ICR; and PCR. Each major scanner manufacturer chooses an acronym to denote their approach to GCR. (As examples, Crosfield's is "PCR" while Dai Nippon's is "ICR.") To minimize confusion, "GCR" was recommended by The Graphic Communications Association's GCR Study Group as a common term encompassing these company's specific approaches.

Important to GCR application is Undercolor Addition (UCA). UCA refers to the method of adding chromatic colors (cyan, yellow and magenta) back into neutral gray areas, primarily in the shadow regions of an image separated using GCR. UCA is needed because GCR separations of some subjects reproduce deep shadows lacking the "depth" or "punch" of conventional separations. GCR employs UCA to satisfy the density requirements of these images.

In their publication, "An Introduction to Gray Component Replacement," Editors Press, a publication/commercial printer located in Washington, D.C., illustrates how GCR works using green grass as an example. In a conventional separation of grass, the reproduction of green demands primarily cyan and yellow inks. The darkness or lightness of the green is achieved using magenta ink, which as the lightening/darkening ink, is the "graying component." In theory, a 60 percent GCR separation of this image would replace 60 percent of the magenta printer and substitute black ink. They note that, in practice, this color separation method results in a four-color separation that has lesser coverage in the three colors and greater a degree of coverage in the black printer.

GCR VS. UNDERCOLOR REMOVAL

UCR is the reduction of process ink in the dark or near neutral areas of a conventional separation. The objective of UCR is to reduce the overall dot percentage and ink film thickness to improve trapping and allow better detail and more consistent reproduction. GCR and UCR are distinct: UCR reduces process colors in neutral gray areas and adds black; GCR substitutes the graying component in a three-color overprint with black ink.

THE GCR ADVANTAGES

Editors Press, whose experiences reflect those of other Study Group members, notes four major advantages of GCR:
• Color is more consistent because predominant hues depend on trapping of two colors rather than three;
• Quicker color OKs are possible on press due to lack of contamination by the third colored ink;
• Neutral tones are more stable because they are comprised of more black ink and lesser amounts of the three color inks;
• More latitude exists for balancing in-line conflicts.

Research undertaken by GCA's GCR Study Group or its members indicates that ink savings are possible with GCR separations. In theory, such savings are possible since color ink is being replaced with black ink. In practice, the increased stability of the neutral tones encourages print buyers and press operators to "pump" (print with more) ink to achieve improved gloss and saturation in the reproduction.

THE DISADVANTAGES OF GCR

Recent GCA GCR Study Group research has confirmed that the different scanner manufacturers employ widely differing GCR approaches. This lack of a common approach, as noted by Editors Press, hampers a designer's ability to specify the amount of GCR to be used. The result? Only experimentation by the designer, separator and printer will determine requirements for the piece's final appearance.

Research also indicates that flat-looking shadow areas may appear in the reproduction if proper amounts of UCA are not employed. It is also possible that in fleshtones, there can be a sharp break in contrast and a tendency to exhibit moiré patterns. These disadvantages can be minimized through close cooperation between the separator and printer by manipulating GCR amounts, line screen rulings and line screen angles.

SPECIFYING UCA AMOUNTS

GCA's GCR Study Group, led by Agi Rosos of Rosos International, has undertaken an

100% GCR

4-COLOR

Black

3-color

Using GCR In conventional printing, black simply supplements the four-color, printed image. Cyan, magenta and yellow combine to produce the gray component that gives the image shape. That color-based gray component is replaced with black ink when using GCR. A 100 percent GCR separation, like the one shown above, removes 100 percent of this gray component and replaces it equally by printing black ink.

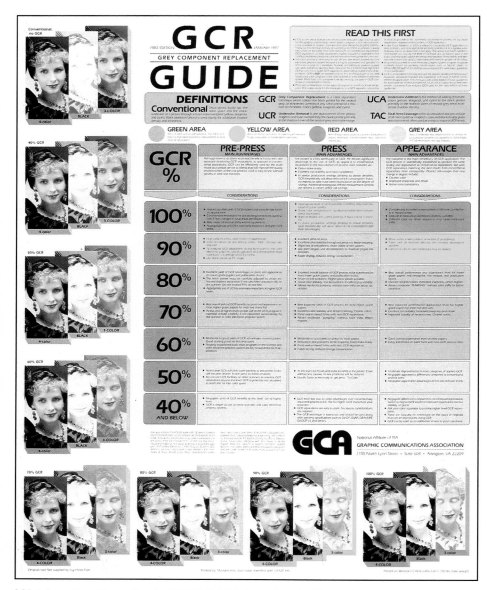

GCR Information The poster-sized "GCR Guide" shown here details how Gray Component Replacement works at different percentages. For information on how to obtain the poster (or any literature mentioned in this article), contact: GCR Information, c/o Graphic Communications Association, 1730 North Lynn Street, Suite 604, Arlington, VA 22209.

industry study of UCA requirements on a wide range of papers, inks, and sheetfed and web presses. Initial study results indicate the UCA amounts can be specified; the study is continuing, with additional sheetfed and web printers and separators. The Study Group encourages those interested to contact GCA about printing and test target films.

GCR AND THE PRINTER
According to Editors Press and other GCR Study Group members, ink sequence does not necessarily need to be changed when printing GCR separations. Editors Press prints with the same black-cyan-magenta-yellow using GCR and conventional separations. Control of black ink density and dot gain becomes critical, however, when printing GCR separations, because in contrast to conventional separations, the black printer has a greater impact on the final reproduction.

GCR separations also run well in-line with conventional separations. In fact, the latitude possible with GCR separations can allow for easier resolution of in-line conflicts. However, this technique will not compensate for bad printing or bad separations.

Study Group members have emphasized that GCR is not an isolated process; it is an integral part of any well-established color program. A bad-looking GCR separation would likely be a bad-looking conventional separation. Editors Press notes that, if anything, control of density and dot gain becomes more important in the pressroom when printing GCR separations.

GCR AND GRAPHIC DESIGNERS
One important benefit for designers stemming from GCR use will be improved consistency in the printed reproduction of an image because there will be less chance of a color shift, such as a fleshtone taking on a reddish or bluish cast. One important caution to designers planning to use GCR will be the need to understand what GCR is—and what it is not—including the advantages and disadvantages of this color separation method. ∎

—Peter Brehm

PRINTING AND PAPER

Many graphic designers will tell you that their print project was absolutely perfect—until it came off the press. On the other hand, their printers will tell you that these jobs were far from perfect when they came into their shops. An art director shares his story: "I chose a toothy, gray paper for a big budget job that would include opaque white blocks where copy and four-color photos would print. My client raved about my comps. But after three passes of the opaque white on press, I learned that opaque white doesn't necessarily mean *opaque* white. The resulting blocks still had about 10 percent gray showing through the ink. The four-color printed on top of that wasn't affected that much, but my client was! I really thought I would lose the job over it."

These kinds of printing "war stories" go on and on. But by using the detailed information provided in this section—everything from sending out bids and scheduling, to imposition, paper and ink selection, press approval and binding—even the most troubling surprises on the pressroom floor can be prevented.

Printing Trade Customs Defined

Learn your rights and responsibilities as specified by the Printing Trade Customs.

Gone are the days of doing business with a handshake. Designers must now divide their time between being artists and being burdened with contracts and documentation. In larger companies, the responsibilities are divided into departmental duties. One department designs, another produces the designs, while yet another does the purchasing, contracts, negotiations, and, if necessary, arbitration. What few designers or companies realize is that if they have not signed a specific contract or, because of time constraints, have not issued work orders or purchase orders, their project automatically falls under "The Printing Trade Customs." In many cases, unless otherwise agreed upon *by both parties, in writing,* terms and conditions for the project will be dictated by the Printing Trade Customs.

WHAT ARE TRADE CUSTOMS?

The Printing Trade Customs were originally written in 1922 by members of the United Typothetae of America as formalized "common practices" in the print industry. They were rewritten in 1986 under the supervision of the Graphic Arts Council of North America, Inc., to update the general business practices between printer and customer and to bring the trade customs current with technological innovations and methodologies.

The trade customs fall into two categories: One addresses the business relationship between printer and client (quotations, payments, delivery, schedules, ownership, and so on); the other category deals with the new technology and the inherent limitations of printing (customer provided materials, proofing systems, overruns/underruns).

While the trade customs are not laws or codes of conduct, they are procedures and business conventions that, over many years of practice within the industry, have become the modus operandi. In essence, they have become expected ways of doing business. However, the "Uniform Commercial Code" (an accepted federal legal code for trade and commerce, except in Louisiana) states: "If it is established that such usage [customs or industry accepted modes of doing business] is embodied in a written trade code or similar writing, the interpretation of the writing is for the Court." Translated, this means that if a company is in litigation with a printer, the printer's lawyer will provide the judge with a copy of the Printing Trade Customs and ask the judge to use the articles in the Trade Customs as a criterion for ruling the case. In the same way, if there was a difference of opinion between two parties with a written contract, the judge would use the contract as the precedent to judge the case.

Though the Printing Trade Customs are not law by definition, they are, in fact, a contract and law *in practice.* For this reason, they are to be taken very seriously and respected.

Roderick Carruthers, in an article written for *Graphic Arts Monthly* magazine, the publication in which the "Revised Printing Trade Customs" were printed, offers this keen analysis of the designer's and the production person's relationship to the customs: "All buyers of printing are not automatically bound by the provisions of the trade customs. To apply a trade custom, it must be shown that the other party knew or should have known of the existence of the trade custom. A first-time or minor buyer, for example, could plead ignorance and avoid having a specific provision interpreted against him. A major buyer...could be presumed to know the customs because dealing with printers is a major function of his business. Specific references should be made in sales documents to ensure that the buyer is aware of his responsibilities to the printer. These are usually on the back of a printer's contract. Under these circum-

stances, the printer will have little difficulty proving the buyer had prior knowledge (or should have)—and that the trade custom in dispute is applicable for interpretation of the agreement between the two parties."

THE PRINTING TRADE CUSTOMS

There are 18 articles in the new Printing Trade Customs (increased from 17), each reflecting a different aspect of the print industry and reflecting new technology, new responsibilities and limitations governing the relationships and expectations of printer and client. They are listed here, followed by an explanation of what has been amended.

REVISED CUSTOMS

1. QUOTATION A quotation not accepted within sixty days is subject to review. All prices are based on material costs at the time of quotation.

The previous 30 days quotation acceptance policy is now extended to 60 days. This certainly does not affect smaller, quick turnaround projects, but larger projects do take much longer to accomplish from concept and delivery. With material costs fluctuating in price, the trade customs protect printers with the inclusion "on material costs at the time of quotation." Always try to accept a quotation to lock the prices as soon as possible.

2. ORDERS Orders regularly placed, verbal or written, cannot be cancelled except upon terms that will compensate printer against loss incurred in reliance of that order.

In order to honor tight deadlines, printers will order materials such as paper and inks as early as possible. Should an order be canceled, reimbursement for these materials is the client's liability so that "no loss [is] incurred in reliance of the order" by the printer who was acting in the client's best interest.

3. EXPERIMENTAL WORK Experimental or preliminary work performed at the customer's request will be charged for at current rates and may not be used until the printer has been reimbursed in full for the amount of the charges billed.

When experimental or trial processes must be used to ensure that a project is possible to complete to the client's satisfaction, the client should certainly be prepared to compensate the printer for time and material. As will be seen throughout the PTC, payment in full transfers ownership of property or technique when indicated in the quote or contract.

4. CREATIVE WORK Creative work, such as sketches, copy, dummies and all preparatory work developed and furnished by the printer, will remain his exclusive property and no use of the same shall be made, nor any ideas obtained therefrom be used, except upon compensation to be determined by the printer, and not expressly identified are included in the selling price.

More printers, in an effort to be competitive and service-oriented, are offering additional services to their clients. Many medium-to-large printing companies have art, production and typesetting departments on the premises. This article makes the distinction between creative services (layout, illustration, paste-up, etc.) and prepress or preparatory services (color separation, stripping, platemaking, and so on).

5. CONDITION OF COPY Upon receipt of original copy or manuscript, should it be evident that the condition of the copy differs from that which had been originally described and consequently quoted, the original quotation shall be rendered void and a new quotation issued.

The PTC have been ratified mostly to incorporate all of the new electronic processes such as telecommunications of copy or images, whether by telephone or satellite. "Camera ready" is constantly being redefined as new equipment (such as CAD/CAM) is introduced into the marketplace. If the condition of the copy, manuscript or artboards differs from that which was understood at the time of quotation, "the original quotation shall be rendered void and a new quotation (using the new specifications) shall be issued." This could affect the cost in either direction.

6. PREPARATORY MATERIALS Working mechanical art, type, negatives, positives, flats, plates and other items when supplied by the printer, shall remain his exclusive property unless otherwise agreed in writing.

This answers the age-old question of "who owns the negs?" In fact, the client is purchasing printing—that is, ink on paper, trimmed, folded, collated, and so on, to specifications. All processes leading to the final product belong to the printer "unless otherwise agreed in writing." More importantly, once the job is completed and the printer paid in full, the printer is under no obligation, legal or otherwise, to maintain or store any of the preparatory materials and can dispose of them. Negatives and other such materials are stored by the printer as a service to the client with the hope of possible re-runs in the future. This also would include color separations, if provided by the printer to the client.

7. ALTERATIONS Alterations represent work performed in addition to the original specifications. Such additional work shall be charged at current rates and be supported with documentation upon request.

No change has been made to Article 7. Be aware that in order to be competitive, some printers will keep their base

prices low with their alteration charges high to make up the difference. Know in advance what your printer charges for alts.

8. PREPRESS PROOFS Prepress proofs shall be submitted with original copy. Corrections are to be made on "master set," returned "OK" or "OK with corrections," and signed by customer. If revised proofs are desired, request must be made when proofs are returned. Printer cannot be held responsible for errors under any or all of the following conditions: if the work is printed per customer's OK; if changes are communicated verbally; if customer has not ordered proofs; if the customer has failed to return proofs with indication of changes; or if the customer has instructed printer to proceed without submission of proofs.

The term "prepress" has been added to Article 8, which is otherwise unchanged, to first differentiate it from Article 9 Press Proofs. Prepress proofs can represent many different processes—overlay proofs (NAPS/PAPS, Color Keys, and so on), laminate proofs (Cromalins, Matchproofs), or some of the newer proofing systems, such as Signature and Coulter. The author believes that progressives, or "progs," fit into Article 9 and "soft proofing" (video or film-less proofing) has not yet been addressed in these PTC.

9. PRESS PROOFS Unless specifically provided in printer's quotation, press proofs will be charged for at current rates. An inspection sheet of any form can be submitted for customer approval, at no charge, provided customer is available at the press during the time of makeready. Lost press time due to customer delay, or customer changes and corrections will be charged at current rates.

Press proofs, or on-press proofing, may come in two forms: progressives or "progs" or the press check, where the client is present at press time to check

the make ready and approve the quality of the printing (plates, blankets, ink density). The last sentence has been modified from the previous PTC to reflect the difference between delays due to changes and corrections at the time of make ready/press check or lost press time needed to make the necessary changes or corrections.

10. COLOR PROOFING Because of differences in equipment, processing, proofing substrates, paper, inks, pigments and other conditions between color proofing and production pressroom operations, a reasonable variation in color between color proofs and the completed job shall constitute acceptable delivery.

Graphic artists must learn that proofs, with the exception of progressives, are only an approximation of the final product. Powders and toners on acetates, mylars, and so on have little relationship to actual printing inks on paper with water, alcohol and drying agents. Proofs only show us the information in the negatives so that we can make relative color corrections. Recently, printers have had so many problems with designers trying to match the proofs exactly that Article 10 is written in their defense. The true question is: What is "a reasonable variation?"

11. OVERRUNS AND UNDERRUNS Overruns or underruns not to exceed 10 percent on quantities ordered, or the percentage agreed upon, shall constitute acceptable delivery. Printer will bill for actual quantity delivered within this tolerance. If customer requires guaranteed exact quantities, the percentage tolerance must be doubled.

The biggest difference between the new Article 11 and the old is that the old used a ceiling of 10,000 copies before it "suggested" that the client negotiate overs or unders. Ten percent-plus has

always been an industry standard. Due to differences in folding and binding processes, finishings (die cuttings, de/embossing, hot foil stamping), there are no set percentages that could cover all of the variables from job to job. The key words here are "or the percentage agreed upon."

12. CUSTOMER'S PROPERTY The printer will maintain fire, extended coverage, vandalism, malicious mischief and sprinkler leakage insurance on all property belonging to the customer, while such property is in the printer's possession; printer's liability for such property shall not exceed the amount recoverable from such insurance. Customer's property of extraordinary value shall be insured through mutual agreement.

Printers have a legal responsibility to have insurance for their premises as well as coverage for customer's property while it is in their possession. If artwork or photography, especially retouched art, exceeds normal values, arrangements between client, printer and either of their insurance companies should be made with an appraisal or declared value mutually agreed upon.

13. DELIVERY Unless otherwise specified, the price quoted is for single shipment, without storage, F.O.B. local customer's place of business or F.O.B. printer's platform for out-of-town customers. Proposals are based on continuous and uninterrupted delivery of complete order, unless specifications distinctly state otherwise. Charges related to delivery from customer to printer, or from customer's supplier to printer, are not included in any quotations unless specified. Special priority pickup or delivery service will be provided at current rates upon customer's request. Materials delivered from customer or his suppliers are verified with delivery ticket as

to cartons, packages or items shown only. The accuracy of quantities indicated on such tickets cannot be verified and printer cannot accept liability for shortage based on supplier's tickets. Title for finished work shall pass to the customer upon delivery to carrier at shipping point or upon mailing of invoices for finished work, whichever occurs first.

No changes have been made to this article.

14. PRODUCTION SCHEDULES Production schedules will be established and adhered to by customer and printer, provided that neither shall incur any liability or penalty for delays due to state of war, riot, civil disorder, fire, labor trouble, strikes, accidents, energy failure, equipment breakdown, delays of suppliers or carriers, action of government or civil authority and acts of God or other causes beyond the control of customer or printer. Where production schedules are not adhered to by the customer, final delivery date(s) will be subject to renegotiation.

Because of increased volumes of projects and stricter delivery deadlines, the new last sentence clearly defines the customer's responsibility to adhere to the schedule as well. If the customer's changes or corrections interfere with the printer's schedule "final delivery date(s) will be subject to renegotiation." The list of delays where the printer is not liable has also been increased.

15. CUSTOMER-FURNISHED MATERIALS Paper stocks, inks, camera copy, film, color separations and other customer-furnished material shall be manufactured, packed and delivered to printer's specifications. Additional costs due to delays or impaired production caused by specification deficiencies shall be charged to customers.

With more customers purchasing separations, films, papers and inks (a new

addition to the list), this article defines that, first, those materials must conform to the printer's specifications, and secondly, if they do not and the printer is delayed or additional costs are incurred, that it will be at the customer's expense.

16. TERMS Payment shall be whatever was set forth in the quotation or invoice unless otherwise provided in writing. Claims for defects, damages or shortages must be made by the customer in writing within a period of 15 days after delivery of all or any part of the order. Failure to make such a claim within the stated period shall constitute irrevocable acceptance and an admission that they fully comply with terms, conditions and specifications.

It is clearly stated on a printer's invoice what their terms of payment are "unless otherwise agreed upon in writing." Any claim regarding defects, damages, shortages or rejection due to inferior quality or not meeting client's specifications (author's addition) must be made within 15 days in writing (immediate action should be taken verbally followed by written confirmation of complaint within those 15 days).

17. LIABILITY Printer's liability shall be limited to stated selling price of any defective goods, and shall in no event include special or consequential damages, including profits (or profits lost). As security for payment of any sum due or to become due under terms of any agreement, printer shall have the right, if necessary, to retain possession of and shall have a lien on all customer property in printer's possession, including work in progress and finished work. The extension of credit or the acceptance or guarantee of payment shall not affect such security interest and lien.

No changes have been made to this Article.

18. INDEMNIFICATION The customer shall indemnify and hold harmless the printer from any and all loss, cost, expense and damages (including court costs and reasonable attorney fees) on account of any and all manner of claims, demands, actions and proceedings that may be instituted against the printer on grounds alleging that the said printing violates any copyrights or any proprietary right of any person, or that it contains any matter that is libelous or obscene or scandalous, or invades any person's right to privacy or other personal rights, except to the extent that the printer contributed to the matter. The customer agrees, at the customer's own expense, to promptly defend and continue the defense of any such claim, demand, action or proceeding that may be brought against the printer, provided that the printer shall promptly notify the customer with respect thereto, and provided further that the printer shall give to the customer such reasonable time as the exigencies of the situation may permit in which to undertake and continue the defense thereof.

The two new additions to this article are the word "obscene" in which a printer shall be indemnified by the client, and the phrase "including court costs and reasonable attorney fees."

ACTIONS AND REACTIONS
Many of the trade customs are self-explanatory, but here are a few of special interest that do need some review and discussion.
PREPARATORY MATERIALS Article 6 very clearly addresses the issue of property rights—who owns what. This states simply that the printer owns everything, even the plates and negatives. If the printer produces the color separations, he owns them, period. The printer owns and retains everything until paid in full. All the buyer is purchasing is ink on paper. The most important words to remember are, "unless

other arrangements are made in writing by the customer." Also, note that the printer is not responsible for storing negs, plates and so on. Once paid in full, the printer has the right to destroy everything. Most of the time, he will not, to ensure re-run possibilities. Make sure to let the printer know how long the negs should remain active or when a possible re-run might occur.
COLOR PROOFING Article 10 is of interest because it is a delicate subject on two counts. First, the concept that pre-press proofs (Color-Keys, Cromalins, Matchprints, Gevaproofs, NAPS, PAPS and so on) are only an approximation of what will happen on press. The idea of going to a press approval trying to match the color proof is buying into a lose-lose situation. How can dry, laminated toners on plastic substrates ever approximate wet ink on paper? Use the proof only to assist in communicating intent.

Second, what is a "reasonable variation" from proof to actual printed piece? Many experiments have led us to understand that the human eye will see a color variation of two percent. We also know that if all four colors vary together, the variation will not be as noticeable as if only one color were to vary. By the time a five percent variation occurs, the quality of the printed piece will be thrown off, differing not only from the original image and the proof or separation, but from the intent of the designer, photographer and the printer as well.

OVERRUNS AND UNDERRUNS Article 11 is the most touchy of all print buying. The most heated arguments I have overheard have been on this issue. Let us break it into smaller parts and discuss each.

First, let me quote the old trade custom—"Overruns or underruns not to exceed 10 percent on quantities ordered up to 10,000 copies and/or the percentage agreed upon over or under quantities ordered above 10,000 shall constitute acceptable delivery." The old trade custom had a ceiling of 10,000; the new trade cus-

tom has no such ceiling. That means we are talking about 10 percent over or under, whether the order is for 1,000 or 10,000 or a million. First problem: Who wants less copies than what they ordered? Second problem: Article 11 clearly states at the end that "if customer requires guaranteed exact quantities [meaning no underruns], the percentage tolerance must be doubled [to 20 percent]." So, if no underruns will be accepted, 20 percent (spoilage) is now enforced over 1,000, 10,000 or a million. Third problem: Does this article provide for sheetfed offset or web-fed offset or both? We should anticipate a significantly higher waste on web. We should also be aware that the more operations that are required (folding, binding, die-cutting, hot-foil stamping, embossing, inserting with glue and so on), the more spoilage there will be. The question is, how much? There are two important reminders, the first written into Article 11: "...or the percentage agreed upon..." Then remember to talk to your printer to find out what policy he uses.

I wrote an article several years ago dealing with this issue, and I called printers throughout the United States and got everything from "It's negotiable," and "It depends on the job," to "We deliver (or charge) for 10 percent, period." Find out what policy is being used and negotiate numbers that are comfortable for you. Also find out when and how you will be billed for overruns. If you negotiate a specific percentage, you will know, in advance, what to expect.

PRODUCTION SCHEDULES Article 14 is of particular interest because more and more printers are complaining about the issue. When a project schedule is being planned and the buyer states when delivery is ex-

pected, the printer and buyer will also discuss when art boards must be delivered in order for the printer to adhere to this schedule. If the buyer is late with art boards, that constitutes a breach of contract, and the buyer should not expect to have the job delivered on the same schedule. As stated in the article: "Final delivery date(s) will be subject to renegotiation." We all know the pressures of dealing with clients, editors, managers, executives and others who change their minds at the last moment. It should be made clear to all involved with a job that once a delivery date is set and art boards are promised accordingly, that is a contract. If the contract is broken, then the buyer should be prepared to pay for that breach, in either time or money.

UNLESS OTHERWISE SPECIFIED
The key words throughout the trade customs are, "unless otherwise agreed in writing," "or the percentage agreed upon," "unless otherwise specified," "unless otherwise provided in writing." The burden is on the buyer to negotiate, to state intent, terms and percentages. Also, because a buyer has written a provision or term into their purchase order or work order, that does not mean that it then becomes the new rule. Both parties must agree on the new understanding in writing. Keep in mind, too, that many of these provisions are based on payment in full to the printer as well.

Let me re-emphasize that while the Printing Trade Customs are not in fact law, they are in action. I cannot recommend strongly enough that anyone involved in print buying not only memorize the trade customs, but also have them enlarged, highlighted and clearly posted so that everyone in your office can see them. We come back to the Romans, who warned us: *Caveat emptor*—let the buyer beware. ■
—*Daniel Dejan*

Printing Job Organizer

Job Name _____ Coordinator _____ Date _____

Function	Person Responsible	Supplier
Write copy		
Edit copy		
Proofread copy		
Approve copy		
Make rough layout		
Approve rough layout		
Make comp and dummy		
Approve comp and dummy		
Choose typesetter		
Specify type and mark up copy		
Set type		
Proofread type		
Create illustrations		
Create charts, graphs, maps		
Create/select photographs		
Approve visual elements		
Miscellaneous camera work		

Function	Person Responsible	Supplier
Choose production artist		
Paste up mechanicals		
Proofread mechanicals		
Approve mechanicals		
Choose/specify trade services		
Make halftones/separations		
Approve proofs of photographs		
Select paper		
Write printing specifications		
Select possible printers		
Obtain bids from printers		
Choose printer		
Contract with printer		
Approve proofs from printer		
Do printing		
Approve press sheets		
Do bindery work		
Verify job done per specifications		
Verify charges for alterations		
Verify mechanicals and art returned		
Pay printer and trade services		

Printer Equipment and Services

Date compiled _____

Printing company _____

 address _____

 city, state, zip _____

Contact _____ or _____

 title _____ title _____

 phone _____ phone _____

Routine quality ☐ basic ☐ good ☐ premium ☐ showcase

Possible quality ☐ basic ☐ good ☐ premium ☐ showcase

Type of printer

☐ quick

☐ in-plant

☐ small commercial

☐ medium commercial

☐ large commercial

☐ specialty in _____

Union shop

☐ yes ☐ no

Comments about samples _____

Sheetfed offset presses

brand _____ max sheet size ___ x ___ min size ___ x ___ # colors ___ ☐ perfector

brand _____ max sheet size ___ x ___ min size ___ x ___ # colors ___ ☐ perfector

brand _____ max sheet size ___ x ___ min size ___ x ___ # colors ___ ☐ perfector

brand _____ max sheet size ___ x ___ min size ___ x ___ # colors ___ ☐ perfector

brand _____ max sheet size ___ x ___ min size ___ x ___ # colors ___ ☐ perfector

Web offset presses

brand _____ maximum roll width ___ cutoff ___ # colors ___

brand _____ maximum roll width ___ cutoff ___ # colors ___

Letterpresses

brand _____ max size ___ x ___ min size ___ x ___ primary function _____

brand _____ max size ___ x ___ min size ___ x ___ primary function _____

Other printing processes (engraving, thermography, photocopy, etc.) _____

Bindery

 cutter maximum sheet dimension ____ folder maximum sheet size ___ x ___ min size ___ x ___

 folding capabilities _____

 binding abilities (wire, paste, saddle stitch, perfect, case, etc.) _____

 other bindery abilities _____

Prepress services (halftones, separations, stripping, platemaking, etc.) _____

Miscellaneous in-house services (design, typesetting, pasteup, pick up and delivery, storage, fulfillment,

 direct mailing, list management, etc.) _____

Negatives (ownership, storage conditions, insurance, etc.) _____

Credit terms _____

Previous customer references

 name _____ name _____

 organization _____ organization _____

 phone _____ phone _____

Comments _____

How to Obtain Competitive Bids

Getting accurate bids can be simple or frustrating— it's up to you.

Gathering and comparing bids can be fairly simple and systematic—that is, if you plan ahead, anticipate what you want, effectively communicate it and then let your printer do his work. On the other hand, the process can be laborious and ineffective, especially if you fail to communicate successfully with your printer.

Assuming you prefer the simple, systematic approach, here are a few steps that will ensure getting the comparable results you want with the least amount of frustration.
1) Provide each prospective vendor with simple, clear, identical instructions and specifications in writing;
2) Insist that all bidders follow your format precisely in presenting their prices to you. An effective way to accomplish this is to tell vendors up front that if they do not follow your format exactly, their bids will not be considered;
3) Look upon prospective vendors as potential players on your team; use their knowledge and experience. Let them give you the help you want and need to get the best results at the lowest possible price by taking advantage of all efficiencies each vendor can offer. Provide them the specifications for size, quantities and results you want, and let them determine what equipment will best produce those results. Printers are keenly aware that to get your business, they will have to deliver the lowest possible price, not by cutting corners, but by operating efficiently and passing those savings along to you, after taking a reasonable profit.

With this article, we have provided a "Printing Bid Request" format that you can photocopy and use immediately. Complete one original form by filling in all appropriate blanks. Then photocopy your completed form once for each vendor. Here are a few instructions to help you complete the bid request accurately. We will work down from the top of the sheet.

Fill in "date" and your company's name and address in "from." Leave the "to" box open. Fill that in for each vendor after you have photocopied the completed bid request.

Everything else in the form is self-explanatory until the "ink" section. There, complete only one line for "cover" and another for "body," if the job will not self-cover. If your project will involve more than two forms (cover and one body), photocopy this section and complete an additional "body" section for each form; number those sections "body form #1," "body form #2," and so on.

Write in color numbers for the ink colors. If you are using five colors, fill in color numbers under "4-Color" and add the fifth color number in the blank following "5-Color." If you plan to use six or even seven colors, indicate that in "other," complete with color number(s). If you plan to varnish, indicate that here (also specify the number of spots you will varnish in the next section "pre-press," so the printer will be able to calculate how many windows to cut.)

"Pre-press" is self-explanatory. However, indicate whether you or the printer will provide separations and film for the four-color process; you might indicate that directly next to that line with "you buy seps" or "we provide seps."

The "finishing" is also self-explanatory. You will likely have different or additional needs, so either specify them under "other" in this section or attach a separate sheet, and write on the face of this bid request "see separate sheet."

If possible, provide each potential printer with a mock-up or a very detailed dummy of your end product, in addition to the completed bid request—or at least show the mock up to each bidder.

If you are looking for only a bottom-line price on your project, you may ask your printer to provide a very simple one-figure bid. If, however, your job may be big enough for you to consider buying your own paper, or if for quality control reasons you want to buy your own color separations, you may want to have each vendor break out costs by section of your bid request as follows: 1) paper; 2) ink; 3) pre-press; 4) finishing; and 5) mailing/shipping. You may even want a finer breakdown to show total cost for cover paper, body paper, and each one of the film prices by size.

The key to getting the best price and quality, and each vendor getting a fair chance to get your business, is consistent, identical communication. It starts with a standard written bid request. If your needs evolve as you discuss the project with vendors, be sure that you communicate this to *all* people bidding, again so they can give you numbers that you can realistically compare. ∎

—Gordon F. Bieberle

Assembling Bids Photocopy the "Printing Bid Request" form on the next page the next time you are collecting printing bids. Complete all but the "To" blank, and then make one copy of the finished form for each vendor. Now fill in the "To" blank as appropriate on each form and distribute. It is crucial that you communicate exactly the same printing needs to each vendor.

PRINTING BID REQUEST

Date: _____

From: _____ To: _____
_____ _____
_____ _____
_____ _____

Phone: _____ Phone: _____

Job Name: _____

Quantity: _____ Trim Size: _____ Number of Pages: _____

PAPER

	COVER	BODY
Grade:	_____	_____
Weight:	_____	_____
Finish:	_____	_____

INK

COVER

1-Color [] Black [] PMS# _____

2-Color #1 _____ #2 _____

3-Color #1 _____ #2 _____ #3 _____

4-Color [] Process [] Other (specifiy)

#1 _____ #2 _____

#3 _____ #4 _____

5-Color 4/C above + PMS# _____

Varnish [] Dull [] Gloss

Other _____

BODY

1-Color [] Black [] PMS# _____

2-Color #1 _____ #2 _____

3-Color #1 _____ #2 _____ #3 _____

4-Color [] Process [] Other (specify)

#1 _____ #2 _____

#3 _____ #4 _____

5-Color 4/C above + PMS# _____

[] Dull [] Gloss

PRE-PRESS

SIZES (indicate approximate number of each)

	4″ × 5″ or less	5″ × 7″	8″ × 10″	11″ × 14″	16″ × 20″
Halftone					
Duotone					
Line Art					
4/C Process					
Spot Varnish					

Other (specify) _____

FINISHING, MAILING, SHIPPING
(check one in each column)

[] Saddle Stitch [] One Fold to (size) _____ [] Carton Bulk

[] Paste Bind [] Two Folds to (size) _____ [] Label on Cover

[] Perfect Bind [] Three Folds to (size) _____ [] Polybag & Label

[] Sew [] Four Folds to (size) _____ [] Kraft Wrap and Label

[] Envelope & Label

Other (specify) _____

A Production Schedule That Works

Finally, a system which coordinates not only single issue projects, but complex, multi-issue print projects as well.

Planning a complex project that involves many stages that must be dovetailed and finished by a specific date is difficult. When the project expands to a series of related booklets or magazine issues, each with a final and firm deadline and multiple overlapping ones in between, the planning process can easily become frustrating, confusing and chaotic.

For this reason, I developed a system so simple that I wondered why it took me so many years of frustration to think it up. It works well for single issue print projects, as well as for complex, multi-issue ones—the monthly or even weekly magazine or paper. The system very simply helps you list all tasks that need to be performed, records the duration for each one, and plots their start and completion times, overlapping them as possible or necessary, without confusing any task with another. The system further tags these start and completion times to real calender dates. If you are working on a corporate quarterly, for example, you will end up with four easy-to-read worksheets. And when you finish the last one, you will be able to pick off calendar dates for each task and plot them into a production schedule that will not take more than one side of a single sheet for even the most complex schedule.

The worksheet sample that we will develop here covers a typical monthly publication cycle, beginning two-and-a-half months before issue date. Adjust this any way you wish, for example, eliminating the 15 days in the month of issue, and adding them at the front of your worksheet, if that is what you need.

Numbers across the top of the sample worksheet represent calendar dates, beginning the 15th of the third month before issue date. Extending down the page, directly below each date, is a vertical line to help you plot start/completion times. Down the left edge of the worksheet is a list of every function that needs to be carried out to produce a publication. (If you are planning a different process, merely change the tasks listed on the left. And if your project duration will be greater than three months and will not require exact days, but perhaps weeks, then change the basis for this across the top of the form to suit your needs—say 52 weeks a year.) In the example presented with this article, the functions range from "reviewing manuscript" to "checking (tracking) copy received."

HOW TO START

Start building the production schedule by listing every action that needs to take place to create and distribute your printed piece.

Alongside each task you list, put the number of work days you, your staff, or any vendor will realistically need to complete it. To make this work later, ask each person who will have to perform the task how much time they will need. Where practical, give an extra day. You will win friends and eliminate possible friction and resistance later, when pressure mounts and you are able to remind everyone that they set the dates and you kicked in extra time.

Any one task may start and stop on the same day. Or it may require several days, even weeks, to complete. Prepared with the list of tasks and number of days necessary to complete each one, follow a calendar and begin to plot the start/complete dates for each activity, inserting between those dates the work days that you have gleaned from people who will be performing the tasks.

Here is a legend of symbols to use in plotting tasks on the worksheet:
- < = start activity
- -- = duration of activity
- \> = complete activity
- o = start and complete on same day
- x = day not counted (weekend, holiday, and so on)

Start filling in the worksheet by placing an "<" touching the vertical line under the date on which the activity will begin. Next, put an "x" on each line that represents a non-work day. Count off the exact number of vertical lines not "x-ed" out, to equal the number of work days you have previously determined will be required to complete the job. End the process with "\>" touching the line that represents the date the task is to be finished. Connect the start and complete symbols with a straight horizontal line to represent the task's duration. If the task begins and ends on the same day ("approving color separation proofs," for example), put an "o" directly on the line representing the date the task will be performed.

Generally, if you are working toward a deadline, such as "mail entry date" in this example, it is best to work from the bottom right corner of the planning sheet to the top left. To do this, first plot your "complete" date for the last task—"mail entry." Work back to the start date. Move up to the next task and do the same and complete this process until you have plotted the start of the first task on the left side of your planning sheet. At that point, the system will automatically tell you what date you must start the job to mail it on your deadline.

Before you begin, decide if you will count "start/complete" days as work days. Often, vendors do not count the dates they receive or ship your material as work days. You must build this into your schedule consistently.

If you are working on a schedule for a single project, when you plot your task, you are finished. If, however, you are working up a schedule for a series of publications, for example, twelve monthly is-

Activity	1	2	3	4	5	6	7	8	9	10	11	12	13	14	15	16	17	18	19	20	21	22	23	24	25	26	27	28	29	30	31
																2nd Month Before Issue															
Review Manuscripts																															
Edit/Design Meeting																															
Assign Manuscripts																															
Preliminary Layout																															
Feature #1																															
Feature #2																															
Feature #3																															
Final Layout..................																															
Feature #1																															
Feature #2																															
Feature #3																															
Color Separations																															
Color to Printer																															
Pasteup to Printer																															
Proofs from Printer......																															
Correx to Printer																															
On Press																															
Enter Mail.....................																															
Tracer Copy In..............																															

Example

(30 work days, including first and last days)

Using this worksheet as a guide, you can build a production schedule for almost any printed piece, including each issue of your publication. The two rows of numbers just below the bold-faced line beginning ''activity'' are consecutive dates for two partial months and two full months. This span represents a typical production cycle for a monthly publication. To complete this schedule, see the legend at the bottom. Then note the example. It represents a task that will require 32 days to complete. That task will start on the 10th of the second month before each issue, as indicated by an '' < '' touching the vertical line representing that date; and it will end on the 22nd of the first month before issue, as indicated by an '' > '' touching the vertical line representing that date. Elapsed calendar time will actually be 44 days, calculated by counting the 32 work days and 12 weekend days that have been ''x-ed'' out. In this example, both start and stop days are counted as work days.

sues of a magazine, you have a few more steps to go.

Even though you may feel that the cycle for each issue is identical, do not assume that you can just prepare one sheet and repeat it twelve times. Publications are tightly keyed to specific days for going on press. Weekends and holidays will not be the same each month. And in some months, for example, when you are preparing for an especially large convention issue, you will need to allow more time for some tasks, such as designing feature pages or special products sections.

CONSOLIDATE WORKSHEETS

After you have prepared a worksheet for each printed project or each issue, you will have very neatly packaged all the data you will need to prepare your final one-sheet production schedule for a year's worth of issues. On the left side of that sheet, list each item/issue. Across the top, list all activities you had listed down the left of each worksheet. Then merely write in the completion dates for each activity, as shown by the line for each task for each month.

Each horizontal line in this grid will then represent deadlines for every function you, your staff and any vendor will have to perform to create an issue. With copies of that schedule in hand, your entire crea-

tive and manufacturing team will be able to work in concert. And with the worksheets you used to develop that schedule, you will be able to periodically spot check start dates to see if people are working as far in advance as they planned, to ensure they meet deadlines. Also, you will be able to look at these worksheets to troubleshoot problems as they may arise.

A refinement of this whole process would be to plot planned activities on the worksheets in black ink, and plot actual activity in a bright color. You may want to use this on a short-term basis when problems arise, to ensure that staff members are aware of their own plans. ∎

—*Gordon F. Bieberle*

Basic Imposition

What you need to know for efficient and economical page planning.

All too often, imposition is viewed by novice designers as, quite literally, an imposition. An understanding of basic imposition, the plan and arrangement of pages on press sheets in a way that results in having them in correct order when they are folded and trimmed, leads to more efficient page planning, saving you time and money (not to mention frustration).

There are three basic types of impositions: 1) work-and-turn; 2) work-and-tumble; and 3) sheetwise.

Work-and-turn imposition uses one plate to print both sides using the same gripper edge. The sheet is printed on one side and is then turned on its side, from left to right, therefore maintaining the same gripper edge. It is the most commonly used form of imposition because the printer can get the maximum number of final pieces from one sheet, it results in less spoilage and is lower in cost than other impositions. (See Figure 1.)

Work-and-tumble imposition also uses one plate, but in a significantly different way than with work-and-turn. After the first side is printed, it is turned head over heels so the gripper edge of the first side becomes the opposite end of the sheet on the second pass. (See Figure 1.)

Work-and-turn and work-and-tumble are very efficient because a printer can run the same job ''two-up'' on the same sheet. That is, the printer can step-and-repeat (duplicate) the negative and strip the two side-by-side, which ultimately results in two identical images on the same sheet of paper.

Sheetwise imposition uses a different printing plate for each side of the sheet. Both sides, though, share a common gripper edge. The major drawback of sheetwise imposition is that there tends to be higher spoilage and higher platemaking costs than with other impositions. Any job printed both sides can be printed using two sheet-

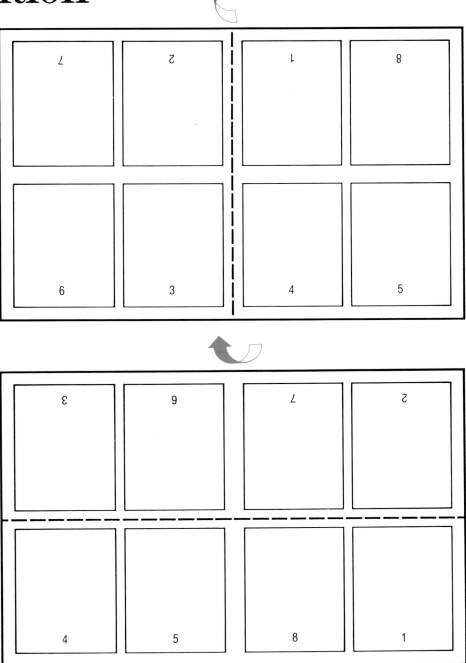

Figure 1 Work-and-turn (above) uses one plate for both sides of a sheet. Each side shares the same gripper edge. Once one side is printed, it is turned over from left to right and is printed again, using the same plate. Work-and -tumble (below) also uses one plate, but flips the sheet head-over-heels so that the gripper edge is reversed on the second pass.

Figure 2 Sheetwise imposition refers to a configuration in which pages on one side of a sheet are imposed on one plate, and the pages on the other side of the sheet use a different plate, but both sides share a common gripper edge.

wise plates. But it can also be printed perhaps less expensively using one work-and-turn or one work-and-tumble plate. (See Figure 2.)

According to the total number of pages in the job, the size of signatures (the folded, printed sheet forming a section of the printed piece), must be determined. Standard signatures are four pages, eight pages, 16 pages and 32 pages. (There are also 12-, 24- and 48-page signatures.)

The signature or signature combinations, coupled with placement of color on the signature, also determines where color falls in the book. For example, if a job is printed four over one, four colors will print on one side, one on the other; four over two, four colors will print on one side, two on the other, and so on. A different combination of these arrangements can give the effect of color throughout the book and achieve other results. (For demonstration purposes, examples shown on the next three pages are all sheetwise. Note that the numerical order would be different for work-and-turn and work-and-tumble impositions.)

Before determining which impositions will work best for a specific project, several factors must be considered: 1) number of total pages in the job; 2) length of run; 3) live/printed area; 4) untrimmed job size; 5) trimmed job size; and 6) type of binding desired (saddle-stitch, perfect, and so on.)

Once these factors are addressed, the printer will select the best sheet size (one that will accommodate the maximum final pieces per sheet), and the most cost-effective press size, with the lowest spoilage and quickest turnaround. ■

Imposition Instructions Each of the 18 impositions given on this and the next two pages display a folded sample and sheet layout. The top end of the sheet layout is the head guide—it is toward the fold rollers. The left-hand side is the side guide. Dashed lines represent folds. Page numbers or letters without circles are face up, while page numbers or letters with circles designate the underside of the sheet. When letters are used, folds are to be made ''A'' to ''A,'' ''B'' to ''B,'' and so on.

Four-Page May be folded two or more up and cut apart.

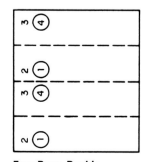

Four-Page, Double Imposition May be folded two or more up and cut apart. Trim edge after folding.

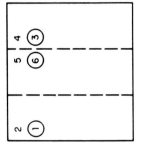

Six-Page, Standard May be folded two or more up and cut apart.

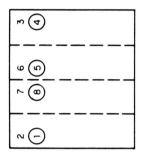

Six-Page, Accordian May be folded two or more up and cut apart.

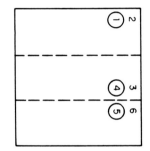

Eight-Page, Parallel May be folded two or more up and cut apart.

Eight-Page Right angle.

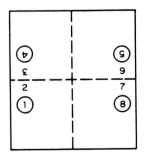

Eight-Page Two right angle oblong.

Eight-Page Right angle double imposition.

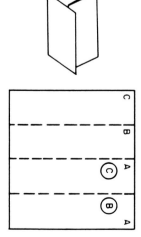

Eight-Page Parallel over and over fold. May be run two or more up and cut apart.

Twelve-Page Book Saddle stitch.

Twelve-Page Book Saddle stitch.

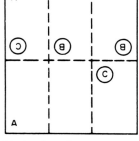

Twelve-Page Letter Fold Heads out.

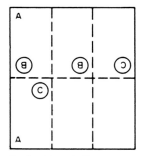

Twelve-Page Letter Fold Heads in.

Twelve-Page Letter Fold Accordian.

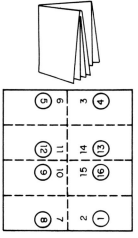

Sixteen-Page Three right angle book imposition.

Sixteen-Page Folder Heads out.

Twenty-Four-Page Booklet.

Thirty-Two-Page Book.

The Fundamentals of Folding

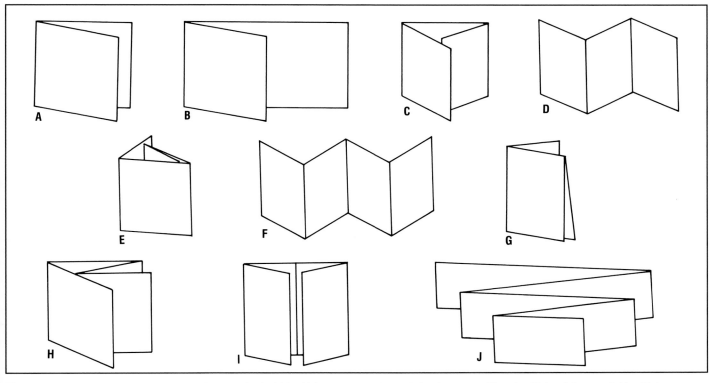

Figure 1 The following describes some of the most basic folds. A) A four-page folder; B) A four-page folder with a short fold. A short fold occurs whenever paper is not folded corner to corner; C) A six-page barrel fold; D) A six-page accordian fold; E) An eight-page barrel fold; F) An eight-page accordian fold; G) An eight-page fold, called a French fold when printing is on one side only; H) An eight-page fold, with two parallel folds; I) An eight-page gate fold; and J) A ten-page accordian fold with four short folds—a folding nightmare for most binderies. Check with your binder before planning this or any similar folding oddity.

From single- to accordian-folds, your options for finishing a printed piece are many.

Sheets can be folded in many ways. Because of today's equipment, the variations are endless. The buckle folders found in most commercial shops are usually equipped with three and sometimes four sections. A section is that part of a folder which stops the sheet and forces it to buckle, thereby creating a fold. Each section is adjustable. Despite the ability of these machines to handle all kinds of sophisticated folds, the customer should check with the binder to make sure his equipment can handle the folding requirements of the job. Binding equipment differs from one shop to another, and if printing is not done according to bindery machines, the end result may be a confused binder who receives 10,000 sheets of something he cannot bind. A printer should always be told to check with the binder for correct imposition.

The number of folding options may seem limitless. Actually, there are ways of categorizing folds. The most common types are shown in Figure 1. Like all machine operations, folding is accurate only to within certain tolerances. For instance, if you flip through the pages of a book, you will see that the page numbers and running heads on a page are not perfectly aligned with those on the facing page. This is normal. Folding is an operation where each step is one of diminished accuracy. If the first fold is not exactly perfect, the inaccuracy cannot be remedied in the next fold. But it can become worse if the second fold is not true, and worse still on the third fold—and so on. Most folding tolerances can be held within $1/8$-inch (that is, $1/16$-inch either way), but even $1/8$-inch can be critical. (See Figure 2.) The point of all this: Beware of losing the image off the page. What

Figure 2 This diagram shows in exaggerated fashion how each fold can lead to greater inaccuracies. The tinted areas show mismatched edges.

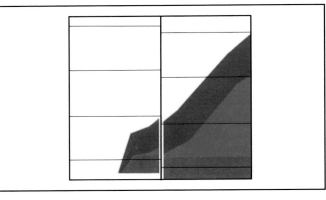

Figure 3 The problems of cross-gutter or crossover alignment, again dramatized in an exaggerated way.

is more apt to happen, and is almost as aggravating, is for the image to wander too close to the edge of the page, where it will look peculiar even though it is still there. As a rule, you should keep type at least ³/₈-inch away from the trimmed edge.

Another source of exasperation is when material is designed to straddle the gutter between two facing pages. Crossover problems are so common that some people think there is no way to prevent them. One way is to plan this kind of illustration for the center spread of the signature. When this is impossible, alert the printer and binder to the situation, and they may be able to minimize the difficulty. (See Figure 3.)

The problem of gutter crossover tells us something on a broader level that is basic and axiomatic: Namely, that folding (and binding and finishing generally) are the least accurate of the machine processes in the graphic arts. Commercial folding is accurate to units measured in sixteenths of an inch. Offset printing is far more precise. The tolerances are measured in thousandths of an inch. A color halftone, for example, requires such accurate printing that each dot of a given color must be in register with the dots of the other three colors. Typesetting is equally precise.

With this in mind, we will advance five generalizations on folding that may help the print buyer or planner:
• "Unbalanced" folds, where the edges do not align corner to corner, such as you see in road maps, are difficult for the binder to execute;
• Any piece with more than five folds may tax your binder's ability. If you reach this level of complexity, you should also reach for the phone and consult the binder;
• The grain direction of paper influences folding. Paper grain should run parallel to the binding edge or spine of the piece. If it does not, the pages will not lie flat. Covers printed on heavier stock will not lie flat either, and the surface of the cover stock will often develop cracks and wrinkles;
• The range of paper weights a binder can easliy fold runs from 50 lb. to 80 lb. Anything lighter or heavier costs more to fold;
• When in doubt about any folding configuration, consult your binder.

Reprinted from "How To Plan Printing," published by S.D. Warren Company, a division of Scott Paper Company.

Standard Paper and Envelope Sizes

Graphic artists should be aware of foreign and domestic classifications

T here are more than 1,500 different classifications of paper, and any sheet can be cut to almost any specification. The size and shape of envelopes are limited only by the designer's imagination. A solid education in paper grade classification, domestic and foreign paper sizes, and envelope classifications, as detailed in this article, is a background from which most graphic artists would benefit.

GRADE CLASSIFICATION
Use this chart as a guide to selecting the size and weight of paper that best fits your design application. Talk with your paper or printing representative to further define your needs.

GRADE CLASSIFICATION	BASIS SIZE*	BASIS SIZE WEIGHTS	DESIGN APPLICATIONS
Bond	17 × 22	13, 16, 20, 24, 28, 32, 36, 40	Letterheads, newsletters, resumes
Uncoated Book	25 × 38	30, 40, 45, 50, 55, 60, 65, 70, 75, 80, 90, 100, 120	Books, catalogs, programs, calendars
Coated Book	25 × 38	30, 40, 45, 50, 55, 60, 65, 70, 75, 80, 90, 100, 120	Annual reports, brochures, magazines
Text	25 × 38	90, 100, 120, 140, 160, 180	Posters, self-mailers, announcements
Cover	20 × 26	25, 35, 40, 50, 55, 60, 65, 80, 90, 100	Business cards, annual report covers, greeting cards

* — Basis size: the standard size in a particular grade that determines basis weight.

INTERNATIONAL PAPER SIZES
In an effort to standardize paper sizes, the International Standards Organization (ISO) has developed a system which has been adopted in many metric-standardized countries. The system is based upon the principle that a rectangle's sides have a ratio of 1:2. By cutting in half any sheet with these proportions, it will always yield two new sheets with the same proportions.

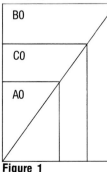

Figure 1

There are three ISO series. (See Figure 1.) The A series is the smallest and most common sheet size classification and includes letterhead and many printed publications. The B series, the largest sheet size of the three, is ideal for wallcharts and posters. It is about halfway between two A sizes and is used when the difference in size between two larger sheets of the A series is too great. The C series, which is used mainly for envelopes and mailers, is the mid-sized division. Envelopes from the C series are suitable for insertion of A series size sheets, flat or folded. (An explanation of foreign and domestic envelope sizes follows.)

Each of these main series divisions is given the suffix 0 (zero). Each smaller sheet within a series (A1, A2, A3, and so on) is equal to half of the area of the preceding larger size. (See Figure 2.) In the A series, sheets larger than A0 retain the same proportions. A corresponding numeric prefix is used with the A for such a sheet. For example, 4A0 is four times as large as A0.

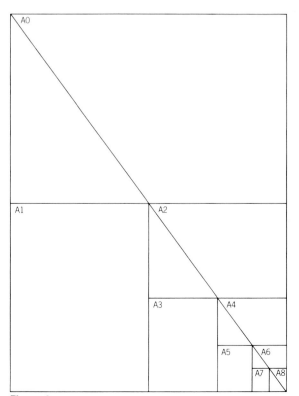

Figure 2

A listing of A series metric sizes and inch equivalents follows.

SIZE	IN MILLIMETERS	APPROX. INCHES
4A0	1682 × 2378	66¼ × 93⅜
2A0	1189 × 1682	46¾ × 66¼
A0*	841 × 1189	33⅛ × 46¾
A1	594 × 841	23⅜ × 33⅛
A2	420 × 594	16½ × 23⅜
A3	297 × 420	11¾ × 16½
A4	210 × 297	8¼ × 11¾
A5	148 × 210	5⅞ × 8¼
A6	105 × 148	4⅛ × 5⅞
A7	74 × 105	2⅞ × 4⅛
A8	52 × 74	2 × 2⅞
A9	37 × 52	1½ × 2
A10	26 × 37	1 × 1½

* — Basic size. In the A series, this equals one square meter.

All A series sizes mentioned here are trimmed. "A" sizes can be cut from two stock sizes—R, which designates normal trims, and SR, which designates extra trims or bleed work. A listing of R and SR metric sizes and inch equivalents are below.

SIZE	IN MILLIMETERS	APPROX. INCHES
RA0	860 × 1,220	33⅞ × 48⅛
RA1	610 × 860	24⅛ × 33⅞
RA2	430 × 610	17 × 24⅛
SRA0	900 × 1,280	35½ × 50⅜
SRA1	640 × 900	25¼ × 35½
SRA2	450 × 640	17⅞ × 25¼

A listing of B series sizes and inch equivalents follows.

SIZE	IN MILLIMETERS	APPROX. INCHES
B0	1000 × 1414	39⅜ × 55⅝
B1	707 × 1000	27⅞ × 39⅜
B2	500 × 707	19⅝ × 27⅞
B3	353 × 500	12⅞ × 19⅝
B4	250 × 353	9⅞ × 12⅞
B5	176 × 250	7 × 9⅞
B6	125 × 176	5 × 7
B7	88 × 125	3½ × 5
B8	62 × 88	2½ × 3½
B9	44 × 62	1¾ × 2½
B10	31 × 44	1¼ × 1¾

A listing of C series sizes and inch equivalents follows.

SIZE	IN MILLIMETERS	APPROX. INCHES
C0	917 × 1297	36⅛ × 51
C1	648 × 917	25½ × 36⅛
C2	458 × 648	18 × 25½
C3	324 × 458	12¾ × 18
C4	229 × 324	9 × 12¾
C5	162 × 229	6⅜ × 9
C6	114 × 162	4½ × 6⅜
C7	81 × 114	3¼ × 4½
C8	57 × 81	2¼ × 3¼

ISO ENVELOPE STANDARDS

As previously discussed, sheets from the A series can be inserted in the C series envelope, flat or folded. For example, a C5 envelope will accommodate an A5 sheet flat or an A4 folded once. A listing of ISO envelope sizes follows. All are taken from B or C size sheets.

ENVELOPE	METRIC (mm)	APPROX. INCHES
C3	324 × 458	12¾ × 18
B4	250 × 353	9⅞ × 12⅞
C4	229 × 324	9 × 12¾
B5	176 × 250	7 × 9⅞
C5	162 × 229	6⅜ × 9
B6/C4	125 × 324	5 × 12¾
B6	125 × 176	5 × 7
C6	114 × 162	4½ × 6⅜
DL	110 × 220	4¼ × 8¾
C7/6	81 × 162	3¼ × 6⅜
C7	81 × 114	3¼ × 4½

ENVELOPE STYLE CLASSIFICATION

Selecting the proper envelope for your job can mean the difference between successful delivery of your printed product and a completely thwarted effort. The following envelope classification chart describes the many different styles of envelopes available today. Ask your printing or paper representative for more specific information on envelopes as they pertain to your project.

STYLE	SIZES IN INCHES	DESCRIPTION	APPLICATIONS
Commercial and Official	$3\frac{1}{16} \times 5\frac{1}{2}$ to $5 \times 11\frac{1}{2}$	Standard correspondence-style envelope for business and commercial use. Open-side style	Letterheads, invoices, mailings
Side-seamed commercial	$3\frac{1}{16} \times 5\frac{1}{2}$ to $5 \times 11\frac{1}{2}$	Side seam provides a larger printing area than standard commercial	Same as commercial
Booklet	$4\frac{1}{2} \times 5\frac{7}{8}$ to 10×13	Open-side style design allows overall printing on envelope	Annual reports, brochures, sales literature; any mailings using inserting equip.
Window	$3\frac{1}{2} \times 6$ to $5 \times 11\frac{1}{2}$	Window allows name and address on enclosure to show through	Statements, checks, receipts
Catalog	6×9 to $11\frac{1}{2} \times 14\frac{1}{2}$	Open-end style. Heavily-gummed flaps good protection for heavier materials	Catalogs, magazines
Clasp	$2\frac{1}{2} \times 4\frac{1}{4}$ to $12 \times 15\frac{1}{2}$	Ideal for heavy enclosures that are inserted by hand	Catalogs, bulky loose papers
Remittance	$3\frac{1}{2} \times 6$ to $3\frac{7}{8} \times 8\frac{7}{8}$	Large flap can be used for printing or coupon	Dual purpose, statement and return for payment
Ticket	$1\frac{15}{16} \times 4\frac{7}{16}$	Open-side style often printed with advertising	For theater as well as other tickets

ENVELOPE STYLE CLASSIFICATION (continued)

STYLE	SIZES IN INCHES	DESCRIPTION	APPLICATIONS
Wallet	4⅛ × 9½ to 6 × 12	Stronger than standard commercial envelopes	Bulky mailings or correspondence
Baronial	3³⁄₁₆ × 4¼ to 5 × 6	Frequently lined with colored paper for formal correspondence	Invitations, announcements, greeting cards
Announcement	4⅜ × 5⅝ to 6¼ × 9⅝	May have deckle-edged flaps	Same as Baronial
Coin	2¼ × 3½ to 3½ × 6½	For paper currency as well as coins	Currency, small parts
Interdepartmental	5 × 11½ to 10 × 15	Punched with eight holes, plain or with string and button, printed with route list	Inter-office correspondence, private material
Air Mail	Same as commercial/official	Made from light-weight paper with red and blue borders	Air mail
Air mailer	Same as booklet	Has red and blue or green borders to expediate postal handling	Air mail for larger items
Self-seal	A variety of styles	Has two latex surfaces that seal on contact	Useage depends on style chosen

Illustrations / information for envelope charts courtesy of Old Colony Envelope.

Paper and Color Printing

Learn how paper whiteness and brightness affect the quality of your color printing.

The immediate source of illumination for a transparent ink film is the sheet of paper on which it is printed. This is called reflected illumination.

PAPER WHITENESS/BRIGHTNESS

A sheet of paper has the property of absorbing some wavelengths and reflecting others. If it reflects all wavelengths equally, which means that it does not alter the quality of the light, it is a neutral or balanced white sheet of paper. (See Figure 1.)

If it absorbs more of some wavelengths than the others, it will be tinted. It is an unbalanced paper. For example, if it absorbs more red and green wavelengths than it does blue wavelengths, it will be tinted blue. (See Figure 2.)

If it absorbs all the wavelengths of white light, it will be black paper. (See Figure 3.) A neutral gray sheet of paper is simply one that absorbs a good part of the quantity, without altering the quality of light that strikes it. You might say that a neutral gray paper is a balanced white paper at low brightness. Just as natural colors become duller and less brilliant during the onset of darkness, so ink colors become duller and less brilliant as the brightness of a sheet of paper decreases. The unprinted area of a sheet of paper is the brightest portion of the overall printed page. The printed areas are less bright than the non-printed areas because they have absorbed some of the light. If a printer starts with a paper of low brightness, the print will be correspondingly low in brightness. (See Figure 4.) The unprinted areas of a tinted paper add their characteristic color to the light reflected from the

Figure 1

Figure 3

Figure 2

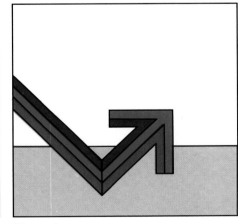
Figure 4

print to the eye, so that additional distortion is incurred.

Bluish papers absorb more red and green light than neutral white paper. Perception of yellow depends on green and red light. If some of this kind of light is absorbed by the paper, the yellow result is reduced in lightness or intensity, i.e., it is grayed. Many blue-appearing papers also reflect proportionately more green than red, which means the yellow result is "greenish." In either case, the blue wavelengths are absorbed by the yellow ink film, hence the "graying effect." Therefore, the most accurate color reproduction is obtained on papers that

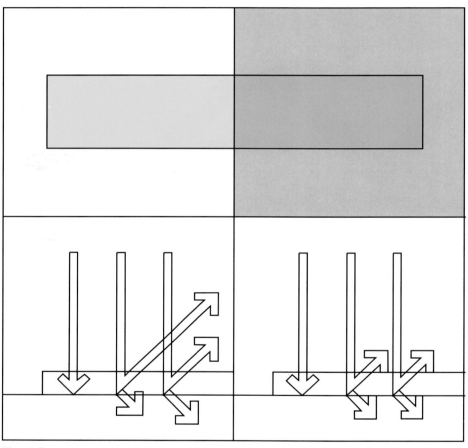

Figure 5

Smooth coated surfaces with fibers buried under layers of pigment minimize light interference by allowing uniform directional reflection of light.

As a rough surface contributes to color degradation, so does an excessively absorbent or "open" surface. An open surface may absorb the ink vehicle and pigment, but leave dull pigment particles on the surface.

A surface with good ink hold-up—a "tight" surface—retains both vehicle and pigment on the surface with the pigment "buried" in the glossy vehicle. Only enough vehicle penetrates the surface to provide a good bond of ink to paper. Ink gloss contributes to purity of printed ink color. Paper smoothness contributes to ink gloss.

Accurate glossy color results may be obtained on some dull coated and embossed coated papers. Even though the papers are not glossy, their surfaces are so refined that—even over the surfaces of the relatively large hills and valleys of embossed finishes—a gloss layer of ink may be supported. Sufficient vehicle is supported as a smooth film to maintain the color purity of the pigments immersed in it.

COLOR INFLUENCERS
1) Paper is the light source for transparent inks printed on it.
2) Transparent inks give best results when printed.
3) Papers should provide balanced highlight reflectance through the ink film.
4) And these papers should have smooth, coated surfaces which support a thin, glossy layer of ink. ∎

Information courtesy of S.D. Warren Company, a division of Scott Paper Company, excerpted from "The Influence of Paper on Color Printing," Bulletin No. 2, copyright 1984.

reflect the light that strikes them without changing its quality. (See Figure 4.)

In addition, the most brilliant color reproductions are obtained on papers with high, balanced reflectance. (See Figure 5.)

THE PAPER SURFACE
Besides whiteness and brightness, the degree of smoothness of the printing surface influences the appearance of ink placed on it.

A rough, fibrous paper surface is composed of a multitude of non-uniform reflecting surfaces. When light strikes them, they scatter it randomly and, thus, adulterate the print with white light.

A black solid or halftone, for example, is grayed because of this addition of uncontrolled and unwanted white light. A colored solid or halftone is not only grayed but also tends to change its hue.

Troubleshooting Press Problems

Learn how to recognize some of the most common on-press problems.

The printing press is like an automobile. It has a lot of moving parts—most of which we do not know what they do. It has an accelerator and brake, and it has a clutch. In much larger presses, the clutch, of course, is the gears and cams that allow a printing press to start at an "idle" speed (the speed at which we do our press checks), and then it finally gets up to "running speed." In sheetfed presses, running speed can be as fast as 14,000 impressions per hour (iph); on large web presses, running speed can be 30,000 to 40,000 iph.

Extending our analogy one step further, the printer can be compared to a mechanic and the graphic artist/production manager to the car owner. When something goes wrong with our car, first we need to know our car well enough to know when something is wrong. Second, we need to know how to be able to communicate to the mechanic where the problem is. We try to explain to the mechanic how the car runs when everything is right, and then direct his attention to what we think might be the problem. Similarly, when we are on press and things are not right, we tell the printer what area to be looking at and where things are going wrong.

Rarely will we tell a mechanic *how* to fix a car. Nor should we be presumptuous enough to tell a printer how to fix our work. We simply try to relate the information, as detailed as possible. By directing the printer's attention to the problem area, we will get it fixed quicker with less expense. We must be prepared to be a part of the solution, and we must always have in mind the end results that we want.

Figure 1 "A" is the design problem—problems that we actually design into our projects; "B" is the feed, where the paper is fed into the press with the grippers; "C" is the ink fountain; "D" is the ink cylinder; "E" is the plate cylinder; "F" is the water fountain or dampening system; "G" is the blanket; "H" is the impression cylinder; "I" is the powder box; and "J" is the delivery where the sheets finally come off.

So how do we know whether the printing is running correctly or not? How do we know where the problem is and how to correct it? In order to be able to solve the problem—to troubleshoot—we must understand the nature of the machinery—the printing press—what the press does and all the ways in which it can fail to perform correctly.

If a sheetfed press is broken down into the different problem areas, you will notice that there are many potential conflict areas. (See Figure 1.)

In this article, however, we will focus on the three main problem areas in sheetfed offset printing: paper, ink and general equipment-related problems. Although most of these sheetfed problems will also relate to the web offset, the web has its own very special set of problems based on the high speed, the printing on both top and bottom of the sheet (known as perfecting), as well as the end line operations that make the web press so valuable to this industry.

PAPER-RELATED PROBLEMS

By no means should a designer think that web paper and sheetfed paper are similar. They are very different formulations, with very different manufacturing systems. Web paper must have a very high tensile strength—the ability to be pulled at high tension without snapping or breaking (what is known as a web break). Second, web paper is printed top and bottom (front and back) simultaneously. So web paper must be prepared to receive great amounts of ink and water, top and bottom, during printing. Last, heat-set, web offset paper will go through a heated drying oven. The web paper is constructed so that it will not blister or "popcorn" because of the humidity within the paper trying to explode at the high temperatures.

PAPER CURING One of the main potential problem areas is paper curing. To cure paper for printing, the printer will bring paper into the press room before the run to allow it to come to the same temperature and humidity as the press room itself. There are two reasons for curing paper in this way: 1) Temperature is critical to drying time; ink does not dry as quickly on cold paper; and 2) The humidity of the paper must be equivalent to the humidity of the press room, or else several serious problems can occur. If the paper is too humid when it gets on press, it will have a tendency to

fan—the tail of the sheet will spread causing mis-registration, or the sheet of paper, having expanded because of the excess humidity, will have a tendency to wrinkle on the press. In contrast, paper that is too dry can also be disastrous. Overly dry paper will absorb all of the vehicle (liquid) in the ink to compensate for the lack of humidity. The end result is a problem known as chalking: The paper absorbs the ink's liquid, its pigment is left dry and brittle on the surface of the sheet, and it subsequently brushes off the sheet like chalk on a blackboard. So it is important that a printer prepares his paper properly before going on press. It is critical that the designer allow the printer enough time to order the paper and bring it into the press room to cure before going on press.

PAPER DUST The next most common paper-related problem is paper dust, which shows up on press as ''fish eyes'' or ''hickeys.'' Paper dust generally looks like little white particles on the printed sheet. Paper dust occurs when paper has been cut with a guillotine cutter that does not have a true and sharp blade. Paper companies guarantee that their paper is as dust-free as possible. Yet many printers buy large sheets of paper and cut them to press sizes on premise. Every time they cut the sheet, they are creating the possibility of paper dust.

Fish eyes or hickeys can be caused by other problems as well, including; 1) small flecks of paper being picked up on the blanket and being constantly inked and printed; 2) ink scum or skin—dried ink coming down from the ink cylinders, catching onto the blankets and becoming an image area; and 3) particles in the atmosphere. If you have ever seen a printing press that has a tent or a tarp over it, that is done because there are particles in the air either falling from the ceiling or a ventilation system.

PICKING AND PICK-OUT PROBLEMS

While many people use these terms synonymously, picking and pickout are not the same. Picking is a misformulation of ink. If

Figure 2 Multi-color printing depends on successful trapping (left). Poor trapping (right) results in an ''off'' color that is uneven.

ink is too tacky for the surface strength of the sheet of paper being used, it literally pulls the surface of the paper off. Pick-out, on the other hand, is a paper problem caused at the paper mill when the surface of the paper has not been properly sealed. Consequently, the ink tack is correct for the sheet of paper, but the surface is pulled off because it is weak. This can also happen with a coated sheet of paper when the coating has not been sealed to the sheet properly and, as the printing continues, particles of the coating are picked off the sheet going through the press. They adhere to the blanket and can prevent the ink from being transferred from plate cylinder to blanket. This phenomenon is known as piling. As the piling becomes more severe, the printed image lightens.

While these are certainly not all of the paper problems by any means, these general areas are concerns that the designer should be looking for while doing a press check or upon receiving samples of a printed job.

INK-RELATED PROBLEMS

Inks are made of four different materials: 1) pigment; 2) vehicle—the liquid (which can be water, alcohol, varnish or oil) that carries the pigment; 3) drying agents which

assist the ink to dry, based upon the type of paper being printed on, and; 4) additives. The additives are blended into the ink based on the type of paper to be printed, how many colors in sequence, the speed at which the press is running and the amount of coverage. Keep in mind that ink manufacturers are chemists, and printing is a very delicate, chemical balance. This is especially true when discussing inks.

INK TRAPPING Using the wrong formulation of ink can show up in many ways. One of the most talked-about problems is poor ink trapping. The definition of ink trapping is the ability of one wet ink to adhere to another wet ink already laid down. This problem is based on three components; 1) the tack (adhesion quality) of the ink; 2) the speed of the press; and; 3) the absorption quality of the paper. If any of these are not in sync with the others, there will be poor trapping, and the ink(s) will not lay down properly. In severe cases, it will not be accepted at all; in other cases, some of the ink will adhere and some will not. The end result is partial coverage in which the color being laid down looks faint, weak or blotchy. (See Figure 2.)

As already discussed, picking is also related to ink being too tacky and subsequently picking off the surface of the paper on press. We also discussed hickeys or fish eyes possibly being caused by ink skin. This skin is either a result of ink drying in the fountain or very little ink being used from the ink cylinder.

DOUBLING Doubling is a problem that occurs on press when ink has been improperly formulated for a multi-colored press. The ink on the first cylinder is printed, but does not dry by the time it gets to the second cylinder. Because it is still wet, the ink is picked up onto the blanket of the second cylinder and is reprinted out of register, causing a shadow effect. It is not a serious problem in that one simply needs to either slow the press down, giving the ink more time to dry, or reformulate the ink with more drying agent. Be aware that when you have a shadow from doubling, it increases the ink coverage of the first color, which will throw the color balance off.

OFF-SETTING Graphic designers are probably most familiar with off-setting problems. When the printing from the top of one sheet, which is still wet, adheres to the back of the sheet above it, its image off-sets onto the back of the top sheet. This occurs because the ink has been improperly formulated and is not drying fast enough before it arrives in the delivery where the sheets ultimately land at the end of the press. It can also be caused by ink being improperly formulated for a coated sheet. Coated stocks leave the ink sitting high, with very little of the vehicle being absorbed into the sheet. This requires more time to dry than normal. Designers should allow more time to produce and deliver printing on coated sheets for this reason.

Off-setting can also occur when a sheet of paper is cold and the ink cannot dry fast enough. Another cause can be simple static electricity. Static electricity makes the two sheets cling to one another, forcing the ink on the top of the bottom sheet to press up against the bottom of the top sheet, and thus off-set its image. If you ever see a press with tinsel on it, the printers are not celebrating Christmas; they are trying to eradicate static electricity.

CHALKING Chalking, which we discussed before, is also an ink-related problem. The worst problem with chalking is that it is often not discovered until the job is completely dry, sometimes 24, 48—or with coated or specialty stocks of paper—72 hours later. This means it may not be discovered until it is in the CEO's hands.

OTHER PROBLEMS

There are many other problems that can happen on press: problems with the plates, problems with the water and dampening systems, the latter being one of the more severe problems. We often hear printers talk about the ink/water (alcohol) ratio. In the offset printing system, water repels ink, ink repels water; that is how lithography works. "How much water to how much ink?" has always been the critical question. Too much water and the ink ends up looking very light and weak; not enough water, the ink prints very heavy and dense. Alcohol is added to the process to assist in the drying, but if too much alcohol is added, the ink will "break." The other major problem in the water and dampening system is the pH of the water. Printers constantly check to ensure that the pH of the water remains at a stable acidic level. If the water level is too acidic, the plates will be quickly eaten away. If the acid level is too low, the printing will be thrown off.

But probably one of the most common problems in offset printing is the blanket. The ink fountain spreads ink onto the cylinder. The ink cylinder in turn spreads its ink onto a pre-watered plate. (By definition, lithography involves a plate that features an image area which repels water and accepts ink, and the non-image area accepts water and repels ink. This planographic plate is perfectly smooth.) In turn, the plate transfers or off-sets its image onto the blanket. Typically, the blanket consists of several layers of fabric or batting, called packing, over which a rubber blanket is stretched around the cylinder. The plate off-sets its image onto the blanket; the blanket, in turn, off-sets the image onto the paper. It is the blanket that makes contact with the paper, not the plate.

PACKING Packing can be one of the most troublesome areas in printing. First, the printer must make sure that the packing is done smoothly and evenly, not more to one side or another, or you will get a denser, deeper image on the side with more packing. This is known as skewing. Second, one must make sure that there is just enough packing. If there is too much, a situation known as dot gain occurs.

DOT GAIN Dot gain occurs when a halftone dot prints larger than it was shot on the negative or burnt onto the plate. Dot gain is a serious and common problem. It is generally evidenced in printing by colors being thrown off balance because one set of dots is larger than they should be. It also appears as an overall muddiness or a lack of detail in the printed piece. If you see a printed piece that looks very dark and contrasty, inspect it with a 16x magnifier, better yet a 30x loupe, and you will notice that the dots are very large and are eating up the necessary white space between dots. Typically, dot gain can be caused by two factors: Either the paper is too absorbent for the formulation of the ink or the pressure of the blanket is too hard and is squashing the dot flatter than it should be. This is usually regulated by the impression cylinder underneath the blanket (between the blanket and the paper). But if the blanket is not sufficiently packed, it will be loose and sloppy, causing a condition known as slurring, where the ink is literally skidded across the sheet.

POWDER Powder can also cause problems. The powder is the last station between the printing area and the delivery. A light powder is dusted over the printed sheet and is absorbed by the ink which helps it dry quickly. It is used to circumvent off-setting. Too little powder and off-setting results; too much powder and you get a grittiness on the surface of the sheet. ∎

—Daniel Dejan

The Technical Press Approval

In addition to understanding what you are looking for, you need to know how to determine whether or not you are getting it.

Much has been written about the press approval, and from widely divergent points of view — from "etiquette" to "pleasing vs. critical" color discussions. But few articles address the essence of the press approval: quality control. In fact, the slogan for printers' seminars and conventions in the 1980s was: "If you can't measure it, you can't control it."

Before you learn how to measure and control quality, though, it is important to grasp the bigger picture. When we go on a press approval, we are there to perform several functions: First, to be sure that the make-ready process has been done properly — that is, the plates have been burned properly, everything is in register, and ink is not printing too heavy or too light. When the job is on press, we then can make last-minute color corrections by starving (lessening) or feeding (adding) inks in specific areas on the printed sheet. Once we have come to a balance (compromise) in the color, we sign the sheet. In this way, we set a precedent for the rest of the press run (plus or minus industry standards of 5 percent). By setting the color quality standard ourselves, we absolve the printer of responsibility. Yet how can we feel confident about setting quality standards ourselves, if we do not know how the printers themselves measure and control that quality?

When a pressman takes a sheet off the press and views it at his console, he gives it only a cursory glance (without the assistance of a loupe) to check image and type

quality. Then he averts his eyes to the most reliable quality control tool at his disposal: the color control bar. The GATF version is the most universally used in the United States; but in recent years, many printers have begun to run the color Control System Brunner color bar along with the GATF Color Bar on the press sheet. Both of these systems were designed by printing quality control specialists to aid the printer in identifying press problems and reading what is happening on the sheet. With these bars they can ensure that, once corrections are made, they have been solved on press.

READING COLOR BARS

"Isn't this the printer's responsibility?" you might ask. Well, the next time you are at a press approval and cannot achieve the colors you want, you will wish you knew how to correct the situation. Let us say the printer tells you, probably honestly, that the color you want simply cannot be built. You have a color proof in front of you showing that it can be built, but it is not translating accurately on press. It is at this point that you could look to the GATF Color Bar or the System Brunner to find out what is really happening on the press. You may find you are not getting the color you desire because you have significant dot gain in one or two colors, or slurring or trapping problems. Without knowing what these press problems are and how to identify them, you might be signing off on a sheet that is too much of a compromise — no doubt leaving you dissatisfied with a print job that is an inferior product. So the sooner graphic artists learn how to read these bars, the easier future press approvals will be.

GATF OFFSET COLOR CONTROL BAR Designed in 1965 by the Graphic Arts Technical Foundation as a means to 1) better correlate color proofs produced during the color separation stage to the actual printing process of ink on paper; and 2) to provide printers with a number of very precise devices as defined by the GATF "for the evaluation

QC (quality control) strip. Used in area where space does not permit the use of the full color bar—trim areas, for example. Solid bar at top should be clearly distinguishable from the screened area below.

Register marks for stripper to position his film.

10% tints of solid colors.

40% tints of solid colors.

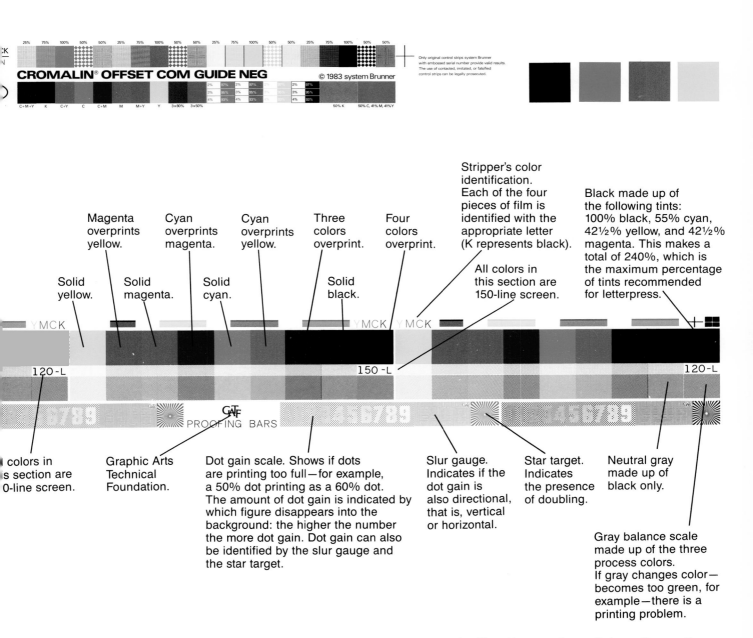

CROMALIN® OFFSET COM GUIDE NEG © 1983 system Brunner

Magenta overprints yellow.

Cyan overprints magenta.

Cyan overprints yellow.

Three colors overprint.

Four colors overprint.

Stripper's color identification. Each of the four pieces of film is identified with the appropriate letter (K represents black).

Black made up of the following tints: 100% black, 55% cyan, 42½% yellow, and 42½% magenta. This makes a total of 240%, which is the maximum percentage of tints recommended for letterpress.

Solid yellow.

Solid magenta.

Solid cyan.

Solid black.

All colors in this section are 150-line screen.

colors in s section are 0-line screen.

Graphic Arts Technical Foundation.

Dot gain scale. Shows if dots are printing too full—for example, a 50% dot printing as a 60% dot. The amount of dot gain is indicated by which figure disappears into the background: the higher the number the more dot gain. Dot gain can also be identified by the slur gauge and the star target.

Slur gauge. Indicates if the dot gain is also directional, that is, vertical or horizontal.

Star target. Indicates the presence of doubling.

Neutral gray made up of black only.

Gray balance scale made up of the three process colors. If gray changes color—becomes too green, for example—there is a printing problem.

Color Bars When reading most quality control manuals, the specific areas (or "devices") on the bars, and the correlating press problems they identify, are greatly magnified to better illustrate the problem to the reader's naked eye. Most designers/production people, even printers, go to press approvals with nothing more than an 8x loupe. However, if you go to press approvals armed with no less than a 16x loupe, even a 30x loupe, you will become a much better "reader." (A System Brunner bar (top) and a GATF bar (below) are shown here.)

and control of offset presswork."

The GATF bar consists of a top line of solid areas — the four process colors — and their overprints into the secondary colors, red, green, purple, a three-color overprint-yellow, magenta, cyan, and the four-color overprint. Below the solids, in the second row, are 10 percent screen tints of each — which would be the equivalent of the highlight areas. Below that, in the third row, you will find the screen tint at 40 percent — an equivalent of the midtones. Of special interest in the tint sections is the three- and four-color overprint. When the three-color, solid black and four-color tints are printed properly, they form the "gray balance bar." What this means is that when in their proper color ratios, the three-color or four-color overprint tints create either a warm gray (three color) or a cool gray (four color), with the black screen tint creating a neutral gray.

Under the screen tints, three devices are featured side by side, each in the four process colors. From left to right, they are: 1) the "dot gain scale," identified by very finely screened numbers from 0 through 9 on a coarse-screened background; 2) the "slur bar"—if a slurring problem occurs on press, the word "SLUR" will appear; otherwise, the word remains illegible; 3) the "star target," which looks like a square made up of many fine triangles reaching and meeting in the middle (in some cases, the square will be a circle, referred to as a "pinwheel".)

In recent years, there have been some additions to the GATF Color Bar, such as the "Midtone Dot Gain Scale" and large "Gray Balance Bars." When space is limited on the press sheet, printers will use a quality control strip or "QC" at the very top of the GATF Color Bar. It consists of a thin solid

Dot Problems On-press problems, such as dot gain, dot sharpening, slur and doubling, are immediately evident when using the scales and gauges on the GATF color bar.

PRESS CHECKLIST

- ✓ Understand your purpose for being there.
- ✓ This is not a field trip, so don't wander.
- ✓ Be patient and gracious.
- ✓ Take only authorized people.
- ✓ Only talk to authorized personnel.
- ✓ Ask and suggest; don't demand.
- ✓ Share responsibility.
- ✓ Accurate viewing means using a 5,000 K viewing booth.
- ✓ Avoid staring at sheets for long periods.
- ✓ Identify problem areas with marker, then check the loupe.
- ✓ Bring product samples for critical color matching.
- ✓ Make sure make-ready was done properly.
- ✓ Don't sign the first good sheet.
- ✓ Check all sides of sheets.
- ✓ Check folds and finishing procedures.
- ✓ You sign it; you own it!

strip with a 70 percent line screen at a 45 degree angle. This simple strip will quickly indicate any changes that would occur on press, such as inking, water/ink ratio and dot gain. As new quality control devices are invented, they are tested and integrated into the color bar.

COLOR CONTROL: SYSTEM BRUNNER Named after its Swiss inventor, Felix Brunner, one of the world's foremost experts on color reproduction, the system was introduced to European printers in 1971. Some twelve years later, it made its debut in the United States.

Brunner's system consolidates the larger format GATF Color Bar into a single bar carrying the same, if not more, information in much less space. Space is of particular concern to printers whose jobs do not allow enough room on the press sheet to use the full GATF Color Bar.

Like the GATF bar, the System Brunner is used during the color separation process to ensure the quality of the color proofs and to correlate that information with the color printing. Designed with many of the same devices as the GATF Color Bar — solid areas to measure ink density, overprint on two color, three-color overprint, to measure trapping, with screens of 25 percent, 50 percent and 75 percent of each to measure for dot gain — one control device this bar features that the GATF does not is the "Supermicromeasuring Element." This element measures dot gain, slur and proper plate exposure. A more specific "Microline Field" very accurately measures plate exposure. Keep in mind that if the plate is not properly exposed, it is very difficult, if not impossible, to achieve quality reproduction.

While not fully integrated into the American printing community, the System Brunner is gaining in popularity and should be in active use within a few years. ∎

—Daniel Dejan

Printing With Specialty Inks

Textured, scented, magnetic, invisible, even glow-in-the-dark— today's specialty inks offer many options.

Ink is one of the principle components of any printed page. Since most printed pieces are used for many diverse applications, a variety of inks have been developed to fulfill specific criteria. Those inks designed for functional applications that a standard ink cannot accomplish are often called specialty inks.

While extensive knowledge of different inks and ink formulations is generally not necessary for the designer, some knowledge of the different types of specialty inks available will allow you to take advantage of their functional properties.

SELECTION

If your job requires outside use, extreme durability, product resistance, if it is to be printed on a stock other than paper, or if you desire a special look that only a certain ink can deliver, a specialty ink will most likely be considered.

Typically, once you have discussed a specialty job with your printer, he will work with an ink manufacturer representative to specify the proper ink. A number of specifics will be taken into consideration, such as visual impact desired, adherence and compatibility to your paper stock, printing and bindery processes to be used, color rotation, type of press, press speed, drying demands, ink finish desired (gloss, dull, transparent, opaque), and the end use of the printed piece.

COST

National averages indicate the use of standard inks typically makes up three percent of a job's total cost. Use of a specialty ink may raise that percentage to five or six percent.

ON-PRESS TROUBLESHOOTING

If a problem related to ink occurs on the press, it is usually one of opacity, color match or drying.

"Many graphic designers sometimes forget that most inks are not nearly as opaque as the markers or paints that are used for comps," says Decator Dunagan, executive vice president of National Printing Ink Company in Marietta, Georgia. "The best way to ensure that the color to be printed will be what you want is to request color proofs of the ink on the exact sheet on which you will be printing. Different papers and printing substrates can vastly affect the appearance of your ink," Dunagan continued.

Robert Russell, vice president of technical sales for National, adds, "The best place to compare, accept or reject color ink proofs is under your printer's lights. Most offices have fluorescent lighting, which is totally different from the daylight systems such as the MacBeth Lighting System for Viewing used by most printers. It's difficult enough when two sets of eyes see color differently, but to add the differences in lighting is totally unfair to the integrity of the piece."

If your ink manufacturer has provided an ink formulated to your needs, if the printer has allowed adequate drying time for the coverage and if humidity controls are applied in the pressroom, you generally should not have drying problems.

TIPS FOR DESIGNERS

• Work with your printer early in the design process by advising him of stock selection (and by providing samples, if possible) so the proper ink can be selected, ordered and tested as necessary prior to press time.
• Check color proofs under the same lighting source as your printer will be using.
• Do not assume that a standard printing ink will run satisfactorily on all printing substrates. Depending upon use, many papers and all synthetics require some sort of specialty ink.
• If a varnish or some other overcoat is to be used, the ink manufacturer should be advised so that he can formulate his inks to prevent an undesired reaction to the overcoat.

—Linda Duncan

Specialty Inks Chart The specialty inks chart on the next two pages lists a number of the more common specialty inks, some of their typical applications, cost relationships to standard inks (1 representing the average cost for a standard ink and 10 representing the most expensive specialty inks), special characteristics and tips for use.

Type of Ink	Typical Applications	Cost Relationship	Special Characteristics	Tips for Use
Fluorescents	Naturally bright inks that reflect and emit light, making use of ultraviolet light waves which other inks cannot utilize. Used often in packaged goods to brighten the package and increase eye appeal.	8	Will fade with time and exposure to ultraviolet rays.	May need two passes of ink to get intensity desired depending upon the printing process used. Surrounding the fluorescent with a dark color in some printed applications, such as outdoor signage, will allow the piece to still be readable after the fluorescent has faded.
Metallics	Metallic powders, such as aluminum and copper alloys, are mixed with varnish bases to give metallic luster. Metallic inks are used for accentuation or to give an expensive feel to a piece.	5	Have a tendency to scratch and rub off.	Consider overprinting with varnish to reduce scratching. However, keep in mind that the varnish overcoat will reduce the luster of the metallic. If you do not varnish, make sure necessary bindery work will not damage the metallic image. Coated papers give the best results, but on uncoated stocks, the sheet may be sized with a base ink, allowed to dry, then overprinted with metallic to give the desired effect.
Matte/Dull	Often used to accent high-gloss printed images.	3	Shows fingerprints; smudges easily.	Consider dull varnish to reduce fingerprinting and smudging.
Fade Resistant/UV Resistant	Ink shows a higher resistance to light. Used for outdoor applications or when printed piece will be exposed to strong lights over a period of time. Also used for art reproduction work.	8-10	Doesn't fade, not quite as transparent as other inks.	Some limitations in the pigments, or colors available.
Scuff Resistant	Typically used in the packaging industry, particulary for folded cartons. Also used for high-end mail order catalogs to reduce scuffing in the mail handling process.	3	Because of its extreme resistance to scuffing, may be difficult to overprint at a later date, should that become necessary. Check with your printer.	Use of this type of ink *may* eliminate the need for a varnish coat, although the varnish will add gloss.
Scented	Used where fragrance is desired to help sell a product or feeling. Often used to demonstrate food or perfume fragrances. Also used in microencapsulated ''Scratch and Sniff'' pads. In this process, the fragrance is locked in microcapsules which are later scratched, or broken, by the intended audience to release the fragrance.	5 for scent without-microencapsulation; 8-9 for Scratch and Sniff	Loses potency over time depending on the scent used. Perfume starts evaporating right after it is printed unless locked in microcapsule.	Take shelf life into consideration when deciding which type of scented ink and application process you need. Remember a particular scent or aroma may be offensive to some in your audience.

Type of Ink	Typical Applications	Cost Relationship	Special Characteristics	Tips for Use
Magnetic	Used to print characters on checks so that they can be recognized by electronic reading equipment. Developed to increase the speed and efficiency of handling bank checks.	9, but typically a very small amount is used.	Inks are made with magnetized pigments that react to electric currents.	Check printers who specialize in printing with magnetic inks. Limited color selection available, with black and red the most prominent.
Sublimination (Heat Transfer)	Used for T-shirt decals on certain fabrics. Designs are printed on a carrier paper. Rolls of the printed carrier and fabric are fed through heated drum where the image on the carrier sheet is transferred to the fabric.	10	Typically doesn't work well with 100% cotton fabrics. May have some color variance at transfer point.	Be sure to do trials on actual material to be printed or screened. Take color variance into consideration.
Invisible	Used for children's books to create ''magic'' and for contest and lottery printing to prevent forgeries.	9-10	Inks are invisible until they come into contact with other chemicals or certain light sources, such as black light.	While invisible inks are typically easy to run, they are very specialized and have had limited applications in the United States. Check to see if your printer has had experience with these inks and can confirm your desired results are attainable.
Luminescent	Silk screen printing ink used when printing needs to be visible in the dark, such as some promotional pieces and pieces for outdoor use.	10	Glows yellowish-green after exposure to daylight. If not exposed to daylight, it does not glow. Permanency based on the number of hours and intensity of daylight to which the ink is exposed.	Some limitations in pigments available.
Moisture Resistant	While most inks are moisture resistant, when dealing with water-based inks, additional mixing varnish may be added to improve moisture resistance. Some uses include bumper stickers and ice cream cartons.	3	Will hold up to excessive moisture in day-to-day use.	Use much as a standard ink. Your printer and ink manufacturer will be responsible for satisfactory press performance.
Inks That Change Color upon Application of Water, Heat or Chemicals	Often used on hospital packaging to indicate whether equipment has been sterilized.	20	Color provided by chemicals that react to water or heat.	Must be printed on a separate, clean press cylinder much as a colored ink.

Working Guide to Binding

	Type of Binding	Description	Relative Cost	Layout Considerations	Common Applications
STITCHING	Saddle Stitching	Probably the most common form of binding. Folded signatures are placed on a saddle beneath a mechanical stitching head, and staples are forced through the backbone of the booklet. The thickness of the sheets and length of the staples determine how well the stitching will hold up.	Simple, fast and inexpensive, typically the most economical.	• Does not yield a flat outer spine that can show printing • Usually best for pieces less than ¼-inch in thickness. Some equipment can stitch greater thicknesses. However, most people prefer other bindery methods for thicker pieces. • On automated machinery, some limitations exist on how close two staples can be placed in one operation. • Do not forget creep and margin allowances.	Thin brochures, pamphlets and catalogs.
	Loop Stitching	A variation of saddle stitching in which each staple has enough play outside the crease to go over the rings of a ring binder. More common in Europe than in the United States. Check to be sure this binding method is available in your area.	Basically the same as saddle stitching although some speed limitations may slightly increase costs.	• Can be used in ring binders without drilling holes.	Consider for catalogs that require frequent updating of sections.
	Side Stitching	Sections are collated, then placed flat under a stitching head. Often used when bulk is too much for saddle stitching. Extremely durable method of binding.	Typically more expensive than both saddle stitching and perfect binding.	• Results in strong bind, but pages will not lie flat. • Since the stitches are inserted about ¼-inch from the backbone, the inside margin must be wider than in a saddle stitched book. • Side stitching is not recommended for children's books since the exposed staple ends on the back side of the piece can occasionally prick the reader's fingers.	Magazines with varying weights of inside pages, almost anything requiring frequent use.

Binding affects the look and cost of a job.

It may be punched, drilled, stitched, sewn or glued, but if you design a piece with multiple pages, you will, at some point, have to make a decision on the best bindery method to assemble those pages. The smart art director or graphic artist takes bindery methods into consideration early in the creative process. Not only can bindery work affect the cost and appearance of your creation, but if the wrong bindery method is chosen, the functionality of the piece can be lessened.

PLANNING
Several general topics should be considered early in the development of any design requiring binding.

COST Typically, a saddle stitched binding is the least expensive method to use—usually around 10 percent of your printing bill—followed by perfect binding. If, however, your quantity is low, you may find that mechanical bindings (spiral, plastic comb, or Wire-O) are just as cost effective. Cost differences among the forms of mechanical bindings are not very great. However, mechanical bindings tend to be more expensive than other binding methods when your quantities are large. (Mechanical binding can run as high as 50 percent of your printing cost.) The most expensive binding method (sometimes more than 60 percent of your printing bill) has typically been case

binding for hard cover books. This may change as more computerized equipment for this process becomes available to the industry. Since each job varies depending on the number of pages to be bound, the type of paper on which the job is printed and the functionality of the piece, it is best to consult with your bindery representative early in the creative process for the most cost-efficient method.

FUNCTIONALITY Does your piece need to be easily and inexpensively updated? Does it need to lay flat? Are colored bindings or spine imprinting important to your design? Do you need to bind a number of thick sheets? What type of appearance do you want your finished piece to convey? Is short run cost a concern?

All of these functionality concerns can be

Type of Binding		Description	Relative Cost	Layout Considerations	Common Applications
MECHANICAL	**Spiral**	Sheets are punched with a series of round or slotted holes on the binding edge. Wires are then coiled through the holes, cut and crimped.	Least costly of the three mechanical bindings	• Allows pages not only to lie flat, but also to be doubled over. • Crossovers (images crossing the gutter) do not match. • Standard colors are silver and white with other colors, including custom colors, available. • Spirals can be damaged by crushing.	Notebooks, calendars.
	Plastic Comb	Sheets are punched with a series of rectangular holes, then plastic combs are hand inserted. Two hole spacings are available—⁹⁄₁₆-inch (GBC-style spacing) and ½-inch (Plastico spacing). Easy to install—can be done at many small printers and in-plant shops.	Usually the most expensive of the three mechanical binding methods due to the high cost of the plastic combs and the hand labor involved to insert the combs. However, equipment is relatively inexpensive so that art departments can afford to purchase if need warrants.	• Not as durable as spiral or Wire-O since plastic can crack and comb can separate if lifted by spine. A locking plastic comb is available for a more secure binding. • Plastic spine can be imprinted. • Bound piece will not open past the point of lying flat. • Standard colors are silver and white with other colors, as well as custom colors, available. • Offers largest capacity of the three mechanical binding methods—up to three inches. • Crossovers will match.	Cookbooks, presentations.
	Wire Comb or Wire-O	Pages are bound by double loops of wire that allow the piece to be doubled over. Very durable, gives a more finished look than spirals.	Typically costs more than stitching or spiral binding.	• Lays flat, crossovers match. • Semi-concealed and skip-loop Wire-O bindings are available to allow some spine imprinting. • Standard colors are silver and white with other colors, including custom colors, available.	Training manuals, cookbooks, calendars.

addressed by the selection of the most appropriate binding method.

PAGE IMPOSITION Page imposition is determined by how signatures will be assembled, so the method of binding must be known before stripping.

MARGIN ALLOWANCES Most bindery methods call for trimming the signature prior to actual binding. Depending upon the binding method used, various allowances should be made on the spine and sides to ensure consistent printed image margins. Check with your printer or bindery representative to determine sufficient allowances before mechanicals are done.

CREEP If your design will be printed on heavy stock or has many pages, take page "creep" into consideration when preparing your mechanical. When a press sheet is folded into a signature, the inside pages creep away from the spine and push out on the opposite side. Creep can be particularly noticeable with designs which have narrow margins or bleeds on inner pages. Shingling is the result of creep on the outside edge. Mechanicals must allow for shingling to assure equal margins throughout the printed piece.

EQUIPMENT While you seldom need to know the specific types of binding equipment used on your job, you should be aware that semi-automatic as well as totally automatic equipment is available for many types of binding. Semi-automatic equipment is typically used when dealing with small quantities, an odd trim size or thicker pieces. The automatic equipment is much faster and considerably more economical for larger runs of standard sizes.

BINDING METHODS
Basic binding methods fall into these categories: stitching, mechanical, looseleaf, perfect and case bound. This chart illustrates a variety of binding methods and outlines relative costs and layout considerations.

MISCELLANEOUS BINDING METHODS
While the chart indicates the most common binding methods, you may come in contact with several other methods of assembling or attaching loose sheets.

GLUING Glue strips that are activated by moisture or covered by a protective strip

Type of Binding	Description	Relative Cost	Layout Considerations	Common Applications
Looseleaf	Utilizes notebooks with rings or binding posts which open to allow the addition or replacement of pages in which holes have been drilled. Binders are available in a variety of styles, colors and sizes.	Binders themselves may run up initial cost, but binding prep (drilling of holes) is inexpensive. This method is economical to update and reuse.	• Allowances must be made in the gutter (inner margin) for punching of holes.	Sales catalogs, any piece requiring frequent updates.
Perfect	Developed to eliminate the expense of sewing and case binding books. After signatures are collated, the spine is trimmed to get rid of the folds, then ground off, leaving a rough surface. A flexible adhesive is then applied along the spine. When the cover is placed over this stack, the glue is forced slightly in between the pages as well as onto the inside cover along the spine. (This *Production Guide* is perfect bound.)	Typically least expensive next to saddle stitching.	• Perfect binding of coated cover stocks may result in less than satisfactory adhesion as the coatings may prevent glues from adhering strongly to the paper fibers. • For better adhesion of the cover, white out (don't print) the center inside spine. Check with your printer or bindery rep for exact allowances. • When possible, minor white out allowances should be made for inside pages bleeding into the spine for better glue adhesion. • Thicker/heavier papers have a greater tendency to come apart with this binding method.	Magazines and large catalogs.
Case Bound-Sewn	Signatures are sewn with thread, then cased into books to form common hard cover books. Types of sewing are center, or Smythe, sewing (similar to saddle stitching with thread instead of wire) and side sewing (similar to side stitching). Best for durability, good looks, high cost.	The most expensive binding method. To cut costs, some publishers insert perfect bound (rather than sewn) signatures into cases.	• Sewn book lies almost perfectly flat. • Designer must specify exactly what he wants—square or round backs, headbands, boards, cover material, dust jackets, end sheets.	Any hard cover book.

until the glue is needed and applied. Many return reply inserts and order forms are glued.

TIPPING Gluing one sheet to another sheet or signature. Many magazine inserts are "tipped in."

PADDING Forming pads from stacks of loose sheets by gluing one side of the stack. Notepads are padded.

TINNING Clamping metal strips along the tops or bottoms of calendars.

SADDLE-THREAD OR SADDLE-CORD Two holes are drilled along the spine, then a thread or cord is inserted and tied. Often used for menus.

BINDING TRENDS

The majority of advances being made in the binding industry today revolve around increased speed, computer-related enhancements and additional automated features.

For example, in case binding, computers are now being developed to reduce an average set-up time of one hour to 10 minutes or less. These computers also check and double check the specifications input by the operator to enhance quality control.

Binding equipment manufacturers are also incorporating automation of a number of downstream operations such as stacking, strapping, polybagging and palletization that formerly had to be done either on another machine or by hand.

Selectronic binding allows a number of slightly different editions, such as regional magazines, to be bound at the same time on the same equipment. These changes and even more still on the drawing board should ultimately result in cost savings for the end purchaser of binding, shorter turnarounds due to faster make-ready and more economical short runs. However, this new equipment is relatively expensive, so changes will depend on the supplier's overall need for the improvements in relationship to his return on investment. ■

—Linda Duncan

TECHNOLOGY UPDATE

To the printer and the graphic artist, "the future" often translates to "every new tool or technique that makes my job better, faster and easier." Digital assembly and electronic prepress are getting the most attention now, but with their advent, even more possibilities emerge. This section tracks trends, details what is to come and how it will affect you and your work, and explains how you can make yourself a viable part of that future.

Trends in Graphic Arts Technology

One expert's view of where technology is leading designers, color separators and printers.

Because the printing industry is experiencing such profound effects of new technology, graphic designers can look forward to seeing jobs printed faster, cheaper and with higher quality. This same technology, of course, is affecting designers in their own studios as well, and they are responding by adding new and expanded skills to their repertoires. Because companies will continue to need far greater print output to remain competitive in their respective markets, the artist's tools will be far more powerful, have more support functions, be quicker, more accurate and more directly linked to the final product.

THE STUDIO

The smaller design/advertising studio will start taking advantage of technology that is finally coming into their price range: Macintoshes/PCs, laser printers, scanners/digitizers, desktop publishing and affordable color copiers. A trend that is growing in popularity is to keystroke and lay out a project on the studio's desktop computer, then send the information, either in disk form or over a modem, to a typographer or service bureau that will output the information in high resolution. This saves the studio and client a lot of time and money.

The trend will also be to bring as many outside services into the smaller shop as can be afforded. This will allow the studio to offer a wide range of quick turnaround work to their clients with as little outside vendor involvement as possible.

Medium to large studios and agencies will be far more concerned with producing medium-to-high volume work efficiently. Many of the projects will be kept completely in-house using sophisticated multi-functioned workstations hard-lined to typographic, line-conversion/scanning equipment capable of rendering a hard copy on premise or connected via a modem/telecommunication system to high-quality output systems at their typographers or printers.

COLOR SEPARATIONS

New color and imaging equipment is revolutionizing the way in which designers are having their separations made. Electronic workstations enable the separator to color correct and airbrush, cut and butt retouch, do emulsion stripping as well as dot etching. With the larger units, pagination as well as imposition is possible. The trend is to link up the output with a CADD (computer assisted design and drafting) machine that will do all ruling, masking, cutting of windows, and stripping directly onto film negatives. These workstations have been successfully tied together to produce finished working negatives done from layout tissues and transparencies provided by the design studio. The transparencies are scanned and the negs ruled, windows cut and traced directly from the tissues, making much or all of the paste-up unnecessary. The design/ad studios are moving toward full-service pre-press shops that can color separate, strip, build working masters and deliver final film to printers with a color proof. Some shops actually can burn the plates as well. In addition, more and more separators are buying sheet-fed presses to be able to press-proof negatives and plates for their clients. These shops, then, can also sell short run color printing on the side.

In sharp contrast, printers themselves are now buying more color separation equipment in order to keep work in-house, offering more control from film to plate to paper. This also decreases the typical problems associated with using several vendors. Since this is a new profit center for printers, it is leading to a new rivalry between printers and separators that should prove to get more interesting with time.

High-tech equipment is also leaning toward soft proofing: Viewing separations on a monitor first, before they are committed to film. Since monitors are tied to scanners—monitors both in the separator's and designer's workplace—corrections can be made before films are produced. This provides great time and money savings, especially in the material costs in the early stages of the separations.

Finally, Gray Component Replacement (GCR) is a color separation method of which designers should be aware. This method builds color achromatically (the way it was done for letterpress color separations), rather than chromatically, as is programmed into laser separations. It should start to become more accepted by industry separators and printers alike. (See the section entitled "Gray Component Replacement" in this guide for more detailed information.) It offers easier makeready, and it is easier for printers to make changes of color in-line. It also can be run on press with non-GCR separations.

SHEET-FED PRINTING

The sheet-fed market will soon be divided into two types of shops: copy only and high-tech shops that do art/production, some typesetting, stripping, metal plating and printing on the premises.

"Copy only" shops will only be able to make direct plates (art-boards to plate, usually a paper or mylar plate good for short-run work) for small to medium sheet sizes and quantity printing.

With the release of the new four-color cameras, the small quick print shops are already offering short run, average quality four-color jobs, inexpensively and quickly. These cameras shoot direct from any color photograph or artwork, create a transparency, scale it to size and put in a dot pattern—producing four, low cost, short run printing plates ready to go on a small two-color press.

Because the new sheet-fed four-, five-and six-color presses are running much faster today (up to 14,000 + iph), with the capability of positioning multiple images on one large (38 × 40-inch) sheet of paper, they soon will be competing for the short run web-fed jobs. Web technology, such as plate scanners and ink fountain controls from the console are also being adapted for sheet-fed presses.

WEB TECHNOLOGY

Due to a greater demand for long runs (100,000 + , multiple signatures) with a wider diversification of end-line requirements, web-fed presses are having to run at much higher speeds. End-line processes like folding, collating, binding and cutting, which run at significantly slower speeds, are having to be done off press. Or the press has to be run slow enough to accommodate the end-line equipment—which is not cost effective.

In addition to higher speeds of 40,000 + iph, new configurations are being used to increase the number of signatures produced, such as using double (or ratioed) circumference cylinders carrying two plates or a blanket that will receive two or more images for every one rotation.

Web printing is breaking off into two camps: The traditional heat -set web printing (ovens dry the inks); and the non-heat-set UV (ultra-violet heating systems) printing. With only a handful of years in opera-tion, non-heat has proven itself well for use with grade five (newsprint) and four (kraft and groundwood mixes) papers, those used for newspapers, newsprint inserts, direct mail and low-quality, high-volume runs.

While non-heat-set has great cost savings associated with it, unfortunately it cannot produce the desirable "gloss" of heat set. Therefore, it is not an appropriate choice for higher grade papers. However, both systems have the technological advantage of "closed-looped" systems, which utilize either an electronic or laser "eye" to read the sheets as they pass through the press. Information is fed to the computerized console and sheets can then be inspected and adjusted automatically, as required. This guarantees the continuity and quality from head to tail of the run.

FLEXOGRAPHY

Flexography is often called "the quiet giant" in the printing industry. Due to an enormous influx of research and development dollars from large rubber manufacturers—this printing process uses rubber printing plates—many of flexography's quality problems have been overcome. The results are finer screen resolutions (200 lines per inch are being seen), denser inks with better coverage and significantly better four-color registration. Current uses for flexography include packaging (foils, mylars, plastics, corrugated surfaces), newspaper publishing, direct mail, comics and inserts.

Flexo has made significant strides in newspaper publishing, for example. Every newspaper in the U.S. is now looking toward flexographic printing as a part of their future. But two big problems with this process remain to be solved: The inks have a tendency to dry too quickly on the plate, and the rubber plates have a tendency to fill up or "plug up" with loose newsprint fibers, causing loss of clean, crisp quality. Both of these problems are being studied, and the industry is being assured of a solution within the next two years.

Great breakthroughs are also being made in converting old letterpresses and old off-set presses to flexo, because the flexo process is much less expensive, easier to clean and touts easier make-ready. It is also less labor intensive, requiring less skilled labor in some of its functions. Flexography will be competing head-to-head with non-heat-set web offset in the future, since they both print newsprint, direct mail, inserts, comics and kraft paper very well.

GRAVURE

Gravure has always been recognized for its high quality and high speed due to the width of the cylinders. The cylinders can carry four to five 16 or 32-page signatures each. The process, however, is also associated with very high costs, as these copper cylinders are very expensive. The engraving can be as much as seven or eight times more expensive than conventional offset half-tone separations. It requires lengthy pre-press time and a minimum quantity of approximately two million to amortize the start-up costs. Nonetheless, it is used by weeklies needing fast turn-around times, large national publications (for its speed and large quantities), and by art book publishers, who print low quantities but require very high quality.

Laser technology and digitization have had a greater impact on gravure than on any other printing system. Inventions such as the Helioklimschograph pioneered by Hell in Germany, for example, make it possible for art to be scanned on a laser scanner and then be engraved with diamond heads directly onto the copper cylinders. This reduces pre-press time dramatically.

Laser gravure is a process which engraves directly on a cylinder coated with polymer resin. By engraving onto the hardened resin instead of directly on the costly copper cylinders, the engraving can then be easily removed and the unharmed copper cylinder can be recoated for multiple usage, bringing the cost and the pre-press time down. In addition, the use of hollow-core cylinders of copper rather than solid ones have brought the start-up costs down.

By far the most exciting experiments, however, have been done in the area of preparing films as halftone film positives. Though not perfected, research is advancing toward the use of these more universal and inexpensive halftone film positives. Again, this would bring the pre-press costs down to a commercially viable level, and would afford gravure the opportunity to compete with long-run web offset.

THE PRINT CITY

Larger printing concerns are being introduced to a Japanese inventory system called "Just-In-Time" (or JIT). Americans have linked it up with a sophisticated computer system known as the "Shop System." Every station is linked to the mainframe computer, so that the stripper, printer, or platemaker simply punches into a very simple terminal the job number, time, function to be performed and so on. All of the information is then recorded in real time, so that any job can be tracked immediately. In this way delivery schedules can be much more accurately predicted. Here is how the JIT system works. If your company prints 120,000 forms a year, rather than printing the entire run and storing inventory, your printer would rely on their JIT system on the computer to automatically tell them it is time to print your company's monthly allotment of forms. The project would go through the computer and schedule the appropriate personnel to order the necessary paper, call up the standing negatives or plates and actually schedule the press time. The result: You would receive 10,000 forms for that month with the balance to be shipped, 10,000 every month, until the order has been honored. In each case, the company gets what it needs in a specific time period, never having to be concerned with warehousing large quantities of inventory. Companies such as IBM and State Farm Insurance, for example, are using this system effectively.

With the current flurry of mergers, aquisitions and corporate restructuring, new and even larger "print cities" are developing. Unlike the large commercial printing concerns, they offer the entire spectrum of services on the premises or on outside premises owned by the corporation. From concept and design, and keylining to pre-press functions including separations, stripping and plate making, through to printing sheet-and web-fed, finishing, binding and finally distribution. These print cities may be in one physical location, like Quad-Graphics in Pewaukee, Wisconsin, or The Graphic Arts Center in Portland, Oregon, or they may be national, such as major magazine and newspaper publishers with offices and printing stations located throughout the United States (*National Geographic*, Time-Life Inc., or USA Today). They transmit pages via satellite. They are owned by corporations, or one person, like the British empire of Robert Maxwell, corporately known as the British Printing & Communications Corporation—or Rupert Murdoch and Kerry Packer's Consolidated Press Holding.

But what effect will the growth of these print cities have on the mid-size printer? Perhaps only in certain geographic locations will the mid-size shop thrive. The smaller shops, of course, will continue to flourish, though they will find they may have to specialize more and more. Or they will target themselves toward the lower-dollar projects. As was aptly put by the CEO of one of the largest printers in the nation: "Industrial Darwinism will take its toll on those companies not fit to compete. Price wars will do the largest damage." Since the financial forecast for the next few years is not good and some printers have bought equipment over the last few years, the task of staying competitive will be an enormous one. Graphic designers may see prices dropping dramatically, or their suppliers may add additional services, somehow suggesting "value added."

With all of this in mind, printers will be far more cautious about the business, once it comes in. Printing Trade Customs will be vigorously enforced, and printers will not be able to withstand loss of profits on jobs, especially if they are not at fault. (See "Printing Trade Customs Defined" earlier in this guide for more information on this topic.) They will rely heavily on the trade customs to protect them through arbitration. Signed contracts will be mandatory, on everything from alterations and change of schedules, to shipping and delivery dates. ■

—*Daniel Dejan*

Print Production in the '90s and Beyond

By the end of the next decade, electronic tools will be the norm rather than the exception for print production.

Predicting the future is slippery business. Gazing 10 to 15 years ahead, we are almost certain to miss something important. For example, in 1975 nobody predicted desktop publishing, or that by 1990 as many as 20 percent of graphic artists and designers would become regular users of studio systems and related services. Readers of this forecast should stand forewarned.

THE FUTURE OF PRINT

Print is not going away. Print will continue to be the dominant medium for visual communication well into the next century. Print is a mature communications medium, the sixth-largest industry in the world. Measured in dollars, the print market will grow at around the same rate as the gross national product. Moreover, color in printing will grow nearly twice as fast.

The good news for graphic artists is that the number of original printed pages will grow by about 10 percent per year over the next decade. So graphic artists will have plenty of work to do, and more of it in color.

A new trend in the '90s will be the synthesis of print and non-print media into new forms of publishing, variously called multimedia, hypertext, hypermedia, hypervideo, and the like. The growth rate for corporate and commercial applications will be two to three times that of conventional color printing.

Print production growth forecast

Category	Growth Rate	Measured By
New studios	2–3%	Business starts
All printing	3–4%	Constant 1990 dollars
Color printing	7–9%	Constant 1990 dollars
Original pages	9–10%	Printed pages
New media	15–25%	Constant 1990 dollars

Source: DAVIS INC, U.S Department of Commerce.

THE PRINT PRODUCTION PROCESS GOES ELECTRONIC

By the end of the next decade, electronic tools will be the norm rather than the exception for print production.

Colin Forbes of Pentagram Design, New York, recently summarized the change of attitude that is sweeping through the design community this way: "We have long been talking about the computerization of our industry, but until recently it has always seemed that the breakthrough was just around the corner. But it is happening now, and the trend of the last 12 months, particularly in the increase of desktop publishing, has shown that it will multiply until it becomes as essential a part of the graphic designer's daily life as the zoom electrostatic copier (photocopier!) or the fax machine. The color copier will be next."

Today print production uses a hybrid of computer-based, photo-mechanical, and manual methods. In the next decade, affordable desktop systems will have the power to create full-color photographic images in real-time. By the year 2000, creative and production steps will be largely digital, from "concepting" and copywriting to illustration, photo-retouching, typography, layout design, production, job planning, presentation, project management and accounting. In short, computers will be used for everything.

Electronic tools of the '90s will also be photo-realistic. They will combine photography and continuous-tone art with informational graphics and two-dimensional and three-dimensional geometric art to support a full spectrum of illustration. Film cameras and conventional darkrooms will begin to give way to electronic still cameras, digital darkrooms, and electronic photo-retouching.

Electronic tools of the '90s will be intelligent, incorporating a much higher level of functionality. Layout software, for example, will become more like a design assistant than an electronic drafting table. The new tools will understand style and use concept palettes to explore design variations. By comparison, the software that graphic artists are using today will seem crude and difficult to use—like writing a letter by coding a program in BASIC instead of using a word processor.

Another characteristic of print production in the '90s will be the explosive growth and widespread use of electronic type and clip art. Since 1985, the number of computer typefaces available to desktop users has grown from three to more than 3,000. By the year 2000, vast resources of graphic and photographic material will exist in digital form. The studio will have fingertip access to all typefaces as well as enormous digital libraries of historical and stock images and symbols. Today's swipe file will become a visual thesaurus that organizes access to vast stores of artwork and design elements.

As the print production process goes electronic, business relationships among studios, customers, and graphic arts services will be transformed. The four current and emerging linkages between studios and prepress services illustrate this trend:

1. MANUAL PREPRESS Today most of the interaction between studios, separators and printers involves manual prepress. It is the most cost-effective solution for most applications. The studio provides transparencies and camera-ready art (keylines); the prepress service scans and separates color artwork, manually strips all elements together, and provides its customer with a contact proof (Cromalin, Matchprint, etc.).

2. CURRENT CEPS (color electronic prepress systems) Current CEPS services address the high end of the color market. According to some industry researchers, only about 25 percent of businesses with graphic arts scanners also have installed CEPS workstations. Most are large color separators or extended service printers who support large advertising agencies and high-volume color print applications. The design studio, in contrast, does not have a system. It provides transparencies and camera-ready art (keylines); the prepress service scans and separates transparencies, scans type and line art, electronically strips all elements together, and provides the studio with a contact proof.

3. NEW ELECTRONIC PREPRESS SERVICE Currently, the industry is experiencing the emergence of a new class of prepress services for customers with electronic systems for print design, but not full print production. The customer provides transparencies; initially, the prepress service scans these and provides a reference scan of each, a 500- to 1,000-line video subset file that can be used for designing with a desktop system. The customer designs the layout and sends an electronic mechanical; the prepress service rasterizes the page file, separates, and electronically strips all elements together, replacing reference images in the PostScript file with full-resolution scanned images. The prepress service then provides color position stats (direct proofs) and contact proofs to the customer.

Experts estimate that the new electronic prepress services can reduce color prepress costs by 25 to 75 percent. By the late 1990s, new electronic prepress services will account for as much as 50 percent of all color prepress.

4. NEW OUTPUT-ONLY ELECTRONIC PRE-PRESS SERVICE By the late 1990s, desktop systems will combine creative and production capabilities. A new category of output-only prepress services will evolve to meet the needs of these customers. The design studio will provide electronic camera-ready art either as a composite page description or as digital color separations; the prepress service (or service bureau) will rasterize the page file, output film separations, and provide a contact proof.

Graphic arts services closest to the press, such as color separators and typesetters, were the first to move to digital equipment. Now, as we enter the 1990s, graphic artists are making the transition. Although today designers are most directly affected by the need to use computers to specify production, as the decade proceeds, creative applications will become increasingly attractive. That does not mean studios will not use both traditional and electronic methods for many years to come. The skill sets are different and studios will need both. And, indeed, electronic systems will displace or greatly change many production-level jobs—those of mechanical artists and keyliners, for example. However, the new tools will also affect designers and illustrators, enabling them to exercise control over a broader range of creative and production activities. ∎

—*L. Mills Davis*

GLOSSARY

The following is a listing of the most frequently used print production terms.

AA Author's alterations. In composition, changes made to copy after type is set.

Accordian fold Two or more parallel folds made in opposite directions, which open like an accordian. *Also called Concertina fold.*

Acetate Transparent film often used to cover mechanicals or layout.

Achromatic A system of color correction used in conjunction with a color scanner that removes a degree of extraneous color. *Also called Without color.*

Additive colors The primary colors of light—red, green and blue—that may be mixed to form all other colors in photographic reproduction.

Against the grain Folding or feeding paper at right angles to the lie of the paper fibers.

Agate Originally the name for 5.5 point type, it commonly defines a unit of measurement used in newspapers to calculate column space (14 agate lines equal one column inch.)

Align, Alignment The placement of type or art so that horizontal and/or vertical edges line up.

Amberlith Brand name for a red- or orange-film-coated acetate sheet, which, when cut to mask out windows or other elements of a mechanical, appears black to the camera. The resulting film is clear in the areas where the Amberlith lies.

Aniline dye Generic term for all synthetic dyes used in flexographic printing inks.

Apron Space left at the edge of a page used for a foldout.

Assembly The collection and arrangement of the art or film negatives necessary for platemaking.

Ascender The segment of a letter that extends above the main body.

Backbone *See Spine.*

Back etching In lithography, reducing the negative's density.

Backing A printing problem caused when new ink does not flow to replace ink removed by the fountain roller, resulting in progressively lighter color on the printed sheet.

Back margin The margin of a page that is closest to the spine.

Backslant A typeface that slants backward, opposite of italic.

Backstep (collation) marks Black marks printed on a signature that show where the final fold will be. Once folding or gathering is completed, the marks should fall in a stepped sequence.

Back up To print the second side of a sheet of paper.

Bad break Awkward, unattractive or illegible hyphenation of a word at the end of a line of type.

Baseline An imaginary line on which the bases of some letters sit.

Bastard size A non-standard size (any material).

Belt press A letterpress machine that uses long, flexible printing plates fixed to a pair of belts so that many pages may be printed in sequence. Used for books and lottery tickets.

Binding The fastening of signatures into books, magazines, booklets, and so on, by the use of glue, thread, staples, wire or other fastener. Also refers to the cover and backing of a book.

Bite A measurement of time when working with acid in photoengraving. The more bites, the deeper the etch.

Blanket A rubber-covered sheet clamped around the blanket cylinder of a lithographic press that transfers the image from plate to paper.

Blanket cylinder The cylinder of an offset press that holds the blanket.

Blanket creep The forward movement of the blanket due to contact with the printing plate or paper.

Blanket-to-blanket press *See Perfecting press.*

Bleed The part of the image that extends beyond the trim marks on a page.

Blind embossing A bas-relief effect achieved by stamping without metallic leaf or ink.

Blind image An image that will no longer accept ink.

Blinding The poor surface condition of an apparently sound printing plate that causes a substandard image.

Blistering A bubble on the surface of a sheet caused by excessive moisture in the paper which boils when it comes in contact with the extreme heat of a drying oven.

Blue, blueline, blueprint A low-quality proof used for checking position of copy and stripped elements.

Body copy, body matter, body type Refers to the text rather than the headline or display copy, usually six to 14 point type.

Bond paper A grade of letterhead and writing paper characterized by its durability, strength and permanence. Used for letterheads, business forms, and so on.

Body size The depth of a typeface measured in points.

Book paper A classification of papers that can be used in book printing.

Book proof A limp, bound proof that shows a book in page form, also used to determine bulk.

Bourges A pressure-sensitive color film that can be cut away from a clear acetate backing to prepare color art.

Brightness The brilliance or light reflectivity of a printing paper.

Broadside A printed sheet of paper commonly used for large advertising circulars and newspapers.

Bronzing In printing, a metallic luster produced by applying bronze powder over a wet sizing ink.

Buckram A coarse-thread, heavy, binders cloth used for legal and library bindings.

Bulk *See Caliper.*

Bull's eye *See Hickey.*

Bump exposure An exposure in halftone photography that increases highlight contrast and drops out the dots in the whites when the screen is removed for a short time during exposure.

Burn The exposure of a plate in platemaking.

Burnish In photoengraving, the darkening of localized areas of a printing plate by rubbing down lines and dots. In keylining, generic term for rubbing down self-adhering letters or shading sheets.

Burn out An opaque mask used to remove unwanted images in platemaking.

Burr A rough edge or curl of metal that remains on a photoengraving due to the burnishing or cutting process.

Burst binding An unsewn binding technique that nicks the backfold in short lengths during folding to allow glue to reach each leaf without trimming the standard three millimeters or ⅛-inch.

Butt Occurs when two or more art elements touch edge to edge. *Also called Kiss.*

C-Print A color print made from a negative which is usually printed to size for layout.

Caliper The thickness of paper usually expressed in thousandths of an inch. *Also called Bulk.*

Camera ready Type, artwork and graphic materials ready to be photographed by a process camera.

Cast-coated A coated paper with a high-gloss, enamel finish.

Casting off *See Copyfitting.*

Catching-up In lithography, when non-image areas of a press plate begin to take ink or scum up.

Chalking The improper drying of ink that causes pigments to dust or chalk off due to lack of binding vehicle. Caused by overly rapid absorption of the vehicle. Primarily due to improper curing of paper before it goes onto the press.

Character A single element in a typeface (letter, numeral, punctuation mark).

Character count The total number of typographic characters (including spaces and punctuation) used in a manuscript.

Chase The rectangular, metal frame that positions and locks up type and plates for letterpress printing.

Chroma *See Hue.*

Chrome *See Color transparency.*

Circular screen A halftone screen that uses a concentric circle pattern rather than dots to create an image, or a circular screen rotated to change screen angles in a platemaker's camera.

Cold type Typesetting that does not require the use of molten metal, such as typewriting, photocomposition, computerized composition. *Also called Strike-on composition.*

Cold-set inks Solid-form inks that are melted and used with a hot press, solidifying when they contact the paper.

Collate To bring pages together for binding. *Also called Gather.*

Collotype A continuous-tone printing process that uses a printing plate coated with gelatin.

Color bars (Such as GATF or Brunner) Appear on four-color process proofs and used primarily to check registration of all colors, dot gain and to show density and evenness of ink.

Color conversion A black-and-white photo print made from a color original.

Color correction Adjustments made in the color separation process to bring the reproduction as close as possible to the original.

Color filter Placed in front of camera in full-color separation process, these filters absorb certain colors in order to permit better exposure of other colors. Can be colored glass, plastic or gelatin.

Color guide Directions on or samples attached to the mechanical detailing position, percentage and color to be used.

Color Key (3M) Color proofs made from overlaid polyester (acetate) layers for each of the four colors.

Color matching system Specifying color by numbered color samples from swatchbooks.

Color negative film Film which provides a color image in negative form after processing.

Color scanner Machine used to make color separations by electronically reading the densities of the original.

Color separation A film negative or positive that holds information on the amount and placement of the four process colors as they appear in the original art.

Color sequence The order in which process colors are printed, usually in the sequence of yellow, magenta, cyan and black.

Color transparency A full-color photograph on transparent film. *Also called Chrome.*

Color value Tonal value of a color as compared to a light-to-dark scale of grays.

Combination plate Halftone and line material combined on a plate to make a photoengraving.

Coming-and-going A type of imposition in which pages are printed head-to-head in order to produce two copies from one set of plates. Frequently used in paperback book printing.

Commercial register A type of color printing in which the register may be skewed plus or minus one row of dots.

Composition Typesetting and makeup.

Comprehensive, comp An accurate layout of the actual project with type and art in correct position.

Concertina fold *See Accordian fold.*

Connected dot Joined halftone dots of 50 percent value or more.

Contact frame A vacuum-backed board for holding copy and reproduction material in contact during exposure for platemaking. *Also called Vacuum frame.*

Continuous-tone copy Copy and art containing tonal gradations, such as photographs or illustrations, rather than strictly line copy.

Contrast The amount of difference between lighter and darker tones.

Copy Type, artwork and mechanicals assembled for printing. Also, the original manuscript used in typesetting.

Copyfitting Calculating how much space a manuscript will use once it is typeset in a specified typeface. *Also called Typefitting, Copy casting, Casting off.*

Cover stock Heavyweight paper used for the covers of magazines, booklets, catalogs and other printed materials.

Crocking The smudging or transfer of dry ink on the finished product.

Cromalin A widely-used, fast, dry color laminate proofing system made by Dupont in which powder instead of ink is used to reproduce color on a proofing sheet.

Crop marks, cropping After enlargement or reduction, these marks designate what portion or areas of the artwork should be included on a mechanical.

Crossover When a photograph, rule or piece of line art carries over from one page of a bound job to the next.

Curing Preparing paper for the printing process by bringing it to the same temperature and humidity levels of the press room.

Cyan The blue process color.

Dahlgren A dampening system used with litho presses which uses up to 25 percent alcohol in its fountain solution in order to use less water and thereby reduce paper spoilage.

Dampening In lithography, the necessary process of wetting the printing plate to prevent ink from adhering in the non-image areas.

Deckle edge The natural, untrimmed edge of paper, sometimes retained to give a handmade or antique look.

Densitometer A photomechanical tool used to measure density of printed color or to get correct exposure when photographing copy.

Descender The segment of a letter that extends below the body and baseline, as in g, p, q.

Desensitizer Chemicals used in platemaking to make non-image areas of the plate unresponsive to ink.

Developer In photography, the chemical used to bring forth photographic images after exposure to light. In platemaking, the chemical used to remove the unexposed coating.

Diazo Direct positive proofs made by contact exposure to film positives. Can be made on paper or film.

Die A stamping device formed for use in embossing, stamping, debossing, cutting.

Die-cutting Using sharp, steel rules to cut special shapes in paper. *See Laser Engraving.*

Diffusion transfer A process in photography and platemaking in which a negative is produced on a photographic emulsion and transferred to a receiver sheet, which then carries the positive image. *Also called Photomechanical transfer (PMT), Velox.*

Dimensional stability The ability of paper or film to resist dimensional change when moisture content or relative humidity varies.

Dingbat Tiny ornaments used to embellish printed text.

Direct positive A print made without the use of a negative. *Also called Photostat.*

Display type Type set larger than the text for headline or display purposes.

Dot The smallest basic element of a halftone.

Dot area The pattern of a halftone that consists of the dots and the spaces inbetween.

Dot etching A method of color correction on screened color negatives, changing the tone by altering the sizes of the halftone dots.

Dot-for-dot reproduction A method of producing printing film by photographing a previously screened image. A maximum 10 percent enlargement or reduction can be achieved.

Dot gain When dots become slightly enlarged on halftone film or plates, leading to darker tones and colors in reproduction. (A dot gain scale is included in proofs to check this occurrence.) *Also called Dot spread.*

Dot loss When the image on the printing plate is less, or sharper, than what is shown on the progressive proofs. (The opposite of dot gain.)

Dot spread *See Dot gain.*

Double-dot duotone Two halftone negatives (a shadow halftone and a highlight halftone) combined on one plate. The image printed from this plate carries a wider tonal range than does a normal halftone.

Double burning The process of combining multiple film images onto a single film to create a single image.

Double digest fold One of four basic folds in web printing that forms a sheet into a signature.

Double-dot halftone A combination of two halftone negatives made from one continuous-tone image, and using different screen angles for each negative, are combined to make one printing plate.

Double page spread *See Spread.*

Double truck *See Spread.*

Doubling A printing defect of lithographic printing. Refers to a second set of dots causing a color shift in the reproduction.

Doughnut *See Hickey.*

Down time Loss of chargeable time in a given job due to machine breakdown or other factors.

Drawdown A smear of ink produced by a smooth blade on paper. Used to check the quality and tone of the color on the paper stock to be printed on. Also checks chemical reaction of ink to paper.

Driers Substances, usually metallic salts, that speed ink drying.

Drop-out halftone A halftone with no dots in the highlight areas.

Drying oven In web offset printing, the station after the ink cylinders that, using high heat, dries the sheet of wet, inked paper very quickly.

Dry litho An offset litho plate that does not need dampening to keep the ink to its image area.

Dry offset *See Letterset.*

Dry proof A color proof made without platemaking, by using toner powders or colored films. (Cromalin and Matchprint are two brand names.)

Dummy A preliminary layout of a piece planned for printing which shows positioning for art, type, copy, illustrations, margins, and so on. *Also called Mock-up, Layout.*

Duotone A two-color halftone produced from a one color photo.

Dupe An abbreviation for "duplicate."

Duplex stock Paper that has different finishes or colors on either side.

Duplicate transparency A second-generation transparency.

Dusting The accumulation of paper particles on the blanket of a printing press. Also, the process of spraying fine powder onto sheets as they come off the press to inhibit wet ink transfer from one sheet to the next.

Dye transfer A full-color photographic print (Eastman Kodak) made from a color original by making three color separations (yellow, cyan, magenta) and contacting these to an absorbant film which soaks up the colors in the appropriate areas.

Elliptical dots Elongated dots which improve the gradation of tones in middle tones and vignettes in halftone photography.

Elliptical dot screen A halftone screen with a graduated dot pattern that includes elliptical dots forming middle tones.

Embossing Paper embossing is a finishing process that produces a raised image on the surface of the paper by means of a die striking from beneath the paper into a counter die above the paper.

Em space A space the width of the em-quad of the typeface.

Emulsion side The side of photographic film coated with silver halide emulsion.

Endpapers Heavy paper used to attach binding at the front and back of hardcover books.

Engraving A method of printing using a plate made with the image acid etched into metal.

En-space A space one-half the width of an em-quad.

Etch Using acid to dissolve any non-printing portion of a plate.

Exposure The illumination of light-sensitive material or a measure of the length of time and intensity of illumination.

Facsimile transmission/fax The conversion of scanned graphic images or type into electronic signals which are transmitted into a recorded likeness of the original at another location.

Faded color Color lost (usually in large solids or solid tints) during drying or when the printed sheet is exposed to light.

Fade-out halftone *See Vignette.*

Fake duotone *See Flat tint halftone.*

Fake process Intricate and slow process of reproducing color artwork by separating color areas using one overlay for each different color.

Fatty A photographic internegative mask used to enlarge copy slightly to allow for exact registration of butted elements by lapping one over the other.

Feathering Ink spread at the edges of type due to poor quality of ink or its distribution.

Filling in A condition when ink fills in the space between halftone dots and also fills in type.

Film assembly *See Stripping.*

Film makeup *See Film mechanical.*

Film mechanical Film positives or negatives of type and design stripped into position on a sheet of base film.

Film negative Film developed after exposure. Images appear with black hues transparent and white areas opaque.

Film positive Film exposed to a film negative and developed. Images appear with black hues opaque and white areas transparent.

Film processor A machine which develops, fixes, washes and dries film and paper automatically.

Filter *See Color filter.*

Final film The positive or negative film used in the platemaking process.

First color down The first color printed on a printing press.

First proofs Galleys of type given to proofreaders and editorial staff for the first series of corrections.

Fixing A chemical action in photography to remove unexposed silver halide and make the image unresponsive to further exposure following development.

Flapping A protective covering of artwork or mechanicals made by affixing a sheet of tracing paper or heavier paper over the face of the original.

Flat *See Assembly.*

Flat color Any color other than process color used in printing.

Flat tint halftone A black halftone printed over a flat tint. *Also called Fake duotone.*

Flexography A form of letterpress printing with rubber or plastic printing plates used on a rotary letterpress with fast-drying inks.

Flop To turn over an image in order to get a mirror image of it.

Flush cover A book cover trimmed to the size of the text pages.

Fold lines Marks usually printed in the trim areas to show where press sheets should fold.

Folio Page number.

Font A complete assortment of a size and face of type, including letters, punctuation, numerals and ligatures.

Form The assembly of pages and materials for offset printing. Also known as a signature or any portion of a signature.

Format Particular style, size and layout specifications of a printed piece.

Former The mechanism that makes the first fold of a web-fed press.

Foundry type Characters of type cast in metal (hot type).

Fountain A reservoir for the ink supply in a printing press or one that supplies a solution for dampening the rollers of an offset press.

Four-color press A type of press that prints all four colors in one pass through the press.

Four-color process Printing in full color, which requires four plates for printing in the process colors: yellow, cyan, magenta and black.

Fugitive color inks Inks which fade when exposed to light or environmental factors.

Full-color art Artwork rendered in the actual colors to be used in the final reproduction.

Galley proof The first proof or rough proof made from the manuscript, used for editing and proofreading. *Also called Reader's proof.*

Gang run A cost-saving run that prints two or more jobs on the same sheet of paper.

Gather *See Collate.*

Generation Each succeeding phase in reproduction.

Ghosting (mechanical) A printing problem that results from improper design/imposition decisions. It can be noticed when a light or dark repeat of an image appears above or below the actual image.

Ghosting (chemical or gas) An ink drying problem caused by excessive rapidity in the drying of ink, with no escape for the gas by-products in polymerization.

Glue bound *See Perfect bound.*

Gloss ink Quick-drying, non-penetrating ink used on coated paper.

Goldenrod The orange or yellow opaque masking paper used to assemble flats for platemaking.

Grain The direction that the fibers lie in paper, determined by the direction of flow in the papermaking machine.

Grain long/grain short If a paper's length is in the direction of the grain, it is grain long. If the paper's width is the direction of the grain, it is grain short.

Gravure An intaglio printing process in which the image is etched into the surface of the printing plate and is transferred by pressure directly to the paper. *Also called Intaglio.*

Gray scale A strip of standard gray tones ranging from white to black, placed at the side of original copy to measure tonal range and contrast during prepress and printing.

Gray solids Solids that lack density.

Greeking Simulated, nonsense type characters used to give an example of size and position of type in a layout or dummy.

Gripper edge The edge of the paper held by metal tongs that pull paper onto the press for printing.

Gripper margin The proper clearance that must be allowed on the paper's edge to avoid damaging the printed image.

Ground A thin, protective coating that keeps acid from penetrating non-image areas of a plate.

Gum arabic Used to desensitize nonprinting areas and to sensitize etching areas on a printing plate.

Gutter The inner edge of a magazine, book or booklet.

Gutter bleed The continuance of an image from one page across to the facing page of a spread. *Also called Cross-over.*

Hairline A rule that is thinner than one-half point.

Hairline register Register within plus or minus one-half row of dots.

Halation *See Halo effect.*

Halftone dot The basic unit in a halftone. Various sizes of halftone dots recreate original continuous-tone copy for reproduction.

Halftone engraving A relief printing plate made from a halftone negative.

Halftone negative The negative film used to shoot continuous-tone copy through a halftone screen.

Halftone positive The film resulting from exposure through a halftone negative.

Halftone process The process of reproducing continuous-tone copy by shooting it with a screen that separates the image into a series of dots.

Halftone screen Used to convert the original gray tones of continuous-tone copy into halftone dots for reproduction. *Also called Screen.*

Halo effect Occurs when ink builds up around printed letters or halftone dots, giving the center a lighter appearance. *Also called Halation.*

Hard copy Typewritten copy or computer print-out of digital data. Used to check for errors in typesetting, for example.

Hard dot In photography, a very clean, fringeless, sharp dot.

Head trim A standard allowance (usually ⅛-inch or 3mm) between the tops of pages that are trimmed off.

Heat-set drying Drying done on a web press by passing the printing paper through driers.

Heat-set inks Inks that are dried quickly with heat and then chilled.

Hickeys An imperfection in lithographic presswork caused by such problems as dirt on the press, hard specks of dust in the atmosphere or any dry hard particles working into the ink or onto the plate or offset blanket. *Also called Bulls eye, Fish eye, Doughnut, Newton ring.*

High contrast The large difference of dark to light areas in a photographic reproduction.

Highlight The lightest area in a photograph.

Holding line *See Keyline.*

Holdout The property of paper that makes it resistant to absorption of ink.

Hologram A laser-created, three-dimensional recording of a 3-D or 2-D image. Reproduced by hot foil stamping or embossing onto reflective-backed mylar.

Hot type Any metal-cast type.

Hue The characteristic of a color which distinguishes it from all others.

Image area The amount of space given to a particular image in design and printing. The space is assumed to be square or rectangular, even if the image is not.

Imposition The configuration of pages which ensures that after forms have been printed, folded, collated and trimmed, all pages will be right-reading, directed properly top to bottom and all folios sequential.

Impression The image printed by the process of ink moving from plate or blanket to paper.

Impression cylinder The cylinder that keeps the paper in contact with the printing plate or blanket.

Indicia Mailing permit stamped on envelopes and cards.

Indirect letterpress *See Letterset.*

Indirect process The color separation process separating original copy into four continuous-tone negatives, then sizing and screening them at another time for color process printing. Direct process does this all at once.

Ink coverage The amount of ink covering the paper in relation to the unprinted space.

Inkometer A tool that measures ink stickiness (tack). *Also called Tackoscope.*

Ink squash Ink spread beyond the edges of the original image.

In line Any operation that accompanies the printing process, such as folding, numbering, gluing, coating, and so on.

Inner form Pages on an imposition that will fold to be inside pages.

Insert A separate piece of printed material to be included between signatures during binding.

Intaglio *See Gravure.*

Internegative The photographic negative from which a print or transparency is made.

Jaw folder The mechanism on a web press that folds paper into signatures.

Jogging To vibrate paper stock to bring the edges into line before trimming. A jogger may be attached to a printing press binder or may be a separate unit.

Justify Type that is aligned left and right.

Kerning The process of adjusting the inter-letterspacing between two letters.

Keyline Paste-up artwork, type and photos ready for photo-mechanical reproduction.

Kiss *See Butt.*

Kiss impression An impression in which ink is put on paper by the lightest possible surface contact and not impressed into it. This technique is necessary when printing on coated papers.

Lacquer A clear, protective coating for paper that renders a high gloss.

Lap The slight overlapping of two printed colors to ensure there is no fault in registration.

Laser engraving Engraving process done by laser, evaporating the paper rather than cutting it.

Laser platemaking Exposing plates with lasers.

Last color down The last color to be printed on the press.

Laydown sequence The order in which colors are printed.

Layout *See Dummy.*

Leaders A row of typographic dots or dashes.

Lead, leading The space between lines of printed type.

Letterflex A photopolymer plate used in flexography and letterpress.

Letterpress A type of printing that transfers ink from a raised printing surface directly to the paper.

Letterset A type of printing that transfers the image from a raised printing surface to a blanket and from blanket to paper. *Also called Dry off-set, Indirect letterpress.*

Ligature Two or more letters joined into one form.

Lightfastness How much a paper or film can withstand exposure to light without losing its original characteristics.

Line conversion Photographically eliminating middle tones from continuous-tone art or photographs so that it can be reproduced as line copy.

Line copy, line art Black-and-white artwork with no middle tones.

Line gauge *See Type gauge.*

Line negative A film negative of line copy. Image areas are clear, blank areas are opaque.

Line printer A machine that produces a hard-copy print-out.

Linen tester A magnifying lens (or loupe) used in checking half-tone dot patterns.

Linotype A typesetting process that casts complete lines of hot type, known as slugs.

Linting A printing problem caused when fibers from uncoated paper are pulled onto the blankets, plates or rollers.

Lithography An offset printing process in which an inked image is transferred from a plate onto a blanket cylinder and then onto paper.

Live area *See Image area.*

Machine proof *See Pre-press proof.*

Magenta The process color for red.

Makeover Material or labor lost on a job.

Makeready The steps (or the time) necessary in preparing the press, folder or bindery equipment for a job.

Makeup Assembling type and other elements in a page to produce the final arrangement for reproduction.

Manuscript, mss The original copy that is typeset.

Mask Any material used to shield artwork or film from additional retouching or exposure to light.

Master plate The plate containing the image for offset printing.

Matchprint A brand name for a dry color pre-press proofing system by 3M.

Matrix The metal mold used to set metal type.

Matte A dull finish on paper, inks or photographic prints. The opposite of glossy.

Measure The length of a line of type, usually specified in picas.

Mechanical The assembly of all camera-ready line copy used to make a printing plate, including size and position of halftone reproductions and instructions to the cameraman and printer.

Mechanical separations Copy with overlays indicating color position and register.

Metallic inks Ink containing metal dust that produces a metallic sheen when printed.

Mezzotint A random dot-patterned halftone screen or a method of engraving a plate to produce variations in tone.

Middle tones The gray areas of a photograph that are lighter than the shadows and darker than the highlights.

Mock-up *See Dummy.*

Moiré Undesirable patterns which occur in printed halftone reproductions due to improperly angled screens.

Monochrome An image made up of varying tones of one color.

Monotype An obsolete form of machine typesetting that casts one letter at a time.

Mottling An uneven impression, especially in flat areas. It is usually caused by too much pressure or unsuitable paper or ink.

Mounting press A machine that dry mounts photographs and artwork without liquid adhesives.

Multilith An offset lithography press small enough to accommodate jobs slightly smaller than 10 x 15-inches.

Multiple exposure A photograph with more than one exposure.

M-weight A paper's weight as measured per 1,000 sheets.

Negative Photographic film which carries an image in which the values of the original are reversed.

Negative assembly The assembly of negatives on a flat for plate-making.

Newsprint Inexpensive, absorbent paper used to print newspapers.

Nick Notches in photographic film that designate the emulsion side.

Non-scratch inks Inks that resist abrasions when dry.

Novelty printing Printing on items such as clothing, balloons, pens.

Offset gravure Primarily done on a flexographic press using the offset principle.

Offset lithography A method of printing in which an intermediate blanket cylinder transfers an image from its source onto paper. *Also called Photo lithography.*

Offset When ink transfers from the surface of one sheet to the back side of another sheet that rests on top of it after printing. *Also called Set off.*

One-up, two-up Printing one (two, three, and so on) impression at a time in a single job.

Opaque In printing, ink which does not allow the substrate beneath to show through. In filmmaking, the process of painting out unwanted areas on a negative.

Opacity The ability of a sheet of paper to keep the type and images from showing through on its reverse side. Also, the density of an ink's coverage.

Orthochromatic film Film sensitive to blue, green and yellow light that records black-and-white images without tonal gradations. Used in platemaking.

Outline Halftone *See Silhouette halftone.*

Out-of-register Occurs when the film for the colors of a printed image is misaligned.

Overlay A transparent sheet covering a piece of artwork indicating color separations, corrections or directions to the platemaker.

Overmatter *See Overset.*

Overprint Printing one color over another.

Over runs Sheets printed beyond the quantity specified.

Overset Excess type that cannot fit into space specifications.

Page makeup Assembly of all materials necessary to produce a page proof.

Pagination The numerical sequence of pages in a book.

Panchromatic Color-sensitive film.

Pantone Matching System (PMS) A registered trade name for a system of color matching in designer's materials such as inks, papers and markers.

Paste up Assembling photos, type, line art and so on with adhesive to produce a mechanical or keyline.

Peaking Using a color scanner, the electronic edge enhancement produced on color separation negatives by exaggerating the density difference of the edges of the images.

Perfect bound A method of binding with glue that produces a flat-edged spine.

Perfecting press A press that prints both sides of the paper at once. *Also called Blanket-to-blanket press.*

Perforating rule A device on a letterpress or the cylinders of an offset press used to perforate paper.

Permanence A paper's ability to resist changes in its characteristics over time.

Photoengraving A photomechanically-produced metal relief printing plate used in letterpress printing.

Photogravure Intaglio printing from an etched form (plate or cylinder) of a photographic image.

Photomechanical *See Film mechanical.*

Photomechanical transfer (PMT) *See Diffusion transfer.*

Photo offset *See Offset lithography.*

Photopolymer coating A coating of compounds which, when exposed, polymerize to a tough, abrasion-resistant plate good for long runs.

Photosensitive Light sensitive.

Photostat A positive print made directly on paper using a photostat machine.

Phototypesetting Setting type photomechanially.

Pica A printer's measure equal to 12 points. Six picas equals approximately one inch.

Pi characters Mathematical signs, ligatures, accents and other typographic characters not typically used in the font.

Picking Removal of part of the surface of paper during printing.

Pigment Finely-ground solid matter that forms the coloring agent of printing inks.

Piling The sticking or caking of ink pigment on the plate or blanket instead of passing on readily to the intended surface.

Pinholes Tiny holes in the emulsion of a photographic negative which must be opaqued before platemaking.

Pin register Holes and pins applied to copy, film, plates and presses which are accurately positioned to ensure correct register of colors.

Planographic printing Any printing method in which the image and non-image areas are on the same plate (lithography).

Plastic plate A lightweight duplicate of a letterpress printing plate which is easy to handle and ship.

Plate A metal or plastic sheet coated with light-sensitive photographic emulsion onto which an image is chemically etched. The plate is then mounted on the press and is inked, thereby becoming the image carrier to another roller or to the paper.

Plate cylinder The cylinder that supports the inked plate on the printing press.

Plate finish An even, hard finish on paper.

Platen A small letterpress that holds plate and paper parallel to each other. (Also known as a clam shell because of its opening and closing motion.)

Plugging A printing problem which occurs when ink fills in around halftone dots, causing a loss of shadow detail.

Point The smallest typographic measure. Twelve points equal one pica, and 72 points equal one inch.

Poor trapping A condition in wet printing when less ink transfers to previously printed ink than to unprinted paper.

POP Point of purchase. Advertising or promotional displays in a store.

Positive A film or print reproduction of an original containing the same color relationship and subject placement as the original.

Posterization A special effect, high-contrast copy of a photograph.

Powdering *See Dusting.*

Pre-press proof A photographically-produced trial print used to check a job before going on to press. *Also called Machine proofs.*

Presensitized plate A printing plate with a light-sensitive coating.

Press proof A color proof pulled from the press to be reviewed by a client before he gives authorization for printing.

Press run The total number of copies produced in one printing.

Primary colors Pure colors from which all other colors are mixed.

Printer The film or plate of a single color produced in the color separation process.

Process camera A camera which is specifically designed to photograph material for printing. It can distinguish between shooting tone and line copy.

Process colors, inks Magenta, cyan, yellow and black.

Process lens A photographic lens that is corrected for line, color and halftone work.

Process plates Halftone plates printed in one of the four process colors.

Process printing *See Four-color process.*

Progressive proofs, progs In color printing, the proofs made on a proofing press to be used as a guide to color quality and registration. Each color is shown separately and also surprinted in all possible combinations. *Also called Hollywoods, Progs.*

Proof A film or paper sheet or assembly prepared prior to printing which allows the client to check how color, photos, type, art and so on, will register and print.

Proportion scale A wheel-like tool used in sizing art (reduction or enlargement) for reproduction.

Quad A specified space size in typesetting (em-quad, en-quad).

Quality control Procedures to regulate and optimize production processes in order to produce a consistently acceptable product.

Ragged right/ragged left Type aligned vertically right or left.

Reader's proof *See galley proof.*

Ream Five hundred sheets of paper.

Reflection copy Original copy viewed or photographed by light which reflects off its surface.

Register The correct positioning of one color in relation to another during printing.

Register mark A symbol used on copy to match with the same symbol on an overlay or flat to ensure accurate registration.

Relief plate A printing plate with a raised, image-bearing surface. Letterpress and photoengraving use relief plates.

Reproducton proof A clear, line copy proof of type on photographic paper that can be used in assembling the mechanical.

Resin An organic binding substance used in making printing inks and paper.

Resist A stencil hardened by light and used on printing plates to prevent etching of non-printing areas.

Retouching Modifying photographs or artwork with paint, dye, pencil, airbrush or other media.

Reverse When the original black image is reproduced white and vice-versa.

RIP Rest in proportion. Instructions to prepare the adjacent side of artwork the same as the side marked.

Roman The style of type in which letters are upright with no slants.

Rotary printing Any printing method that utilizes a cylinder as its printing surface.

Rotogravure Gravure printing on a web-fed press.

Rough proof *See Galley proof.*

Rubber plate A flexible relief plate made from rubber and used in flexography.

Rubbing When printed ink appears dry, but does not resist surface rubbing or abrasion. *Also called Scuffing.*

Rubylith A red masking material opaque to light which is used to mask out areas that should remain unexposed to light.

Runaround Type that is set to outline a design element.

Runability Qualities in a paper that affect its ability to run on press.

Saddle stitching Binding a publication with staples down the center of the spread.

Sans serif Typeface characters without serifs.

Sawtooth edge The edge of a halftone that angles across the line of its screen, causing the dots to look like the teeth of a saw.

Scaling Figuring the proportion of original artwork to reproduction size in percentage of enlargement or reduction.

Scanner An electronic machine that scans images to make color separations or negatives for platemaking.

Score To crease a sheet of paper or board so that it folds easier.

Screen *See Halftone screen.*

Screen angle The position of a halftone screen when it is arranged over other halftone screens to avoid moiré patterns when printed.

Screen finder A template that determines the correct screen ruling for a halftone.

Scumming A printing problem that occurs when the non-image area of a plate accepts ink in random areas.

Secondary color The color that results when primary colors are mixed in equal proportions.

Self-cover Using the same paper on the cover of a publication as on the inside.

Separation Negatives or positives made from four-color art and separated into four process colors.

Serif The embellishments of some letter styles that extend from the main stroke of a letter.

Set-off *See Offset.*

Sharpen To make the printing dot sizes smaller on photographic films using contact printing techniques and exposure manipulation. Printing plates can sharpen due to wear.

Sheet-fed A printing press into which sheets of paper are fed singly.

Sheetwise An imposition and printing procedure utilizing two plates to print the front and back of one sheet.

Show-through When a printed impression on one side of a sheet is visible through the other side of the paper.

Side-stitching A method of binding that involves stapling through the spine of a publication from front to back. Prevents a book from lying flat. *Also called Side wire.*

Signature A group of pages for a book, booklet or magazine printed on the same sheet, front and back. After printing, the sheet is folded so that the pages fall into the correct sequence.

Silhouette halftone A halftone with the background removed.

Silhouetting Outlining continuous-tone art with paint or film before it is made into a halftone silhouette.

Skewing When ink, plate or blanket cylinder are not parallel, and so do not make proper contact.

Slurring A distortion of the printed image caused by dots that appear elongated or smeared.

Soft dot When halation is excessive around a halftone dot.

Specifications/specs A description of the requirements of a particular printing job, including size, press run and color, given to the printer by the client.

Spine The bound edge or backbone of a book.

Splice To join webs of paper on a press.

Split fountain Printing more than one color with one impression by using more than one ink in the ink fountain.

Spoils, spoilage Badly finished sheets which are discarded before delivery of a job.

Spot varnishing Varnishing specific areas on stock.

Spread Two pages that face each other. *Also called Two-page spread, Double-truck.*

Standard viewing conditions An area surrounded by neutral gray and illuminated by a light source of 5,000 Kelvin both for viewing transparencies and reflection prints.

Static neutralizer A device that removes static electricity from paper.

Step-and-repeat A photomechanical method of using negative or positive images to produce multiple images.

Stet A proofreading term meaning "let it stand" and print as in the original, not as changed.

Steel engraving An intaglio printing process that presses an inked, engraved surface onto paper, leaving a raised printed impression.

Strike-through *See Show-through.*

Stripping The process of assembling film for type, art and halftones in position for photomechanical reproduction. *Also called Film assembly.*

Subtractive colors In printing, an ink or filter that subtracts some of the colors from white light projected through it.

Surprint Superimposing a second negative on an already exposed negative.

Swatch book A book of material samples.

SWOP Specifications Web Offset Publications, Revised, a booklet that gives the web offset specifications for separations, proofing and printing process color.

Tack The adhesive quality of a printing ink.

Tackoscope *See Inkometer.*

Tearsheet A single page of a publication containing a specific ad or article in print.

Thinners Liquids mixed with inks to reduce tack.

Thermography A simulated engraving done by combining a resinous powder with a wet image and fusing it with heat, resulting in a raised impression.

Three-color process Reproducing four-color artwork using only the primary colors and not black.

Tint Various tone strengths of a solid color.

Tip-on An insert that is glued onto a page.

Tissue overlay A protective tissue flap attached to cover artwork.

Tonal value The relative densities of tones in an image.

Transparency A color photograph viewed by transmitted, rather than reflected, light. *Also called Chrome.*

Transparent ink Inks that are not opaque (most inks are not transparent).

Trapping The ability to print wet ink over already printed ink.

Trim marks Marks that indicate where to trim stock. *Also called Cut marks.*

Turnaround The length of time elapsing between the start and finish of a particular job.

Two-color press A press that prints two colors on one side of a sheet in one pass.

Two-page spread *See Spread.*

Typeface A classification of a font of type in a specific type design.

Typefitting *See Copyfitting.*

Type gauge A ruler divided into points used to measure how many lines are in a column of a specified type. *Also called Line gauge.*

Type specifications Instructions to the typesetter on how to set the type from a manuscript.

U/lc, U & lc Upper and lower case letters.

Undercolor removal (UCR) To improve trapping and reduce ink costs in process color printing, color is reduced in areas on color separation films and black film is increased to compensate for the amount of color reduced.

Vacuum frame *See Contact frame.*

Value The relative lightness or darkness of a color, or the relation of one part of a photograph to another in regards to lightness or darkness.

Varnish A protective liquid lacquer applied to a printed surface.

Vellum Heavy, translucent paper often used for overlays.

Velox A photographic print made from screened negative. *See Diffusion transfer.*

Verso Left page.

Vignette A fade-away background in an illustration or photo.

Vignette halftone Etching out the tone around the edges of the image on a halftone to make it fade away.

Viscosity The degree of tack and flow of an ink.

Watermark A symbol or trademark manufactured into the paper so that it is visible when paper is held to light.

Web A continuous roll of paper used for printing.

Web-fed A printing press fed by a web or reel of paper.

Wet-on-wet Color printing in which the first color of ink is still wet when the subsequent colors are printed.

Widow A single word or part of a word ending a paragraph of type.

Window An area reserved in a flat for an image to be stripped into.

Wire mark A mark on the underside of a piece of paper made by the paper-making machine's wire.

Without color *See Achromatic.*

With-the-grain The direction of the stock's fibers.

Woodcut A block of wood with a design carved into it and non-printing areas cut away. The woodcut is inked and pressed against stock to make an image.

Work-and-tumble A printing procedure in which both front and back images are imposed on one plate. The sheet is printed on the top side, turned head over heels, and the back side is printed. Two different gripper edges are used.

Work-and-turn A printing procedure in which both front and back images are imposed on one plate. The sheet is printed on the top side, turned over sideways and the backside is printed. One gripper edge is used.

Wrong-reading A reverse of the original image or type.

Xerography An inkless reproduction process that uses static electricity and toner powder to copy an image (Xerox).

x-height The height of the lowercase characters of type, not including ascenders and descenders.

Yapp binding A flexible book cover.

Zinc engraving, zincs Line or halftone art etched into zinc plates for letterpress.

■

Index